"Frank Langella's *Dropped Names* offers shrewd and often poignant observations that linger in the mind long after each chapter ends. . . . A tour-de-force debut that, in the proudest show-business tradition, leaves us wanting more. . . . Indeed, *Dropped Names* bristles with lively (and often foulmouthed) ghosts, whom the author vividly resurrects with skill and humor. It was F. Scott Fitzgerald who allegedly said, 'There are no second acts in American lives,' but that novelist never met Frank Langella, who, at age seventy-four, displays a shimmering gift for prose. He's the literary life of the party, and I hope he has enough material for a sequel. . . . There's no question that readers will be eagerly awaiting an encore."

—*Huffington Post*

"If Frank Langella's memoir simply did what its title promises, it would be deep-dish gossip. But his memories of the stars he's encountered during a lengthy career on Broadway and in film shed perceptive light on the costs of pursuing and maintaining fame. . . . Whether he's flattering or skewering, Langella doesn't shy away from noting that celebrities *are* just like us, precisely because they're flawed human beings."

—*Detroit Free Press*

"Satisfyingly scandalous. . . . Each of the sixty-five chapters in *Dropped Names* offers a no-holds-barred eulogy somewhere between mash note and carpet-bombing. . . . Reading it is like being flirted with for a whole party by the hottest person in the room. It's no wonder Langella was invited everywhere."

—*New York Times Book Review*

DROPPED NAMES

Frank Langella

DROPPED NAMES

Famous Men and Women As I Knew Them

HARPER ● PERENNIAL

NEW YORK • LONDON • TORONTO • SYDNEY • NEW DELHI • AUCKLAND

HARPER ● PERENNIAL

A hardcover edition of this book was published in 2012 by HarperCollins Publishers.

HarperCollins books may be purchased for educational, business, or sales promotional use. For information please write: Special Markets Department, HarperCollins Publishers, 10 East 53rd Street, New York, NY 10022.

FIRST HARPER PERENNIAL EDITION PUBLISHED 2013.

Library of Congress Cataloging-in-Publication Data is available upon request.

ISBN 978-0-06-209449-0 (pbk.)

13 14 15 16 17 OV/RRD 10 9 8 7 6 5 4 3 2 1

for
Sara

PREFACE

It began as a fleeting, one-time-only sight gag in an actors' communal dressing room on a dinner break between matinee and evening performances. It was 1991 in New Haven, Connecticut. As indeed it was everywhere else. But a room full of actors at feed is not quite like anywhere else.

As the tin foil gets unfolded and the coffee cups get filled, a freewheeling banter starts up and the decibel level increases in direct proportion to the personalities of the participants. You would think the respite between audiences would be a welcome bit of relaxation, but actors are each other's best audience and when the stories begin, so does the bloodlust, and there comes a race to see who'll get the final call.

In this case, the room was a heterogeneous mix of crusty old vets and as yet history-less virgins to tales of reminiscence. So when one of the old-timers threw out yet another famous name in that casual, "Oh, I'll never forget when the Queen Mother turned to me and said . . . ," I couldn't resist. I picked up a piece of silverware and sent it clattering loudly to the floor.

"Oops! I dropped something!" I declared. And a ritual was born. Like a pack of wolves let loose on a defenseless critic, the gathered predators got the joke and began to drop names and toss silverware in a frenzy of competitive hilarity. So riotous that the stage manager arrived to see what the animals were up to, and stayed to join in the game.

Inconceivably, I have begun my fiftieth year as an actor. And the opportunity to drop names of the famous, both here and gone, has increased substantially.

But were it not for one fateful morning sitting quietly in my sixth-grade homeroom at Number 3 School in Bayonne, New Jersey, this book, most likely, could not have been written. Our principal, Mrs. Ida Zeik, came in to ask if there might be a volunteer willing to audition for the role of an elf in the annual school extravaganza: an operetta entitled *Lazy Town*. Mysteriously, my hand shot up into the air as if having been yanked there by some divine puppeteer.

In the four life-changing minutes it took me to walk from my classroom to the auditorium, climb the three steps to a platform above the floor level, walk into a dim narrow space I would later learn was the *wings,* wait, hear my name, and walk out onto what I would later learn was a *stage,* I found my calling. I got the part in all likelihood because I was the smallest boy in my class. But on such a minor happenstance careers can be launched. This one moved me quite literally from the dark into the light and I have remained in its warm and comforting glow ever since.

But out of it, in the less forgiving cold light of reality, I have lived my life as many actors have: available and waiting, and often in a sort of emotional wilderness feeling alone and apart.

Five decades in my profession has afforded me the transient company of many remarkable people. This book is about only the famous among them. Like elusive fireflies, they flickered for a time, shone brightly, dimmed, and ultimately disappeared. Separate and diverse individuals as they may be, my subjects have in common the inevitable outcome awaiting us all: to live on only in memories. In this case, mine.

I admit they are most likely prejudiced, somewhat revisionist, and a tad exaggerated here and there. But were I offered

an exact replay of events as they unfolded, I would reject it. I prefer my memories.

Don't turn the page if you like your stories spoon-fed or sugar-spread. I didn't always like some of my subjects, and I'm quite certain a number of them found me less than sympathetic. There will be a fair amount of forks to the eye and knives to the throat; even a self-inflicted wound or two. I present these people to you, not perhaps as they might have described themselves, or as others might recall them, but as I *perceived* them.

Should you decide to read on, I hope you will find them to be as enriching and engaging a galaxy of human beings as I did. While listed with respect to the order of their passing, they can be visited in random order, with no regard to chronology, status, or billing.

So get out your silverware. I'm about to drop a whole bunch of names on you.

FL

CAST of CHARACTERS
In Order of Disappearance

DROPPED NAMES

MARILYN MONROE

She was my first. Not bad for a boy of fifteen awaking one Saturday morning preparing for his inauguration.

It had taken a while for me to save enough from my allowance and the birthday dollars from my uncles, which I rolled tightly in a rubber band and hid behind the radiator in my room, but I was determined.

When I had the necessary amount, I adjusted my wings, bolted from my small house in Bayonne, New Jersey, for Journal Square in Jersey City, and flew, so to speak, on a bus, to the Port Authority Terminal in New York City for the first time.

It was the winter of 1953. Dwight D. Eisenhower had just delivered his first inaugural address; our borders were safe and we were at peace. But I hardly noticed. Inside my head there were larger issues at stake.

I thought then that New York City meant only Times Square. Somehow I believed that if I went too far north, south, east or west, I would fall into the ocean or hit a mountain. So, I wandered the streets from 42nd to 50th between Seventh and Eighth Avenues unaware of what lay beyond. And equally unaware of what I was looking for. I didn't have much time. If lightning was going to strike, it would have to be by sundown, when I would need to be back home before being missed.

Late in the afternoon as it was growing dark, I was racing back to the Port Authority, disappointed, my head down against the icy wind. Coming slowly toward me on a side

street was a long black limousine. When it stopped, the driver jumped out, came around to open the curbside back door, and as he did, put his other hand out, palm up, to block my way so the passenger's path would be clear and undisturbed.

From inside the darkness a white-gloved hand reached out for help and it was given. Then came a face of dizzying beauty, the head slightly lowered to avoid disrupting the spun gold blond hair caressing a white fox collar clutched close to a milky white throat.

As she emerged fully, a long white coat emerging with her like hot steam freeing itself from inside an opened shower door, my heart began to pound. Once fully standing on the street, she let go of the collar, allowing the coat to fall free, exposing a body encased in a full-length skintight gown made of what looked like tiny white pearls seemingly flung at her in wild abandon and clinging to every pore. Around her neck, over her wrists, and on her ears were brightly sparkling diamonds.

She lifted one of her gloved hands, felt for the necklace, and with the other reached for the side of her coat, pushing it back to reveal still more of her. My pulse raced faster. She turned briefly to her right, saw me standing there, smiled like a sunbeam, and said in a soft whisper:

"Hi."

Then she glided up some steps into a building and flashes of light obliterated her from my sight. I returned to the Port Authority and sat trembling on my bus as it transported me back home.

An indefinable yearning to free myself from a life I instinctively felt was killing my soul had caused me to venture forth that day without guidance or direction; not so much from bravery as from desperation. I was a small, skinny kid in horn-

rimmed glasses, born into a middle-class Italian family, feeling always as if I didn't belong. As if I were in a prison, incarcerated for crimes unknown to me. At twenty-seven years of age, Marilyn Monroe had, I'm certain, awakened that morning yearning for something she too could not define; a tortured soul that I saw only as a beautiful woman and a Movie Star.

What were the odds of this chance encounter? Had I turned the corner sixty seconds later or had her car caught a light and been delayed it would not have happened. She was my first. Someone existing outside my prison walls. An ineffable creature, stopping for an instant, looking directly into the eyes of a fifteen-year-old boy, smiling, and speaking just one word. One was enough. Lightning had struck.

CHARLES LAUGHTON *and* ELSA LANCHESTER

"Come in, come in. Lovely to see you. Lovely."

Elsa Lanchester, widow of the actor Charles Laughton, greeted me at the door of the home somewhere in Los Angeles the two had shared during their thirty-five-year marriage. Everything I'd hoped and expected her to be, she was. Wildly eccentric, extremely bright, and wonderfully saucy.

It was the early 1970s. After over a decade of work on Off-Broadway stages in New York and regional theatres around the country, I had begun my movie career with the films *Diary of a Mad Housewife* and *The Twelve Chairs* and I was in L.A. looking to find more work in them.

Miss Lanchester agreed to see me because it had been communicated to her by a mutual friend that I was fascinated with her husband and his approach to film acting. Mr. Laughton had passed away in 1962.

"First tea, I think," she said, and we settled down in the living room of a house I remember only as English Tudor and suitably shabby. The Brits don't like anything to look new. Furniture must have rips in the upholstery, exposed stuffing, paintings hung crooked, crockery unmatched and properly chipped. The feeling being, I suppose, one is above caring; however self-consciously tattered it appears.

Miss Lanchester settled comfortably onto the couch and talked animatedly about their life in California, her passionate love of gardens, her husband's devotion to the sun, their animals, and the good life his success afforded them. "England is our home, of course," she said, "but life here, as it is for so many of our expats, is divine. Particularly as one gets older and the bones begin to creak. And, of course darling, there are all the delicious perks Hollywood has to offer. Charles adored them all and, frankly, so do I. Our tiny island could never afford us this sort of life. So many of our friends are here. Although I must say Charles preferred not to be part of the English contingent. He was, by nature, an extremely solitary man and cared not to heavily associate with our compatriots. But, including ourselves, dear, I can tell you: nobody corrupts quicker than a Brit."

Charles Laughton was, to my mind, an extraordinary actor. His particular brand of English hauteur irritated many of his own countrymen, I think, more than the Americans. His performances as Quasimodo in *The Hunchback of Notre Dame* and Captain Bligh in *Mutiny on the Bounty* are superb. All the style, technique, and precision of the British actor, but with an ingredient rare in that breed: soul!

My personal favorite is his performance in *Witness for the Prosecution*. Aided and abetted by his wife, it is consummate stage/screen acting—serving both mediums beautifully.

Miss Lanchester spoke of him with love and affection, talking of his deeply sensitive nature, bouts of depression and insecurity.

"I can't do this one. I can't. Must get out of it," was his usual clarion call of alarm after he agreed to be in a picture. Stories of his threatening to back out of or shut down productions because he couldn't "find his character" were a part of his legend. He eventually showed up to show off and his rather distant and paranoid behavior often amused his fellow workers. Peter Ustinov once said of him:

"There was Charles, lurking about the set, hoping to be offended."

"Charles was devastated by bad notices," Miss Lanchester said. "He would take to his bed in agony, reading them again and again. Finally, he devised a method for exorcising them from his soul. He taught a Shakespeare class here at the house in his studio and he would gather the notices and perform them for his students. If a critic said, 'Mr. Laughton is pompous,' he would deliver the word with ten times the venom it engendered. He'd act the review with tremendous power and vitriol, exhausting himself and then burn it in a bucket. It was very entertaining."

We ended a tour of the house in Mr. Laughton's bedroom, not very bright, also suitably tattered, with books by the hundreds. Then on to her room.

"Come here to the window," she said. "Look out. What do you see?"

"Your swimming pool."

"Yes. Can you see all four corners?"

"No. Only three."

"Yes! Only three. There is an area of the pool that cannot be seen from any window of the house. And had you visited when Charles was alive, that is the area in which he would have taken you, suggested you swim in the nude, and then seduced you. That's where he took the beautiful boys. He was homosexual, you know."

"I'm not that easily seduced," I said.

"Don't be too certain, dear boy. Charles could be very persuasive."

JOHN F. KENNEDY

Yellow pants. The President of the United States was wearing yellow pants. And I was standing before him clutching the waistband of a wet bathing suit, three sizes too big for me, with one hand, while shaking his with the other.

How I came to be shivering in front of him, soaking wet, partially blinded by my thick matted dark hair and barefoot on a lawn in Cape Cod, Massachusetts, at twenty-four years of age, is happenstance at its most unpredictable. Meeting a president is no small matter. Meeting him wet and half naked cements the occurrence profoundly and preserves its place of honor on my mental mantel.

He would be dead a scant twenty-seven months later, at forty-six years of age. But on this ordinary day in his life and a seminal one in mine, there he was: a handsome, smiling, charming young man out for a good time with his wife and friends.

It was the summer of 1961. There is a theatre in Dennis, Massachusetts, called the Cape Playhouse. Still there, still thriving. I was a member of a troupe of young actors performing children's plays in the afternoon, taking classes, and helping to build sets for the Equity productions performing at night. One of our troupe would become a lifelong friend until she herself died tragically young.

But on this glorious summer day my friend was deliciously alive and quite happy with the trick she'd played on me. Her name was Eliza Lloyd. Not yet twenty years old and an incorrigible prankster. One day she said, "My mother and stepfather are having some friends over for lunch on Sunday. Would you like to come?" I'd met and liked her mother. "Sure," I said, happy for any free meal I could get. She wrote out the directions on a piece of brown wrapping paper and I stuffed them into my madras shorts.

I started out about 11 a.m. on Sunday and found the place much quicker than I had anticipated. When I pulled into the gravel driveway in my hand-me-down Ford station wagon in front of a beautiful gray and white house, I entered a world I had never before experienced. It was as if the matching gray and white pebbles had been arranged on the ground one-by-one and the house had been freshly painted that morning. Even the colors of the flowers seemed brighter and their shapes more perfect than any of the forsythia bushes growing wild around my little house in Bayonne, New Jersey. This was Osterville, Cape Cod, a paradise for the privileged, but a strange and magical mystery to me.

Dressed in khakis and an open shirt, my hair long and unkempt, pre-Beatles-style, I sat in the car not certain what to do next. But the front door opened and standing there was a figure the likes of whom I had never seen before, who quickly solved my dilemma.

I got out and walked over to him. "Hi. Liza asked me to lunch. Am I very early?" He stood there with a countenance that displayed neither warmth nor disdain but an enigmatic stare that instantly made me want him to like me. He was a black man of indeterminate age, dressed in a white jacket, black pants, black shiny shoes, and white gloves. He did not answer my question. "Please come in, Mr. Langella. Miss Eliza

is not down yet but she left word that when you arrived you might like to have a swim." "Oh, I didn't bring a suit." "I'm sure you'll find some hanging on hooks down by the beach house. Help yourself."

He walked me through the spacious, understatedly elegant house, to a large patio, and down a stone path set into a beautifully manicured lawn, toward a tiny little blue and white house with sculpted white birds dotting its roof and a wooden dock meandering toward the water's edge. "May I bring you something to drink, sir?" "No, thank you," I said. And he left.

At that time I doubt I weighed more than 160 pounds with a waist under thirty inches. None of the suits I found fit me so I did the best I could with one at least three sizes too big, by pulling its tie very tight and twisting the waistband into a bulky knot that immediately came undone once I jumped into the water and splashed around in the open sea.

Seemingly out of nowhere came the sound of a helicopter overhead and I continued to float about, assuming it would pass by, although to where I couldn't imagine. It soon became astonishingly clear that it wasn't going anywhere but down toward the lawn of this house, and as it grew louder and came closer, I emerged from the water, clutching my suit with one hand and shielding my eyes from the sun with the other. Nearsighted from birth, I could just make out two figures waving at me from inside the chopper. It came to rest on the lawn just as Liza's mother appeared from the house, her hand firmly atop her blue hat, followed by the black gentleman in the white gloves, whose name I would later learn was Buds. The blades began their slowdown and a door opened. The pilot jumped out, turned to extend his hand, and it was taken by the single most famous female hand in the world at that moment, Jackie Kennedy, dressed in a simple top and pants with two cameras slung around her neck. A moment later she

was followed by the President, gingerly stepping out, smiling, and greeting Liza's mom. "Hello, Jack," she said, offering her cheek. "Isn't it a lovely day?" She and Jackie kissed and hugged and the President turned in my direction. I had been slowly moving up the lawn, completely unaware that I was having an out-of-body experience. All I could focus on was those yellow pants.

"Who's this?" the President said with a big beaming smile.

"This is Liza's friend from the Playhouse," said her mom. "Frank, this is the President and Mrs. Kennedy."

Liza and her stepfather had just reached the group as the President and Jackie shook my one free hand and Liza said, "Hello, Mr. President. We didn't tell Frank you were the luncheon guests. We wanted to surprise him." And amid the indulgent laughter Jackie said her first words to me after "hello," in that world-famous whisper, "We'll have to plot your revenge, won't we?" As the group climbed up the lawn to the house, the President turned back and said, "Frank, I hope you're going to change for lunch."

"I didn't want to tell you," Liza said as we headed back to the beach house, "because I thought you'd be too scared to come." I changed back into my clothes, then sat on a blue and white chaise, as Liza stood behind me towel-drying my hair. "So, who are your parents?" "Mummy's name is Rachel Lloyd, her nickname is Bunny, and after she divorced my father she married Paul Mellon. Jackie and Mummy are best friends and Jackie wanted to meet somebody so Mummy arranged a little lunch for them." Why *Mummy* wasn't pronounced *Mommy*, my New Jersey boy ears could not fathom.

"Meet who?" I said.

"Surprise."

"Just tell me."

"Nope."

We walked up the lawn, my hair still damp and my heart beating slightly faster than usual. But the sight of the man I saw through the French windows standing inside the house stopped me cold. Regaling the President with a story that had him hysterical, standing taller than I had expected, holding a drink in one hand and a cigarette in the other, was Noel Coward. "Noel, this is Liza's friend Frank from the Playhouse," said the President. "How do you do," said Sir Noel, "My, what a lot of hair." The room exploded in laughter, not for the words but for the way in which he said them, dry as the Sahara.

Riding the laugh, as if on cue, a hugely confident, brassy woman strode into the room. "Am I late?" she said. "Yes," said the President. "Hello, Jack. Noelie, darling!" "Come here," Coward said, "and give us a kiss."

"Who?" I said to Liza.

"Adele Astaire," she whispered back, "sister of Fred."

"How do you do, young man?" she said, shooting out her hand. "I'm Dellie."

So our little band was complete: Noel Coward, Adele Astaire, Paul Mellon, Bunny Mellon, Jacqueline Kennedy, Eliza Lloyd, me, and of course, the President of the United States. Lunch for eight, or as this rarefied set would call it: luncheon!

I'll tell you more about the others elsewhere in this book. The President has the lead in this chapter.

He stood in the middle of the living room, at ease and in high spirits, with no circle of people around him. The others flopped on chairs or leaned against doorways chatting. Frozen to my spot I turned around, forced to face the fact that I, like the President, was standing alone with no one else to talk to. Dynamite could not have dislodged me from my place, which I'm sure the President knew, so, graciously, he came to me.

"Are you enjoying your summer?"

"Yes, sir."

Looking at me with total concentration, as if I were the only person in the room, he asked:

"Are you going to make the theatre a career?"

"Yes, sir," I said. "I can't do anything else."

Paul came over to us. "Frank, would you get the President a fresh drink? He's having a Bloody Mary." *What*, I wondered *was that?* The President handed me a drained glass with a celery stick standing alone among red-stained ice cubes. "The bar is down the hall," said Paul.

I walked toward it thinking, "How could they trust me with this glass? I could be a Mafia prince or a modern-day John Wilkes Booth with a pinky ring full of arsenic." It was then that I saw the blank faces of the Secret Service guys stationed quietly behind doorways.

When I handed the President back his drink he was deep in discussion with Paul, but he took it, squeezed my shoulder, and said, "Good luck with your acting, Frank." "Thank you, sir," I said.

There were gales of laughter in another part of the living room caused by something I wished I'd been there to hear Noel Coward utter. And laughter is what came to dominate the rest of the afternoon. Not just occasional or sporadic. Full-belly laughs coming so fast and furiously I thought the President was going to have a heart attack. Buds came in and quietly announced lunch. Excuse me—lunch*eon.*

We were seated at a rectangular table in a modest dining room facing the sea. The President in the center with Coward directly across from him. It was set with blue and white china on a blue and white tablecloth, three glasses to a setting: water, red wine, white wine, and at least six utensils divided on either side and across the top of our plates. At each place setting was a small bouquet of freshly cut flowers set in a tiny

straw basket; and on each plate a large linen napkin folded in a way I had never before seen. All the visuals of that table, as I remember them, were completely new to me, as was the meal we were served. A cold soup, lobster salad, steamed vegetables, and some kind of thick white pudding.

As the afternoon progressed our napkins would grow increasingly damp with tears of laughter as Noel Coward reached into his bottomless hamper of stories, jokes, one-liners, and character assassinations. And the sight of my President pounding on the table with one hand and holding the other out, palm up, to Coward, begging him to wait while he caught his breath, has never left my memory. To see the leader of the free world so hopelessly convulsed with laughter, wiping his eyes continuously, and to watch his wife genuinely delighted to see him so happy, made a profound impression on me. How glorious it must have been for him. Not a single subject of importance discussed all afternoon. No current affairs, political views, or social commentary. Add to that the fact that Coward's stories became increasingly vulgar with the liberal use of the words *cunt* and *prick*, and the beautifully pronounced, in his trademark clipped staccato, *cocksucker* and *motherfucker*.

We retired to a sunroom, directly off the dining room, for coffee and dessert. It was three steps down into a cozy and bright space, also facing the sea. There was a couch under a large window, directly across from which sat a baby grand piano and several small armchairs scattered about. The President flopped down on the couch, Adele next to him. Bunny and Paul took an armchair each and Liza curled up on the floor at her mother's feet. Jackie and I ended up sitting on the steps, shoulder to shoulder. "Isn't this fun?" she whispered as Sir Noel took his place at the piano. It was then she explained to me the purpose of the afternoon. Coward was in Boston trying out a new musical entitled *Sail Away*, and Jackie asked

Bunny if she could, through Adele, invite Mr. Coward down to the Cape in order, as she put it, "to give Jack a good time."

Act 2 was a triumph for Coward as he tirelessly sang one signature song after another: "Mad About the Boy," "If Love Were All," "Mad Dogs and Englishmen," and as the last note of each song left his lips, Jackie would request another and another, and sing every lyric along with him. At one point we all sang "I'll See You Again." Like all the others, she knew it by heart, and following her lead, the President sang along just a beat behind.

"Okay now," said Adele in a loud forthright voice, "let's get this show on the road. Come on, Jack." She grabbed the President with one hand, swept the magazines off the coffee table in front of them with the other, and said, "Noelie, give us 'A Room with a View.' Hit it." He did, and for the next ten minutes I watched the President in his yellow pants, just two feet away from me, attempting to follow Adele Astaire in a soft-shoe dance that had the rest of us singing to the music and Jackie up and snapping away. His face was blissfully silly as he feigned a nightclub entertainer and tried to mirror Adele's moves: hands out in front of him, feet shifting in small kicks, body turning in circles one way and then the other, and slapping his hands and thighs in the tried-and-true vaudeville style.

Two choruses and Sir Noel brought the song to a resounding finish. By now we were all up on our feet applauding wildly and the President stepped from the coffee table, took a bow, reached for Adele, and she joined him on the floor, each of them bowing with mock humility as the piano played them out of the room. I turned to Jackie, who was beaming with happiness, and said my first words to her since "hello."

"Not bad for a President."

"Not bad for Jack," she said.

We all trouped out to the lawn to say our good-byes, and before boarding the helicopter the President said to me:

"What do you think, Frank? Should I keep my day job?"

And then he was gone.

———————

I left later in the afternoon, having sneaked back into the dining room to steal the small bouquet that had been in front of the President's plate. And that night I replayed every moment of the day in my mind. Coward had ended a medley from his new show with a haunting ballad entitled "Something Very Strange." And as I sit here writing this on December 12, 2010, looking at snow-covered grounds from a window in the countryside forty-eight years later, Sir Noel's lyrics seem sweetly prophetic.

This is not a day like any other day!
This is something special and apart!
Something to remember
When the coldness of December chills my heart.

Nobody is melancholy. Nobody is sad.
Not a single shadow on the sea.

Something very strange is happening to me.

———————

All but two of us from that day are gone now: Jack, Jackie, Noel, Paul, Adele, Buds, and Liza. Other than myself, the sole survivor is Bunny Mellon, who in 2012 will turn 102, and has remained my lifelong friend. The President, had he lived, would be ninety-three years old. I kept the flowers I had taken from his place sitting in a tin cup in my room for the rest of the

summer, until they withered and died. Of the forty-six years Jack Kennedy spent on this earth, I was privileged to have been in his company for four hours when he and those flowers were still in bloom.

It was a day not like any other day. Nobody was melancholy. Nobody was sad. And there was not a single shadow on the sea.

MONTGOMERY CLIFT

He never spoke a word to me. Never even knew my name.

It was 1962. I had moved into a four-flight walk-up on Third Avenue and 61st Street. One night there he was again. I don't remember when or how often it would happen, but coming home late at night, I would find him rolled up in a ball in my covered vestibule, against the front door of the building. The first time I found him I thought he was just a street bum, of which there were very few in the 1960s. But when I focused in on his haggard and broken face, I saw the beautiful, profoundly gifted young actor he had been. Along with Marlon Brando and James Dean—two other men who also had talent, looks, sex appeal, and mystery—Montgomery Clift possessed an inner flame impossible to extinguish with age or death. All three exuded an androgynous quality that made them appealing to both sexes. Dean and Brando allegedly played with boys secretly, but Clift was openly gay in a time when it was forbidden.

I knew he lived around the corner in a townhouse. I'd seen him often climbing or sitting on the steps. On a few occasions I picked him up in my hallway walked him there, and deposited him with his houseman, who took him from me with a silent thank you.

His indelible performances in *A Place in the Sun, From Here*

to Eternity, Judgment at Nuremberg, and *The Misfits* all reveal what must have been an agonized soul. And if there is any consolation to be found in his early death at forty-six, it is in watching him harness that agony and use it both creatively and thrillingly.

As if by a tiny little creature in a film about aliens that crawls into your ear and occupies your brain, he must have himself been invaded, most likely at a time when he had no way of defending against it. And the invader must have brought with it a torment so great that it caused this lovely actor to curl up in an abandoned hallway, not his own, rather than turn a corner and suffer in his empty house.

On this particular night, he was not even semi-conscious. My girlfriend opened our front door, gave me back the outside key, and went upstairs. I bent over, sat him up, put my hand under his knees, and lifted him into my arms with the ease I would have a five-year-old child. His head fell against my chest and I began the familiar walk toward his front door.

He made no sound, did not open his eyes, and remained inert when I handed him over to his keeper. On my way home I cried not from pity or sadness, but from fear. Could such a fate happen to me? And, I wondered, where had he been, what was the terrible pain, and why had he no one to hold him through the night? You wonder those things at twenty-four. When I got upstairs my girlfriend took me into her arms and we made love. Young, romantic love.

Fifty years later, I no longer wonder the things I did that night. I understand there is nothing particularly romantic about a broken man lost and alone. But there is something profoundly noble in Mr. Clift's efforts to hold his pain close and leave us with just the memories of his artistry.

BILLIE BURKE

Billie Burke spent the last part of her career paying off the debts of her late husband, the great showman Florenz Ziegfeld, deserving the moniker of her greatest role: Glinda the Good Witch in the classic film *The Wizard of Oz*.

In the summer of 1956, she was touring in a lightweight comedy entitled *The Solid Gold Cadillac*, in which she played a woman who outsmarts the corporate guys and ends up with the money. Some of the touring plays had parts with one or two lines in them and these roles were played by the apprentices of the various theatres. When it got round to the Pocono Playhouse, where I was apprenticing, I was lucky enough to get not one but two bit parts. The first was that of a reporter holding a camera. I think I said something like "Look this way please" after first picking up Miss Burke and sitting her on a desktop. The second part was a groundbreaker for me.

If you were among the chosen few to get a small role in one of the touring productions, it was necessary to have a quick rehearsal with that week's star on the day of the opening night. They would have arrived the evening before or even early that morning from their last performance in some other northeastern state.

There she was, seventy-two years old, dressed in a two-piece blue suit, wearing a hat and gloves in July, coming onto

the stage after we had all been pre-rehearsed. The voice was exactly as one would have hoped, distinctively tweety. I was instructed to lift her on her right side, and another lucky apprentice would do the same on her left. We were then to place her on the desktop, pick up our cameras, say our one or two lines, take a photo, and leave the stage.

She stood rigidly as we approached, and as I went to lift her she said politely to the older gentleman sitting at the edge of the stage:

"Mr. Director, would you kindly tell these young men to place each of their hands under my elbows, and I will grab them to steady me as I reach the table." She then turned to us and said: "I'm so old, my dears, that if you're not careful I might break."

And that is precisely what we did for the following eight performances as this delightful woman charmed and entertained the Pocono Playhouse audiences with her particular brand of inspired silliness; as she prowled her way around the stage, missing no laughs and playing her audience. She did, however, have one serious problem: her bladder. At any given moment in any performance she would suddenly exit the stage and rush to the nearest bathroom. The rest of the company, long used to these unannounced exits, ad-libbed their way around until she came back, blithely entering with lines like:

"Oh, I just met the most delightful person in the hall and stopped to chat. Sorry. Where were we?"

One evening the young leading lady was having a phone conversation during the time Miss Burke was relieving herself. As she reentered she spotted that the cord of the phone wire, which was taped to the end of the desk leg, had come undone

and was on the floor. I watched as she peered down at the wire, saw a comic opportunity, got down on her knees, and took hold of it. As she stared at its frayed edges, the audience began to see the joke along with her. She held onto the cord's end with one hand, used the desk to pull herself up to her full height, and stared blankly at the actress on the phone, who was as yet unaware of what she was doing. The audience was riveted to her every move and now laughing uproariously. Once the laughter died down, Miss Burke ad-libbed:

"I don't see how you can be speaking to anyone, dear. It seems to me you've been cut off."

I have often thought of Miss Burke when watching actors walking around a fallen prop, ignoring it. Pick it up, I think, we see it. We know you see it. Be creative. Use what's there. I would be willing to bet that in *The Wizard of Oz* when Margaret Hamilton as the Wicked Witch disappeared in a large puff of red smoke, Miss Burke ad-libs her next line:

"What a horrible smell of sulfur."

My second role in the production was actually much more exciting than the first. I was to appear in the curtain call with Miss Burke. At the end of the play, her character receives as a reward for her victory, a Solid Gold Cadillac; so, when she appears for her curtain call, she is to be brought on by her Solid Gold chauffeur. I got that assignment because I was the kid who fit into the costume, which consisted of gold lamé pants, jacket, boots, cap, and gloves. My face was smeared with gold makeup during the Act 2 intermission, and I was told to take my place in the wings during the final applause. Miss Burke would come offstage, have a sip of water, grab my hand, and lead me out to warm, enthusiastic applause. The stage manager told me that after I led Miss Burke out for her curtain call, I

was to take a step back and, as she bowed, leave the stage. As the week wore on, my step back grew slower, and my exit less rapid. I finally ended up lingering in her light so long that the curtain was coming down with me basking in the glow behind her. Miss Burke was totally unaware of my presence.

At the last performance, the audience's enthusiastic applause swelled even more than usual, and emboldened by the acceptance, I remained close to the star and reached out and took her hand as she rose from her slight curtsy and grandly led her off the stage. She turned, looked at me with utter bemusement, and as we hit the wings she said, "Mustn't be greedy, dear. Your time will come."

NOEL COWARD

"**B**ig things for you, I think," said Noel Coward as I sat at his feet on a summer's day in 1961. Never mind there was a President and First Lady in the room or that our host was one of the richest men in the world: Mr. Coward only had eyes for me.

You will read stories of John F. Kennedy and Paul Mellon in this book and discover why and how Mr. Coward and I got to where we were. It was after lunch now, after he'd performed and before we were all to depart from our magical afternoon in Cape Cod, Massachusetts. Magical to me, certainly, but for Mr. Coward most likely not at all an unusual occurrence. He was sixty-three years old and looking fit as a fiddle. And there was no question, as he leaned forward to brush the hair out of my eyes, that he wanted to kiss me. Why wouldn't he? If the only song he had ever written was "Mad About the Boy," it would have been enough to understand his longing, romantic heart. I just happened to be *the Boy* of the title at that moment.

But straight, cut or queer-shaped, there is nothing as sexy as rapt attention to your every word, and I was mad about the man. He wanted to know everything about me, making me feel completely and profoundly wanted in a way that transcends gender. I could have sat on that floor at his feet for a century, so seduced was I by his quiet and intelligent pursuit of my inner thoughts. Which of course he hoped was his gateway to my inner thighs. He learned in our conversation that I

was residing nearby while apprenticing at the Cape Playhouse. And he casually mentioned the name of the hotel he was then staying at in Boston, preparing his new musical: *Sail Away*. "Perhaps you can come visit me on your off days," he said.

We were joined by Adele Astaire (Fred's sister), who perched on the armchair, flinging her arm around his shoulder and looking at me with sweet indulgence.

"The lad wants to be an actor," Coward said.

"Well of course he does, Noelie. Look at him."

They then proceeded to discuss me as if I were an alabaster statue perched on a pedestal and up for sale. My body, my eyes, my mouth; deciding no doubt if I would be worth bidding on.

"I think he must cut his hair, don't you?" she said.

"I rather like it," he said, brushing it off my forehead again.

"Now, Noel," came the motherly response, and she moved away giving me a little squeeze on the shoulder. "You couldn't have a better teacher," she said.

This was, remember, the beginning of the sexual revolution. And it was everything legend would have you believe. To be twenty-three years old in 1961 was tantamount to having a million-dollar lottery ticket blow into your face on a windy day. And most of us were on a twenty-four-hour spending spree.

I didn't sign up for Mr. Coward's class, primarily because I was too busy cashing in my ticket all over Cape Cod. I'd only just begun to realize my sexual potential and when you're ripe for the picking, you don't need to travel too far from the tree to enjoy the harvest.

———————

I would not be in his presence again for seven years. This time we were surrounded by several thousand worshippers on the

occasion of his seventieth birthday at the Phoenix Theatre in London. My friend, the great English actress Celia Johnson, would be one of the many luminaries of the English theatre, performing moments from Coward's illustrious career, and she scored me two tickets in the balcony.

He sat in a box, his companion the legendary beauty Merle Oberon. For three hours in a perfectly focused flattering amber light he watched, in tears, as his extraordinary gifts were being unwrapped before him.

It's difficult to explain the glory that was Coward then, as wit, intelligence, and style have lost ground to stupid, vulgar, and loud. He was, even in his heyday, often dismissed as facile and lightweight. But listen to his songs, read his best plays, and you feel the seductive power of his mind—just as I did on that summer day in 1961.

I don't know what Sir Noel would have divined had I traveled to Boston that summer and let him kiss me. He probably would have looked deep into my opportunistic eyes and said:

"Trying to decide which way the wind is blowing, dear?"

Of one thing I am certain: I would have laughed a great deal. As I often have by the following examples of his legendary wit, told and retold, but which I can't resist telling again.

When hearing a rather pretty but dumb young man had blown his brains out, Coward said:

"He must have been a terribly good shot."

Peering at a tiny sketch on the wall of a wealthy matron's luxurious apartment, he asked:

"Who did this?"

"Picasso," she said.

"Hmm! Serves him right."

———————

Of a well-endowed dancer who had neglected to wear a supporter under his costume, he said:

"We must tell Dickie to take the Rockingham Tea Service out of his tights."

———————

To a woman resolutely picking her nose at rehearsal, he called out:

"When you get to the bridge, dear—wave!"

———————

When the actress Lily Palmer told him she was madly in love with a certain gentleman, Coward replied: "Don't be ridiculous, he's as queer as a three-dollar bill."

"He can't be queer," she said. "He's married, with two children!"

Coward retorted, "That only means he managed to lash it to a toothbrush . . . twice!"

———————

Sitting on the porch of a country cottage one warm afternoon, watching a young boy play, one of his dogs mounted the other and began a happy hump.

"What are they doing, Uncle Noel?" said the little boy.

"Nothing, dear. One of them is sick and the other one is pushing him to the doctor."

———————

Receiving a secret fan letter from Lawrence of Arabia, signed with the code name "227460," Coward replied: "Dear 227460, May I call you 227?"

And in fond memory of his hoped-for conjugal visit from me in 1961, there is a wonderful story of his having invited a boy of another moment to come up to his apartment. When the elevator doors closed, Noel moved quickly across the floor and kissed the boy full on the mouth. Once upstairs, he changed into a smoking jacket, poured some white wine, lit a cigarette, placed it in a holder, and coquettishly stood at the mantel. The young man mustered up his courage and said:

"Mr. Coward. I'm afraid I must tell you now before we go any further, I'm not gay."

Coward took a deep drag of his cigarette, looked deep into his eyes, and said:

"Yes. I knew it when I kissed you!"

LEE STRASBERG

Of all the short men I've known, the guru of the Actors Studio, Lee Strasberg stood tallest on the list of the arrogant and insufferable. Even climbing as he did onto a self-constructed pedestal, he seemed still, in my estimation, to rise only to the height of a pompous pygmy.

Many classic traits of the diminutive man were his in abundance: misplaced narcissism, imperiousness and the tendency to view himself as a benevolent god. He was, I thought, a cruel and rather ridiculous demigod who ran a highly profitable racket.

Our first meeting was not a meeting at all, and I was not even supposed to be there. A good friend of mine wanted desperately to belong to the Actors Studio. At the last moment, her scene partner backed out, and she asked me to help. It was the early 1960s. In a room so dark you could see no one other than your partner, sat a few bodies facing the light. By the end of the audition one could make out their shapes and sizes. Sitting in the center was Strasberg, most definitely in need of a booster seat. He said nothing. When he left the room, a man came over to me and said:

"We would like you to prepare something of your own and come back to see us."

"Oh, no thanks," I said. "I just came by to help out my friend." I was, at that tender age, already uninterested and unimpressed with Mr. Strasberg and the Method. And I will confess, at the height of my own youthful arrogance.

I can still see the look of incredulity on the messenger's face. It was as if he had told me I'd inherited a fortune and I told him to keep the cash. It was reported to Mr. Strasberg that I had declined to cross the moat, and his drawbridge was forever after closed to me.

My future encounters with Strasberg were all the same. We would be introduced, he would look at me with disdain and condescension—not easy to do when you're the height of my belt buckle—and give me a clammy, all fingers, no grip handshake. Hell had no fury it would seem like a Strasberg scorned.

Lee Strasberg encouraged his actors to act not in *spite* of their neuroses, but *because* of them. The result being floods of tears, both on celluloid and floorboards, from actors determined to sacrifice their characters' lives to a subplot of personal turmoil and aimless rage that may make them comfortable, but leaves the viewer misled. I had occasion to work with one such Strasberg acolyte onstage, whose predilection to wallow in sense memory obliterated his character as written and subsumed the author's intention. It resulted in the audience feeling totally left out of and uninterested in his masturbatory performance.

Both Arthur Miller and Elia Kazan, on a number of separate occasions, told me they felt Lee to be a complete charlatan and a self-serving martinet. And the really great teacher of the twentieth century, Stella Adler, said to me:

"Lee is not a man of the theatre. It will take one hundred years to undo the harm he has done to the acting community."

And Marlon Brando, perhaps the greatest film actor of the twentieth century; at his best a brilliant combination of truth and technique until he dissolved into a self-indulgent, lazy bore, found Strasberg to be, as Stella repeated it to me, "An asshole and a fake who taught me nothing."

Oddly enough Marilyn Monroe, whom Strasberg had under his spell, seemed to profit from his misguided teachings. In the film *The Misfits*, she is transcendently and heartbreakingly honest. Strasberg certainly profited from her as well. In Marilyn's will he was left her entire estate.

There was a great deal of hoopla around his acting in a film with Pacino, one of his renowned students, in which his sense of "truth" was offended when he was given a pair of brown socks instead of the black ones more appropriate to his costume. His performance, to my eyes, was ordinary and without distinction, but nevertheless Oscar nominated. As comfortable as he may have been in his black socks, he lacked the magic and mystery that makes a star actor, and his most famous students all had that and would have succeeded, I believe, without him.

I am prepared to admit that my antipathy toward Mr. Strasberg had a great deal to do with his grandiosity and his misguided self-importance. And certainly, I have seen some remarkable performances from one or two of his students. But my sense was always that his outsized ego and kingly behavior stemmed more from his diminutive stature than his desire to protect and nurture his students. A teacher, I believe, should guide, not rule. Too many actors told me how afraid of him they were. The very opposite, I would think, of the emotion a teacher should inspire in a student.

In 1964 he directed a stupefying production of Chekov's *The Three Sisters*. Mr. Strasberg's methods may have helped his students find, perhaps, their inner truth, but resulted in a limited and narrow perspective, creating actors totally unprepared for the classics and the challenges that come with the technique required to perform them. At twenty-six years old I sat mesmerized by only one person that evening. It was the great actress of her generation, Kim Stanley, who gave a transcendent performance combining all the ingredients necessary

for great acting: truth, honesty, skill, and craft. The Method is, for me, a dangerous movement put forth by a self-serving charlatan, who totally misreprensented the brilliant technique of Stanislavski.

Whenever in the same room with Strasberg, I avoided his sycophantic circle. The last time I was in his presence he sucked the air out of the elevator we were riding in and when we hit the ground floor he put out his hand in a "stand back, I'm departing" gesture that caused me to laugh out loud. He stopped, looked up at me with pure hatred and exited in a low-hanging cloud of fury. It remains one of my fondest sense memories.

CELIA JOHNSON

It was her eyes that first struck me. Huge and saucer-like.

A renowned television personality named David Susskind was producing a series of dramatic stories and had cast me in one of them. It was called *The Choice*. My costars were Jill Clayburgh, Melvyn Douglas, and Celia Johnson, whose fame in America had come from a classic film she'd done for Noel Coward in 1945 entitled *Brief Encounter*.

Melvyn Douglas had appeared opposite Greta Garbo in *Ninotchka* and was considered now a venerable and charming character actor— a quiet, polite man with a constant twinkle in his eye.

It was 1968 and I was dressing androgynously. It was the era when many young men in New York were wearing bell bottoms, scarves, love beads, bandanas, all accented by an earring or two. I asked my girlfriend how I looked as I was preparing for my first day of rehearsal and she said: "Great! But take any three things off."

So I arrived late in what I thought was a fair compromise: a white silk Cossack shirt, hanging loose, with gold braiding around the neck and sleeves.

"I'm so sorry," I said. "I overslept."

"Looks like you forgot to take off your pajamas," Mr. Douglas said.

A few days later we started shooting in Toronto and I was deeply impressed with Celia as a consummate actress and

trouper. One late morning I watched her perform a complicated tracking shot in which she would be given some bad news about her husband while walking with a doctor and end up entering an elevator, turning to the camera, and registering heartbreak. She was flawless and perfect in one take—eyes welling with tears precisely at the right moment. Everyone applauded. She made no fuss about it, just blew her nose and headed for her camp chair.

The assistant director then announced there'd been a glitch in the camera and they'd have to go again.

"Right away, people," he said. "It's twelve minutes to the break. We can do it."

Celia was up and to her first mark immediately. She could have said that the scene was too emotional and complicated and she'd prefer to do it again after lunch, but she didn't. It was reshot and the camera was perfect. Celia was not—less powerful, less emotional. They got it one minute before the break.

Susskind came over to her.

"Brilliant, darling," he said.

"Is there any way you could use the first one?" Celia asked. She knew she hadn't nailed it again.

"I'm afraid not," Susskind said. "It's one long shot, no cutaways, and we had a bumpy camera."

"Bad luck," Celia said and headed to lunch.

The following year I was making my film debut in Mel Brooks's *The Twelve Chairs* and was in London rehearsing. Celia lived in a place called Nettlebed, Oxfordshire. I called and she immediately invited me out for the weekend. I was not prepared for the beautiful country estate and large property she owned with her husband Peter Fleming, brother of the famous Ian Fleming, scion of a banking dynasty and author of

the James Bond books. I began visiting Nettlebed often, loving the beautiful countryside and damp English weather. Peter did all the English country gentleman things. Coming in from a ride in jodhpurs, his dogs floating around his legs, standing at a roaring fire and banging his pipe bowl on the mantelpiece.

My room overlooked a courtyard with a stone wall surrounding it, and I could see the tops of the heads of people whizzing by on their bikes. One tall thin man came careening past every morning at roughly the same time, fine white hair billowing in the cold wind.

"Oh, that's Alastair," Celia answered when I inquired at breakfast who he was. "You should meet him. Lovely actor."

"Alastair Sim?" I said.

"Yes."

Alastair Sim was most famous in America as Scrooge in the classic English film *A Christmas Carol* and I had seen him once on the stage in a light British comedy and found him to be extraordinary. He had been Mel's choice for the lead in *The Twelve Chairs*, but turned it down. The part went to Ron Moody, Fagin in the musical film *Oliver!*, a much less charismatic actor.

I never did meet Mr. Sim, but love a story Celia told me about him.

"One day, I was pulling into the courtyard in the pouring rain," she said, "and I could hear the phone ringing. I'd just been to the market and I had quite a lot of bags with me. I came round to open the boot, the pelting rain flooding over my hat and into the bags. One bottom began to break and I was trying desperately not to drop the eggs. Still the phone kept ringing incessantly. Bloody hell, I thought, go away. I got everything in the kitchen on the counter. I was soaked and furious. The phone did not stop. I picked it up and shouted into it:

" 'Hallo!'

" 'Celia? Alastair here. Darling, I just saw you in the market. You were *marvelous*!' "

It was from Celia that I got some perspective on what it was to be a working actor and to live a full family life. She loved to ride around her property in a Land Rover and would often take me with her. One afternoon as we were bouncing along she told me she'd been offered a play in New York.

"Johnnie and Ralphie are doing it." (Gielgud and Richardson, of course.) "I'm to be one of the four characters. It's called *Home*."

"Why don't you want to do it?" I asked.

"Oh, darling. It's just when all my flowers will be blooming."

Years later I saw her perfect performance opposite Maggie Smith in the film *The Prime of Miss Jean Brodie* and called to congratulate her.

"Smashing part," she said.

In the winter of 1978, I was again in London shooting *Dracula* at Shepperton Studios and I received a message from Celia. I immediately rang her up.

"Come out for the day—bring your new wife."

I agreed, but cancelled at the last minute because of a 5 a.m. set call the next morning.

"Is it because you're now a bloody film star?" she said.

One afternoon she came into town and we had tea at the Savoy Hotel.

"Oh dear, oh dear," she said.

"What's wrong?"

"Doing *Hamlet*! Having a go at Gertrude. I'm afraid it's a disaster. The avant-garde bohemian approach. Greeting the audience in half makeup—utter rot. Oh well," she said, sipping her tea, "nothing to do but carry on."

———————

Many years later, after Celia had passed away, I was performing in New York opposite the great English actor Alan Bates in a Turgenev play entitled *Fortune's Fool*. One night at supper I told him the story about Celia and the disastrous *Hamlet*.

"Oh, I know that story very well," he said. "*I* was her Hamlet."

He then proceeded to tell me his fondest memory of Celia:

"She was quite right. It was a tiresome approach. I remember one day our director said,

" 'Celia, I think that scene could be a bit more moving.'

" 'More moving?' Celia said. 'Right.'

"She then proceeded to devastate us into floods of tears. When it was over she looked at him and said:

" 'You mean like *that*?' "

DOLORES DEL RIO

We did not meet or speak. And certainly did not touch.
It was the summer of 1956. I was eighteen years old,
still a virgin, away from home for the first time as an appren-
tice at the Pocono Playhouse in the mountains of Pennsylva-
nia. It would not be the summer I would lose my virginity
but it would be the beginning of my appreciation for a kind of
female that until then, I had no idea existed.

The untouchable was the magnificently beautiful Mexican
actress Dolores del Rio. She was touring, as stars did in those
days, from summer theatre to summer theatre, playing one-
week engagements to full houses of audiences anxious to see
the glamour, allure, and mystery celebrities of today no longer
possess. No TV talk shows then for the incessant dismantling
of self. If you wanted to see Miss Del Rio you had to watch
her movies or venture forth of a summer's evening. She was
the first great star into whose orbit I ventured for a period of
time, and my first lesson in style, behavior, and elegance.

Miss Del Rio's costar was a formidable old broad named
Lili Darvas, a well-known character actress and widow of the
Hungarian playwright Ferenc Molnar. The play was *Anas-
tasia*, soon to be a film starring Ingrid Bergman and Helen
Hayes, along with Yul Brynner as an opportunistic fortune
hunter. Miss Del Rio played the title role of a twenty-four-
year-old woman searching for an identity she believed made
her a part of the royal family of Romanovs, and Miss Darvas

played the suspicious Grand Duchess of Russia, her supposed grandmother. At the time, Miss Del Rio was fifty-one, and Miss Darvas fifty.

My job that week was prompter. I was positioned stage right in a small booth that had a narrow slit through which I could see the actors onstage. I held a flashlight while sitting on a high stool, the script on my lap. I never needed, in the course of their eight performances, to shout out a line to either of them. So I turned the pages, kept track of where they were and mostly watched their interplay. Few memories of the actual performances stay with me, except the absolute precision and repetition of their choices, down to the smallest gesture. What does remain are the circumstances surrounding those two and a half hours.

During that summer, most of the touring stars appeared around the theatre somewhere during the day. Miss Darvas was ever-present. She arrived at lunchtime and ate with the rest of us.

"Will we see Miss Del Rio?" I asked.

"Darling! No! She doesn't leave her accommodations. Never on this tour does anyone see her in the daytime. She travels alone in her Rolls-Royce with her lady-in-waiting from theatre to theatre and only comes out for the performances. Her shades are always drawn in her rooms to protect her skin from the light, and she lies in a bath of milk."

I was mesmerized by this story and by Miss Del Rio's reported meticulous daily and then nightly routine.

Each evening at about fifteen minutes before the curtain went up, the audience already mostly seated, Miss Del Rio's car, tinted windows tightly shut, drifted down the driveway and circled to the back door of the theatre, close to the stage entrance. She emerged fully dressed in her first-act costume,

completely made up and breathtakingly beautiful. Her driver held an open parasol over her exquisitely coiffed jet-black hair and her lady-in-waiting preceded her up the wooden steps, making certain there would be no one in her path as she disappeared into the dark of the theatre. A special carpet had been laid up the steps and across the backstage to protect the soles of her shoes and the hems of her costumes and a private area had been set up for her in the wings, which consisted of three flats bracketed together to form a small cubicle with a table and chair inside. On the table sat a mirror, a flask of water, a crystal glass, the script, a small light covered by blue plastic, and a few basic makeup items for touch-up purposes.

I watched every night, hidden, next to the backstage door, as she sat down, smoothed out her dress, and folded her hands across her lap. When the stage manager called *Places*, I moved to my spot in the prompter's booth.

Miss Del Rio never left her cubicle between scenes but returned there for her costume changes, which were executed immediately; after which she sat back down to wait for her next entrance. She never once went into a dressing room or used a bathroom but spent both intermissions sitting calmly and quietly. We were told never to approach her and, certainly, never to speak with her.

During the act breaks, I was drawn to her lair like a cub looking for its mother. I obeyed the rules but did get what I hoped for. As I slowly passed by, I received a faint nod of the head and a warm smile. No word ever left her lips, other than onstage, where she spoke in a measured, slightly accented, beautiful voice.

Her final confrontation scene, with Miss Darvas as her grandmother, dramatically staged with Miss Del Rio on her knees, holding Lily's hands as Lily wept, calling out, "Malenkia, my little Malenkia," was exquisitely played by both.

———————

Curtain, applause, and more magic to come.

Each actor came forward, center, took a bow, Lily being the last, and then exited, leaving an empty stage. A wait of approximately five seconds. The two center doors upstage opened, and out came Miss Del Rio in a stunning white flowing gown over which hung an equally beautiful soft and voluminous long white coat. She floated to the apron of the stage, a radiant smile on her face, and sank into a deep curtsy as the applause swelled; then rose, arms outstretched, and beckoned the rest of the cast back out for a company bow. She and Lily were then left alone, bowed to each other and the audience, and Lily once again left, leaving Miss Del Rio alone in a spotlight.

By now I was out of the prompter's box and hovering by the back door of the theatre in order to watch my favorite ritual of the night: the sight of Dolores del Rio moving toward the French doors of the set, the audience behind her, then turning with a radiant smile to face them, bow once more, take the handles, and close the doors just before the curtain hit the stage. The house lights were very slowly timed to coincide with her next actions.

In the dim backstage light, I watched as her attendant lifted the voluminous trains of her gown and coat and followed behind her across the carpet. Her driver, standing by the door, arm outstretched, took her hand, brought her down the steps, and put her into the waiting Rolls-Royce, its engine already humming. The yards and yards of material were pushed in and gathered around her, the backseat looking like a mass of cozy clouds. Her attendant moved to the front door and the mysterious lady was transported down the driveway, into

the summer night, away from the theatre before the audience stopped applauding and the houselights were up full.

———————

One could, I suppose, remember her as a lonely older woman, desperate to preserve her beauty, living on illusion and reputation. Or one could see her through the eyes of this virtuous eighteen-year-old, as the epitome of glamour, discipline, and professionalism, exemplifying the magic of Live Theater.

JAMES MASON

"Do you still love it?" asked possibly the most beautiful speaking voice I have ever heard, then or now. Original, distinct, and totally unself-conscious, it belonged to James Mason, the actor.

He and his wife, Clarissa Kaye, sat across from my wife and me at a small round table in the home of Marilyn and Alan Bergman, the married composers of such classics as "The Windmills of Your Mind" and "The Way We Were." It was the early 1980s. Scattered around at other tables were Tommy Thompson, the writer; Roddy McDowall, the actor; and Georgia Brown, the singer.

I still remember Mr. Mason's melancholy sadness and the wistful way he held his hand under his chin, his pinky resting on his lower lip as he spoke.

"Do you still love acting?"

"Yes," I said, "I do. I wouldn't do it otherwise. Don't you?"

"Oh no. Not anymore."

"Why do you do it?"

"For her," he said, glancing at his wife. "She wants it."

"Well, I find it very exciting still. I particularly like being onstage in front of a live audience."

"Well, don't let me stop you," he said in the perfectly modulated British style that gives no hint of opinion.

He was, to my mind, an absolutely marvelous actor whom I had never once seen give a bad performance. He is breathtakingly perfect as Humbert Humbert in Stanley Kubrick's *Lolita*—funny and tragic. The same in *A Star is Born* opposite Judy Garland and particularly wonderful in Marlon Brando's *Julius Caesar*—the perfect combination of truth and technique. He also had an androgynous sex appeal that made him seem languorously available to both genders.

That night at the Bergmans he had about him an air of bemused resignation. I can still see him clearly, smaller than I had imagined, and appearing to me deeply disillusioned and fatalistic. When in the future I would watch him onscreen I was always impressed with his natural intelligence and uncommon grace, but could always spot that hint of sad resignation. A look of bored complacency that put me in mind of three other wonderful actors with whom I had equally brief but similar encounters.

In the lobby of the Beverly Hills Hotel sat Peter Finch in the late 1970s, Oscar nominated for his brilliant performance in *Network*, appearing desperately unhappy as he barely shook my hand and accepted my congratulations. He died only two months before winning it.

Sitting in a greenroom with Jack Palance before taping a Charlie Rose interview, he talked of nothing but his horses and told me he regarded our profession as a meat market in which, if you hang in long enough, you get lucky.

"It's not the actor that wins," he said. "It's the role."

A gentle, polite, and soft-spoken man also nominated for an Oscar late in his career and winning it in 1991.

———————

And sitting a few seats away from me at the Oscar ceremony in 1998 was James Coburn, who won that night for his marvelous performance in *Affliction*. When he returned to his seat, I said, "How do you feel, Jimmy?"

"I just want to go home," he said, rueful and exhausted.

———————

In all three men I sensed a light gone dim, a fatigue of the spirit. It was what I'd seen in Mason that night at dinner. He never achieved the great stage stardom of Laurence Olivier or the great film stardom of Marlon Brando, and he never won an Oscar. But if Peter Finch, at sixty, Jack Palance, at seventy-seven, and James Coburn, at seventy-four, are any indication, it doesn't appear it would have lifted his spirits all that much.

RICHARD BURTON

Richard Burton, a Welsh actor looked upon in his youth as the successor to Laurence Olivier, received his seventh Oscar nomination, for his performance in the film *Equus*, on the morning of the day the phone rang in my apartment in New York. It was Robbie Lantz, our mutual agent calling. The year was 1977.

"I've organized tickets for Richard and Suzy to come see you in *Dracula* tonight. Do you have any liquor in your dressing room?"

"No."

"I think it would be a good idea to get some."

———

After the performance Richard arrived at my door with wife number four in a floor-length gown over which she wore an even longer white fox coat. Richard was wearing a black mink car coat and very heavy deep orange makeup. His fine hair was dyed and teased in an effort to make it look thicker and him younger, but succeeded only in aging him further. Behind him, crowding the hallway to my dressing room, was an enormous group of photographers.

"It was quite a problem keeping the audience's attention on the stage tonight," I said, as the flash bulbs popped. This was pre-digital time.

"You managed quite well," he said, in one of the most distinctive voices of the twentieth century.

My dressing room at the Martin Beck Theatre on West 45th Street was large and spacious, rare in Broadway houses. So in they swept: Richard, Suzy, and the entire group. More photographs as Richard said:

"You know, I was nominated for the little fella today."

"Yes, congratulations," I said, knowing of course that Robbie had seen this as a great photo op for both his clients.

———————

After the press departed, Richard sat down at my dressing table and turned in my barber chair to face the room. My dresser offered drinks from the bottle of Scotch she'd gone out to buy before the show, leaving it next to him on the table. I grabbed a hand mirror, sat on a straight-backed chair and began the nightly ritual of removing my makeup.

"Who was your Renfield tonight?" Richard asked.

As fate might have it, the actor playing Renfield, who had never missed a performance, was out sick, and his understudy had acquitted himself admirably.

"It was an understudy," I said. "I thought he did very well."

"I want to meet him."

I asked my dresser to fetch the young actor. Richard poured another drink as I continued wiping off the residue of my makeup and Suzy made small talk with my wife, who'd come to get a look-see. The three of us did not talk nor were we offered a drink.

A knock at the door and in came Sam, the understudy.

Richard did not rise. Sam came up to meet him, excited and nervous.

"Marvelous," Richard said. "I'm doing *Lear* on Broadway next season. I want you to play the Fool."

It was, of course, going to be a great story: Understudy Catches Burton's Eye! On to Stardom! I knew the actor playing Renfield was going to be miserable when he heard of it, but Sam might, after all, become the Shirley MacLaine of the 1977–78 Broadway season. Shirley had been raised from Chorus Girl to Movie Stardom after going on for the star in the musical *The Pajama Game.*

After he left, I asked Richard a question that may have been close to the last words I uttered for the next two hours. As the level of liquor lowered in the bottle, he began a series of reminiscences about Olivier, Richardson, Gielgud, and other theatrical luminaries, and then launched into reciting lengthy sections of Dylan Thomas. By the time the bottle was near empty, so was my brain. The sonorous voice, now slurring its words, had succeeded in numbing and stunning me. Could anyone, I wondered, be so unaware of what a crashing bore he had become? There sat a man approximately fifty-two years of age, looking ten years older, dressed in black mink, with heavily applied pancake, under a tortured, balding, helmet of jet-black dyed hair, grandly reciting tiresome poetry.

It was well past 1 a.m. when the night watchman knocked on my dressing room door. The first and only time he'd needed to do that in the year I played *Dracula.*

"I'm sorry, Mr. Langella, but I've got to shut down the lights and close up the theatre now."

I was still in my robe and slippers, and as I managed to quickly change into street clothes, Richard launched into yet another poem. Suzy and my wife had long since dried up on small talk and were sitting stupefied on the couch, facing straight ahead. As I grabbed my coat, they leapt up, and we all four made our way out of my dressing room. The ladies preceded us through the dimly lit backstage toward the street, no doubt aching for a nap in the backseats of our waiting limos.

When Richard and I got to about center, he stopped, lifted up the rope slung across the back of the stage and headed toward its apron.

Although terrified that he might recite a monologue from some obscure Irish play, I nevertheless ducked under the rope and joined him at the edge of the stage. And there we stood, staring out over the empty house, the standing lamp dead center reflecting on one of the most famous faces of the era. A once young Welsh buck primed to take Olivier's crown, now looking more like a successor to some aging Italian fashionista about to present the best of his collection; and, in the glow of the single lamplight appearing even more surreal than he had in my dressing room.

He seemed melancholy and pensive. A colleague, I thought, anxious to return to the boards as the great King Lear. I had never forgotten his brilliant performance as King Arthur in the musical *Camelot*, and his early promise as a major force in the English theatre. Maybe his return as Lear would be a way of undoing the last two decades of debauchery, booze, lousy movies, and Elizabeth Taylor, his second and third wife. He stared intently out into the dark.

"How many seats in this house?" he said.

"About eleven hundred," I answered.

"Hmmm," he said. "Can't gross enough for me."

Then he turned, walked upstage, and we proceeded out the door.

Only a few die-hard fans were waiting for us, as, Richard, ignoring them, moved quickly to his car, tossed back a "good night," and was gone.

He did not win the Oscar that year. Or ever, in fact. Richard's inevitable descent began in earnest with his meeting and marrying Elizabeth. The Welsh boy had climbed to the top of a ladder on rungs covered with money, fame, sex, booze, and

all the other slippery slop of our profession. He clearly loved it all, and it was tragic to watch him slide slowly down and eventually disintegrate.

He stumbled on for another seven years, divorced the Suzy, married a Sally, toured in a play with La Liz, and revived *Camelot*. Sam the Understudy was denied his chance at playing The Fool, and Richard The Star never ascended to Richard The King.

YUL BRYNNER

"No pictures with baldy," Yul Brynner whispered to the press agent who was handling his return to Broadway in his great hit *The King and I.* It was the 1977–78 season and I was starring in *Dracula* at the Martin Beck Theatre, subsequently renamed the Al Hirschfeld. My dressing room was crowded with well-wishers after a Sunday night Actors Fund performance, and one of the many actors in the room was Reid Shelton, who was starring in the musical *Annie*, as Daddy Warbucks. Mr. Brynner was not about to allow himself to be permanently recorded with another cue ball. As far as he was concerned, there was bald and there was BALD.

The King of Siam was dressed all in black with accents of silver: silver belt buckle, watch, ring, etc.

"It makes life simpler in the morning," he said.

We took a few of the perfunctory photographs and he turned to leave. Such was his aura, that everyone cleared a path, as he silently exited my dressing room, looking neither right nor left.

————

That season on Broadway was to be immortalized by the first of the extremely successful *I Love New York* campaigns. Yul, myself, Hume Cronyn, Jessica Tandy, the casts of *Annie* and *A Chorus Line*, among others, all sang or spoke New York's praises to the catchy new jingle: *I Love New York*. On the day we shot the commercial, Yul, smoking incessantly, prowled

the room with his own camera around his neck, advising our director what and how to do anything and everything, demanding and receiving constant attention. He was, at the time, represented by Robbie Lantz, as was I. Robbie had told me one night over dinner of Yul's phenomenal deal and list of perks. Everything from the color of the carpet to the number of tissue boxes to the bottled water was spelled out in great detail, and his salary was astronomical.

"You may be the Prince of Darkness," Yul would often say to me, "but I'm the King of Broadway."

His show was enormously successful, sold out to standing room every night. So was mine. When I would run into him at a late-night restaurant, he would consistently ask me:

"How big was your audience tonight?"

"Sold out," I said.

"Mine, too. But they were *shit*. I would not bow. I gave them my ass."

The word *I* passed Yul's lips more often than perhaps any actor I have ever known, and it is a pronoun that comes quite easily to most of us.

———

During that season, New York was hit with a tremendous snowstorm. It was a Monday night, and the theatres were all dark. My phone rang. It was Robbie.

"Yul wants you and your wife to join us at '21,'" he said.

"Robbie, there's fourteen inches of snow on the ground. We're staying home."

"Yul says he'll pick you up in his car."

One hour later, our doorman called to say, "Mr. Brynner is here, sir."

My wife and I came downstairs to find, in the middle of the street, the longest white limousine I'd ever seen. The driver

opened the door and we stepped in as if we were entering a small New York City apartment; high ceilings; wide floor space; large, comfortable, plush armchairs in the corners.

Yul was sitting deep in the back of the car, black-clad legs crossed, smoking a cigarette. We made our way to him and sank into a pair of the armchairs.

On the way to '21,' the streets seemingly devoid of all other traffic, he demonstrated virtually every gadget the car possessed.

"I had it custom made," he said. "It comes up on a special elevator at the theatre, so I don't have to go outside after the show and I don't have to deal with the public. The windows are tinted and the glass is bulletproof."

He picked up a large pair of strobe lights, aimed them at us, and clicked twice, temporarily blinding our vision.

"This is in case blacks attack my car," he said. "I shine these at them and click many times. They think they are being photographed and run away."

"If you don't want to be attacked," I said, "why are you riding around in a twenty-foot-long white limousine?"

Once at '21,' the mood turned festive. At the door, Yul was greeted like the king he believed himself to be, and we were immediately ushered to our table. To my surprise, the restaurant was full, and the other diners were happy, noisy, and profoundly impressed, as he swept into the room surrounded by obsequious staff members, anxious to please.

Once settled into '21''s best corner table, Yul ordered drinks and then told me he would take charge of dinner, ordering everything from appetizer to dessert. It would be an expensive five-course meal and, at one point, I unappreciatively and provocatively said:

"I could have done with just a plate of French fries."

His elbows on the table, a cigarette dangling from his lips, he signaled to the waiter.

"Bring Mr. Langella a plate a French fries," he said, spitting out the words as if he was saying "a plate of shit," "and send a large plate of French fries to every table in the room."

Soon, giant silver platters of French fries were pouring out of the kitchen, much to the delight of the patrons, all of whom waved one at Mr. Brynner in gleeful gratitude. Yul did not touch a single one at our table but constantly encouraged me to finish them all up. I had been suitably one-upped.

"What are you going to do after *Dracula*?" he said, not waiting for an answer. "We should find something I could direct you in."

He then rambled on about his acting experiences, his youth, his conquests, his triumphs, and his memories of celebrated people. He talked of his house in France, his box office grosses, his daily routine, and even his sleeping habits. While listening to him, I reminded myself not to succumb to the actor's habit, in social occasions, of talking only about himself.

When, at last, he landed on a story of an incident involving his son, Roc, I leaned forward in anticipation of some fatherly advice. It seems Yul had been renting a house. Roc, an infant at the time, was in a baby carriage on its lower level, above which was a four-sided balcony with two sets of stairs leading down. While Yul was upstairs taking a nap, the house suddenly caught fire and was up in flames in seconds. Yul came out of an upper-level bedroom, looked down, and saw that Roc's carriage was surrounded by flames. He saw, too, that the only way to reach his infant son was the one staircase still standing but in danger of collapsing. He raced down the stairs, grabbed Roc out of the carriage, raced back up before the stairs crumbled, and ran out of the door to safety.

"How awful for you," I said. "It must be a great bond between you and your son."

"I never told him about it."

"Why not?" I asked.

"Why should I?" he said. "It was *my* experience."

That season, I would often see Yul at award shows, social functions, and actors' benefits. Carol Channing was also appearing that year in a revival of *Hello, Dolly!* and I was seated several rows behind him at her opening. He had his black coat neatly folded across his lap during the opening number. Moments before Carol's first entrance, I watched him pass it to his wife. Just as Carol's Dolly Levi appeared stage left, sitting on a trolley, holding a newspaper in front of her face, Yul leapt to his feet and began wildly applauding. The rest of the audience followed suit, so that by the time Carol's trolley had stopped and she had lowered the newspaper, she was already facing a standing ovation. The next day, the then popular columnist Earl Wilson, who had been sitting across the aisle from Yul, wrote this headline:

"The King Welcomes Dolly Back to Broadway."

No mention of the Prince of Darkness.

Yul possessed a steely and unique sexuality women found extremely appealing, and he certainly enjoyed and bragged about his prowess. And indeed, no one smoldered or walked across a stage or a screen like him. He was a one-of-a-kind star, singular in appearance and original in voice, who knew what he had. Never far from a full-length mirror, he maintained his aura assiduously. What he had left in 1978, and indeed what he would trade on for the rest of his career, was *The King and*

I, and he played it till the end. After his death, a commercial appeared, made by him less than a year before, warning us not to smoke. He still looked incredibly handsome, and was at that point in his life doomed to continuously play the one major chord in his minor arsenal.

One night, as I sat in my seat, ready to watch Hume Cronyn and Jessica Tandy in an Actors Fund performance of *The Gin Game*, there was a tap on my shoulder. It was Yul. It was a few days after we had shot our segments in the *I Love New York* commercial.

"How did your piece go?" he asked.

"Oh, it was fine," I said. "We got it in one take."

"Well it was just you alone."

"Yes," I said.

"My whole company came out in the snow to support me," he said.

"I almost didn't do it in one take," I remarked. "The smoke from the fog machine almost made me sneeze, but I managed to get the line out."

Yul looked at me imperiously and said:

"Smoke? I didn't allow smoke!"

RITA HAYWORTH

It is 2 a.m. and I am alone in the dark with her again.

———————

On my television set tonight, in the black-and-white movie *Gilda*, Rita Hayworth is seducing Glenn Ford, heartbreakingly refuting the old adage "the camera never lies." It is close to forty years now since last we were together and the woman I had known in real life is, for me, still the single most tragic example of how far from the real person an image can be.

She was a Goddess onscreen, about as desirable a woman as any man could want—perfection in feminine allure. From the moment I saw her, she haunted my imagination. And from the moment we met in the lobby of a small hotel in the tiny town of Guanajuato, Mexico, in 1972, until her death from Alzheimer's disease fifteen years later, she continued to haunt it, eliciting a far more profound emotion than lust.

My agent at that time, David Begelman, had talked me into a Western titled *The Wrath of God*—aptly named—to be shot entirely in Mexico. It would star Robert Mitchum, with Rita in the "and" position, set off in a billing box at the end of the actor credits. She was by then finished in pictures and the word was that Mitch had insisted on her, possibly for old times' sake, the rumor being they had once had a tumble or two.

Mitch would play a runaway priest. I would be the town's

despot, who swears revenge on all priests for murdering my father, and Rita would be my mother, a God-fearing matron who never lets go of a set of rosary beads. What was I thinking? Well . . . I was thinking: *Rita/Gilda*.

And, here she is, tiny and scattered, standing in front of me, a rain hat on her head. She shoots out her hand and smiles. "Hey, I know you," she says. "I've seen ya in the movies. You're gonna be my son." I spout all the clichés: how excited I am to meet her and work with her, etc.

She tears off the rain hat, frantically runs her fingers through the once-lustrous auburn hair, now shorter and more sparse, shakes it out, pulls at it, and whips her head back and forth in an exaggerated "no," flailing her hands in the air as if shooing away an army of flies.

"Oh, cut it out. Cut it out," she says in a high-pitched, impatient tone, jamming the hat back on and fleeing the lobby.

Once on the set she is a total pro. Ready to go, eager to do her best. But the lines won't come. No matter how hard she tries, she can't retain the simplest phrase. In our first scene together, I approach her at prayer in a church and ask, "Why are you here?" Her line is "Because God is here." But she can't do it. Take after take she is unable to retain those four words. Oblivious to the rising tension and unkind remarks from the crew, she presses on. "Let's do it again," she says. "I'll get it."

Finally a man is laid down on the floor at her feet. Action is called. I ask, "Why are you here?" he whispers, "Because God is here." Then immediately Rita says, "Because God is here."

"Cut. Print. We got it," slurs Ralph Nelson, our director, and the crew bursts into cheers and applause. Rita beams like a little girl who's just been crowned Miss Snow Queen, com-

pletely unaware the cheers are jeers. At lunch, as she rests in her trailer, the jokes about her are lewd and cruel and for years after, I too would be guilty of reenacting the scene for friends at her expense.

———————

At about 5 p.m. on our first day off, the phone rings in my room. "Hey, it's Rita. Do you wanna eat?" Thirty minutes later we are sitting in the hotel's tiny restaurant. "We'll be friends to start, okay? Dutch treat on dinners. One night you, one night me. Deal. Let's have red wine. Just two glasses each." After the first one she asks me how old I am. I tell her: 34.

When dinner is over we walk through the chilly, dirty streets and she gathers her black-fringed shawl close around her shoulders, slips her arm into mine, and forgets my name. "Oh yeah, yeah, Frank," she says. "You'll be Frankie. I love Frankie. Not Sinatra. The guy was never on time." We pass an open-air market and she insists we buy fruit and cheese to keep in our rooms. "Just to have, you know, for the ghosts."

As we walk back toward the hotel holding string sacks of food, she clings to me, her arm tight in the crook of mine, our bodies finding a rhythm, and she whispers words I cannot understand. When I see her to her door, she leans up to chastely kiss me good night and says: "Do me a favor, baby: don't ever call me Mother."

———————

Film sets, particularly on remote and distant locations, can be anything from warm, collegial good times to lethal, tension-filled bloodbaths. Without the familiar surroundings of home, family, and routine, these shoots can become a breeding ground for heightened drama, soaring libidos, and neurotic

behavior. Ours becomes a polarized, not altogether homogeneous collection of crazy loners. At night, doors are closed tight and the cast mostly isolates. On this set, a lot of the crew, a mix of American and hard-bitten Mexican wranglers, hit the seedy whorehouses regularly. There are torn-up hotel rooms, hallways reeking of marijuana, heavy bar bills, and drunken brawls at 3 a.m. on the barren streets.

Rita and I drift toward each other like two boats torn free of their moorings on an unfamiliar sea. We could just as easily have floated in opposite directions, but real life is now reel life and on movie locations, personal relationships are less often chosen than grasped at. Rita grasped at me and I chose to take her on. The twenty-year difference in our ages suited the unreality of time and place. Each of us wanted something from the other and neither of us much contemplated motive or consequence.

A ritual began. Dinner most nights in her rooms. She buys dozens of candles, lights them all, and puts them on every surface, including the floor. I start a fire and pour the wine. And we sit by the open window, our elbows resting on the low wooden sill. Three stories below is the main street of the town, brightly lit, dusty, dirty, and noisy. She wants to make another deal.

We will count trucks. All trucks passing by her window going left to right are mine. All going right to left are hers. Whoever has the most trucks by dinnertime gets treated. I stay with the wine but she graduates to bourbon. Dinner is served on the floor and we eat to the cacophony of noise from the street. Her hair is washed free of the day's set and spray, her face polished clean of makeup, her dress a plain white caftan thrown over her naked body. She crosses her legs, barely touches the food, and talks and talks. Mostly about men. Shards of these ramblings stay with me.

"He found me when I was a kid. Brought me to L.A. What the hell did I know? I went along." Of another she said, "Oh Christ, he beat me bad. Then he skipped. I had to sign with Cohn [Harry Cohn, president of Columbia Pictures] for another seven to pay off the debts." Of Orson Welles she said, "He tried to help me to be a great actress, but he always needed money." And Prince Aly Khan: "I didn't want to live nowhere where they kiss the hem of your skirt. I mean, what is that, for Chrissakes? Two guys laying on top of each other outside my bedroom door so I couldn't get out. I didn't want to be no fuckin' princess anyway. So I went to the old man. He liked me and I said to him, 'Just give me my kid and let me out of here. I don't want anything.'" And then she says, "Geez, they were always around. Husbands, boyfriends, lawyers, managers, press agents—the bosses. Where the fuck did they all go?" Her voice is tinny and high, almost childlike; until she picks up the telephone and says in movie-star timbre: "This is Miss Hayworth. Would you please send up another bottle of bourbon."

When it becomes late and she has had enough of it, she flings her head back, hair flying about her face and, in the candle's light and fire's glow, once again becomes the Goddess. She knows I am looking and she holds the pose, lowers her head, tucks in her chin, raises her eyes to mine, grabs my hair, and says, "Don't stare at me, baby. You can see me in the movies."

We will be seven weeks on this turbulent sea and no other boats take notice of ours or even float past—none but Mitchum's. A man whom very little escaped. As regards Rita and me, he becomes my one and only confidant. We never discuss their past together nor does he offer any wisdom or make any

judgment. He would just listen, and then say: "Frankie, it is what it is."

But one day he comes to me and says: "Listen pal, we're never going to finish this fucking picture if we don't get your girl to work on time." Mitch, Rita, and I had our own local drivers and each of them regarded the harrowing ride along narrow unfenced mountain roads as challenges to be met with daredevil speed. Mitch slept through his rides and so did I. But Rita, who is terrified of all moving things, makes her driver go at a snail's pace and often arrives at work an easy hour or more after everyone else. So Mitch comes up with a plan: "Look," he says. "Let's the three of us ride together. You sit up front and we'll put Rita in the back with me."

Early mornings become a struggle of manipulating Rita into a broken-down jalopy and laying her down on the floor of the backseat. Mitch tosses a blanket over her as she pulls her floppy sailor hat down past her eyes. I then hop in the front and off we go. These rides become a hilarious routine of Rita laughing and screaming at the top of her lungs, with Mitch stretched out on the backseat outshouting her, singing Gilbert and Sullivan patter songs, exactly as written in perfect pitch, while a non-English-speaking driver careens close to the narrow road's edge as wildly as he dares. When we reach the location, I get out and Mitch and I lift Rita from the floor, remove the blanket, pull up her hat, and calm her down. "Cheated the old Grim Reaper again," he says and saunters off to his trailer.

On set, Rita continues to be a nightmare for everyone. There is not a shred of temperament, not a demand, not so much as a hint of cruelty. Rather it is like watching a school-girl desperately trying to learn her timestables and unable to get past the twos. Very little sympathy is shown for her. It is

assumed she is a drunk and is boozing in her trailer. No one, including Mitch, reaches out to help her. So little was known then of her disease that even I regarded the panic and terror in her eyes as the neurotic insecurity of a fading star.

In all her scenes, large placards are put next to the camera and her lines are written out in huge block letters. It becomes an agony for her to try to hold on to what little she can, and an embarrassment to face each daunting day. But she does face them, and she does make it through. Her pride and happiness at the smallest of her achievements is pitifully touching.

The nights are another kind of hell for her. She has climbed into my boat and I come to see I have set a dangerous course for which I am woefully unprepared. There are stretches of time when the mist in her mind clears and she is very much with me. But often she desperately clings, weeps, and talks in words I cannot understand and it is not always my name she calls out in the dark. When at last she sleeps, I leave her and go back to my room. There is, sadly, never a time when we awake in the same bed.

Our film comes to its predictable end and on our last night, with my bags packed and waiting in my room, late in the candlelight I say the words I know she wants to hear. An easy lie to tell. The next morning at dawn I abandon her and fly back to real life.

Months pass. I am in L.A. and guiltily decide to call her.

"Hi baby," she says, as if it had been only a moment since we last spoke. "Come on over for lunch. You gotta meet my savior. He's gonna make me a star."

Her house is somewhere up behind the Beverly Hills Hotel and she greets me at the door, again in a long white caftan. As usual, free of makeup, hair unkempt, happy to see me. Clasping my hand in hers she says, "You're the first. Come on, I'll show you around." We go from room to room and through the windows she points to property she used to own. "They sold it off," she says, "husbands or agents—I can't remember." On the walls, where paintings once hung, only faded patches remain, hooks still in place. "That one's on loan," she lies. "That one's out being cleaned." It is a barren, empty shell of a house, sparsely furnished and lit, with only one picture left on the wall of her living room. It is over the fireplace, a gigantic black-and-white charcoal drawing of her in the glory days. As we enter her messy and cluttered bedroom she closes the door, comes into my arms, and kisses me. "Stay with me tonight, baby. I need a man to be with me."

Out on her patio we are greeted by an absurdly tan fellow with patent-leather hair, gold rings, a gold ID bracelet, and a gold watch. He is wary and suspicious.

"There he is! My savior," she says.

They hug and giggle and she kisses him full on the mouth.

"He got me the cover. The goddamn cover. *Esquire*. And he's got plans. Wait till you hear."

We sit down to lunch at a barely set glass-top table on the patio. Plastic plates, paper napkins, a pitcher of water. An angry young Spanish girl brings out a tray of cold cuts, a loaf of white bread in a stack, and a large bowl full of lettuce. There are bottles of salad dressing and mayonnaise on the table. During lunch, Rita's mood turns sullen and morose. She sits quietly, bent over her plate. She has kicked her shoes under the table and a butter knife dangles listlessly in her hand. Her savior regales me with stories of his future plans for her. A film in Europe, a book deal, photo spreads for a magazine,

a TV show, Carson wants her. Rita is listening hard, her face staring down into her lap as he praises her legendary beauty. "Look at her," he says. "Look. No surgery and still gorgeous."

She raises her head, tosses back the once luxurious mane, stares at him, her smile wide and radiant. "Have some salad," she says.

"No, love, I'm fine."

"Aw, come on, you want some salad." She lifts her leg, the caftan rolling back to her thighs, exposing her, and puts the heel of her foot into the large plastic salad bowl, then pushes it under his nose.

"Take some," she says. And he does.

I leave the table with a made-up story about an afternoon meeting and she follows me out to the car. "You can't leave, baby. I gotta have a man with me." She again comes into my arms and kisses me. "Let him think it," she says. "Let him think we're together." I open the car door, get in, roll down the window; she leans into me. "What do you think of my savior?" she asks.

"Rita, be careful. He doesn't seem like the most honest guy—" But she cuts me off, her voice soft, low, and modulated. "Frankie, he's all I got." I am never to see or speak with her again.

———

Several months later there she is on the Christmas cover of *Esquire,* looking like a waxen image of herself, smiling and confident, her arms wrapped around a Santa dummy, once more facing a lying camera. None of her savior's promises come true and he fades from her life, as did almost every man she ever knew. As did I. Our film is an embarrassing disaster and the last movie she ever makes. Her physical body passes out of

existence on May 14, 1987, but Rita's essence had faded from the frame long before.

———————

Tonight, almost forty years after I left her life, there she is in black-and-white on my television screen. And the camera's lie is actually welcome and soothing. Her beauty is staggering. Her sultry voice, her body, the way she moves close to a man, the sway of her hips as she drunkenly belts out "Put the Blame on Mame" stop time and obliterate what had been our reality. Her acting is honest and true. A thoroughbred, desperate to be taken seriously, cursed with a divine beauty, who could not find a man to desire that beauty as only a part of the whole woman.

Near the end of *Gilda*, it seems she has lost Glenn Ford forever because he believes her character is what she has been pretending to be: a loose woman out for a good time with as many men as she can find. Feeling profoundly alone and misunderstood, sitting at a bar, shyly smiling at the bartender, her face full of loss and vulnerability, she is hauntingly lovely. The bartender asks: *Would you like, perhaps, a tiny drink of Ambrosia suitable only for a Goddess?*

In the movie's final moments, the villain is killed and the lovers reunite.

"Let's go home," Rita says to Glenn as they face a new sunrise.

———————

Those nights we spent together in Mexico, she'd say:

"Put all the lights out, Frankie, and open the shutters."

And by the light of candles and fire, she would once again become the legendary beauty who had obsessed and haunted my young imagination, swaying and dancing for me.

"Stay with me, baby. Stay with me tonight."

———————

I never shared a sunrise with Rita Hayworth; and I did not try to save her, nor could I have. The best I was able to do was take into my arms someone no longer any of the things she had once been: Movie Star, Princess, Goddess, or Gilda. Just a 54-year-old courageous and gentle woman named Margarita Carmen Cansino, one of God's lost souls, clinging in the night to a man whose name she could not remember.

LAURENCE OLIVIER

He had decreed it would be Larry and Frankie. Or to be more precise, as he would pronounce it: Frankay!

It was the fall of 1978 and I thought I'd better get it over with. Break the ice. The seventy-one-year-old legendary Sir Laurence Olivier was to play Van Helsing to my Dracula in Universal's remake of the 1931 classic. I walked down to his rooms in a drafty castle in a place called Tintagel in the south of England. His door had a piece of white paper taped to its upper center. *L. Olivier*, it read in handwritten black letters. I knocked.

"A moment please," came a male voice. Seconds later, its owner, a tall, thin, reedy man who appeared to be just shy of one hundred, opened the door a sliver. "Yes, please?"

"I'd like to introduce myself to Sir Laurence," I said. "We're going to be working together."

"Oh, Mr. Langella. Of course. Do come in."

I stepped into a fairly large sitting room similar to mine and saw a small man, back to me, leaning over a table, fussing with a pair of cufflinks. He turned sharply, upper body still bent, focused on me, then stood ramrod straight. The cufflinks clattered to the table and his arms shot out, palms wide, face beaming. It was a standing-still entrance. I began to cross toward him, but he beat me to it, grabbed both my wrists in an extraordinarily tight hold, and drew me to him.

"Dear boy," he said, fixing his gaze on me and studying my

face as if it were a small-print road map. "Oh yes, of course . . . "

He let go and began a rapid-fire series of questions about his *frocks*. Did I think this jacket was suitable? Was the collar too tight? "One wants it a bit more loose, I feel. Gives one a fragile appearance." I couldn't imagine him looking any more fragile. He was at the time suffering from a rare blood disorder, paper thin, a bit hard of hearing, and unsteady on his feet. Other than that, he seemed made of cast iron. A master of deception who, long ago, I sensed, had lost touch with the simple act of just being. The artifice of his persona was, no doubt, long practiced and I knew instinctively that I was in danger. I was in the presence of a predatory animal who had caught me in his sights, and I would need to be on guard for the next several months.

We discovered that a connecting door joined our two suites, both of which overlooked a lawn leading to the sea. "We can have tea in the morning, dear boy, or a bit of champers after work. Do come in any time." His arm was tight in mine as he ushered me to the door.

"Oh, it's going to be something, isn't it?" And I was in the hallway again. Ice broken. Already refreezing. Laurence Olivier had the extraordinary ability to embrace and dismiss you in one gesture.

That afternoon there was a first reading of the script. He was in full costume. "Never too soon to break it in," he said. He fished a pack of cigarettes out of his pocket, lit one, and we began. The reading was perfunctory, uneventful, and courteous. At one point he had this line to say: "I shall have to cut off her head and stuff her mouth with garlic." He turned to our director John Badham and exclaimed:

"I shall need to say that line directly into the lens, dear boy!"

"Would you like to have dinner?" I asked after the reading.

His hand leapt up from the table in a gesture of carefree flamboyance as if I'd invited him to bungee-jump with me, and the voice sounded out clear as a bell:

"Why not!"

I came round the table as he pushed back his chair and placed my hand under his elbow. He gratefully accepted my aid, wrapping his fingers round my forearm. But once up and steady, he gingerly preceded me out the door.

The bar of the hotel where we were in residence was dark, mirrored, and opened into a small dining room. Still in costume, he ordered champagne. "Let's start it off right, shall we, dear boy?"

Once several glasses had been downed he seemed to drop ten years and there was a swaggering manner in how he leaned on the bar, gestured, and took a stance away from it from time to time.

"Now you will help me out with this, won't you, dear boy? Help me sex up the character a bit?"

"You're not going to play helpless with me, are you?" I said.

Placid face, steely eyes, champagne chugged. "Cheers," he clipped out. "Let's eat." And he sailed quite confidently into the dining room.

Whatever it was we did eat that night, he ate it with immense gusto, ripping hunks of bread, slathering them with butter, shoveling in the meat, flinging down glass after glass of red wine. The early talk was of acting styles. "Your Ethel Merman," he said. "Your Chita Rivera. They're ab-so-lutely marvelous. That's what you Americans do best. Big, vulgar musicals. I adore them." The "a-" and the "-dore" were separated by a tiny pause, and the "-dore" was punched out with even more voice.

"We just can't do any of that. I don't mean sentimental shit like *A Chorus Line*. Oh, and your Gwen Verdon in *Once Upon*

a Mattress. Fan-tas-tic." I had a hard time convincing him it hadn't been Gwen but Carol Burnett.

"Now you've had a great success with this in America, haven't you dear boy! All camp and winky-winky, was it?"

Dracula had indeed been a phenomenal hit on Broadway, supported by the black and white Edward Gorey designs. I launched into a description of how I intended for the film to be played in a Gothic, romantic style, not Hammer Studio camp. I would wear no fangs, I told him. There would be no wolf's eyes, no blood dripping from my mouth.

"Have you read the book, dear boy? You know it's Van Helsing's story."

It was now 2 a.m. and both Sir Laurence and Larry were stinko. A young assistant appeared in the doorway. "Mr. Langella, I have your per diem with me. Would you mind signing here?" I did and he handed me a packet of my expense money. The young man turned to leave, looked over my shoulder, and realized that the tiny little person in full period costume slumped over next to me was Sir himself. "Oh, Sir Laurence," he said. "Forgive me. I didn't know you'd arrived. I have yours in the car; do you need it?"

"*Need* it? *Need* it? Of course I don't need it, dear boy. I just like to *collect* it. Go get it."

Over the course of the first several weeks we had dinner together most evenings and he could be vastly entertaining. The stories poured out of him in well-rehearsed rhetoric. The one constant in his endless repertoire was the actress Vivien Leigh, whom he referred to as "my late wife."

"I got the call that she was gone, and I rushed over to remove some papers and such before the fuss began. There she was laid out on the bed, dead. I tiptoed through the apartment, almost going ass-over-teakettle to the floor. I looked down and there was a small puddle at my feet, between the

bedroom and the bath. She must have gotten up in the night and couldn't make it to the bathroom so she just stood and peed herself. You know, she was a nymphomaniac! And I'm a premature ejaculator! Not a good matchup!"

Quick off the mark were certainly not words that could be applied to our film. It was grossly underprepared and the waiting was endless. So the door between our suites stayed open most mornings. In Larry would pad wearing his flannel robe and his velvet slippers, and take tea with me and read the morning papers sitting by the window. I'd sit up in bed, drink my tea, and read as well. Those were the times I most enjoyed him, being a silly old English gent who loved to play camp and gossip about anyone and everything. And as the days wore on his stories and his language grew more and more ribald. I slept in the nude but when I heard him stirring I would slip on a pair of boxers and climb back under the covers. And if I needed to dash to the john he'd say:

"Oh, we're not going to have a look at the naughty bits, are we?"

So one morning, as a gag, I slipped off my boxers under the covers and streaked to the bathroom, then turned at the door and said: "Oh professor, see anything you like?" He howled with laughter, flung his arms in the air, clapped loudly for me and shouted out, "Bravo, dear boy, bravo!" Returning to his newspaper he chose not to look up as I scurried back to the bed.

As yet another workless day stretched before us, a makeup man arrived in my rooms to make a plaster cast of a portion of my chest for the love scene in which I open a vein so Miss Lucy can drink my blood. Larry sat by the window watching the process. When it was done he beckoned me over to him

and we sat staring out to the sea. "You know, Frankay, you have a very good chest. I had a lovely chest when I was your age. In fact, one of my fantasies was to be standing on a pedestal in a museum and have people pay to worship my naked form."

"You too?" I said.

I was forty, still vain, still watched my dailies, and pored over stills.

"Oh, there'll come a time, dear boy, when you'll take a look at yourself in the mirror and you'll just settle. I look like an old trout now and there's nothing to be done for it. Ahhh! Tears before bedtime."

After our morning sessions, he'd pad back to his rooms, leave the door open, and I'd hear him relentlessly repeating his lines in an indeterminate accent:

I did not hear you come in, Count, he would say over and over again, with the *Count* slightly extended and broken into two syllables. And finally, when I entered the scene in which he was to say the line, on camera, months later, he turned to me and said it exactly the way I'd heard it dozens of times coming from his room. He could have been playing the scene opposite the March Hare for all he noticed me, and he was gone the moment his on-camera lines were finished.

Perhaps one of the most ludicrous scenes I've ever played in a film was performed sitting on a horse in the back lot of Shepperton Studios on a cold and rainy afternoon surrounded by bags of garbage. Larry was long gone from the production, so as my horse's hooves sunk into the mud, I acted to an 8x10 photo of him that had been taped onto a wooden stick and stuck into the ground. The horse and I kept sinking lower and lower, forcing my eye-line to change and the stick

to be pounded deeper into the ground with each take. When watching the film it is impossible to tell that several months had passed between Larry's close-ups and mine. I was, in fact, so used to acting without him there, that one day as I said a line on the set of the study, I turned in shock when I heard his voice off camera feeding me a cue.

"What's Larry doing here?" I asked Badham.

"The press is visiting," he said.

———————

But with or without their obsequious presence, Larry was always consistently for Larry. One afternoon we were asked to stand on the balcony of the castle to pose for publicity photographs. We both faced the camera in full regalia, staring intently into the lens.

"Sir Laurence, would you have a look at Mr. Langella, please?" the photographer asked.

"No," he shot back.

"Mr. Langella, would you have a look at Sir Laurence, please?"

"No," I retorted.

As we came back inside he took my arm and said, "You know, Frankay, dear. You're a monster. So am I. It's what you need to be to be a Star. But really there is nothing so rewarding as being inside an *ensemble*. Particularly when playing Chekhov. So much more thrilling than giving a Star Performance." I did not believe or agree with him then, and time has not in the least altered my opinion.

He could no longer, of course, give star performances. His illness and age prevented the sort of theatricality for which he had been lionized. But the monster in the man was still very much alive and I was actually regretful at not having caught him at a time when his teeth were sharp and his claws were

out. He was doing *Dracula* for the money, giving it his formidable showmanship, having his tea, and being, from time to time, a delicious old camp.

———————

One afternoon, with his feet up, turning the pages of a big movie picture book, he hilariously commented on some of the performers with whom he had worked.

Of Merle Oberon:

"Dear Merlie. She was always complaining to Willy Wyler [who directed them both in *Wuthering Heights*], 'Willy. Larry's spitting on me.' 'Well, I'm from the theatre, Merlie dear,' I said. 'That's what theatre actors do. We *spit*.'"

———————

Of Kate Hepburn:

"Fancied herself a laaady, so I'd just say, 'Fucking cunt' any time I could, and she'd pretend shock. 'Oh come off it,' I'd say. 'After all those years of living with Spence you've heard a lot worse.'"

———————

And once he said of a young actor who'd never quite succeeded and tried desperately to appear straight:

"Darling chap, but he just couldn't hide the Nellie. And you know, dear boy, you've got to hide the Nellie."

———————

The months dragged by and, on his last day of work, I had to drive a stake through his heart, pinning him up against a wall. Most of it was done with a double, but he was brought in for his close-up. John Badham, whose style of direction was pretty direct and pragmatic, was going to take Larry through

the shot, as there was no sound required. And it went something like this:

"Action.

"Okay, Larry. The big guy's coming at you. You see the stake. There it is. No way out. Give me some fear. Okay, here it comes. It's in. It's in. It's in. Give me some eyes, Larry. Throw your head back. Now give the sucker one last look. Good, good. Okay, Larry. Now die."

He did exactly as he was asked, rolled his eyes to the heavens, lowered his head, looked at me, opened his mouth, did his signature twist of the tongue, slumped, and died. The camera kept rolling for a few beats until John's voice rang out:

"Great! Close your eyes, Larry."

Sir Laurence Olivier managed to keep his eyes open for another ten years, and died at the age of eighty-two. There was a great deal about him I found charming, delightful, and admirable. But I was always keenly aware of the fact that I was dealing with a deadly cobra capable of striking without notice. A cobra who nevertheless had a way of looking deeply into your eyes when saying good-bye that made you feel you were the most important person on earth to him. He managed a sort of tender pathos that defused the monster, until, of course, the next time you met him in the woods. It was one of many cunning tricks from a man whose bag of them seemed bottomless.

There is a tradition in the English theatre that when an actor has played a successful Richard III, he must pass down the sword to the next generation's Richard.

"Who are you going to give it to?" he was asked.

"Nobody," his lordship replied. "It's mine!"

BETTE DAVIS

When asked what it takes to succeed in the acting profession, Bette Davis would answer, "The courage to be hated." And she unsparingly lived up to that maxim until the end of her days. My relationship with her was brief, provocative, and, at the one time I was in her presence, humbling and sad.

In the early eighties, we were both represented by an agent named Robbie Lantz, whose specialty was charming and cajoling a great many divas and monsters. At various times he represented Bette, Elizabeth Taylor, Milos Forman, Peter Shaffer, Myrna Loy, Marlene Dietrich, and Richard Burton.

Miss Davis, it seemed, had seen me in a film and liked what she saw. "Is he gay?" she asked Robbie.

"Bette, dear, he's married with two children."

"So what?" she snapped. "Get him on the phone."

So, with Robbie as Cupid, Miss Davis and I had a number of racy phone conversations, not quite phone sex but certainly rife with foreplay. She was complimentary and seductive and funny. I have a fan, I thought. So surface were our exchanges though, that I recall virtually none of them. She resolutely avoided anything that could be remotely described as an honest exchange. And when she was done, she was done.

"Well, good-bye" was the abrupt finish, then click.

"Why don't we all have dinner?" I suggested.

"Oh Frank, you don't want to actually meet her," Robbie said. "Leave it as it is. She'll eat you alive. There is no way you can possibly win with Bette. Keep your illusions."

"I don't care what she'll be like," I said to Robbie. "I want to meet her." He dutifully tried to set up a dinner at his apartment in New York. Miss Davis agreed, but cancelled. He tried again. She agreed and cancelled again. The phone calls dwindled away, and I resigned myself to having been juiced up and jilted. Just a temporary boy toy.

Perhaps it wasn't a bad thing, I thought. I had remembered a friend of my former wife's telling me that when Bette was staying with him in L.A. she asked to meet Mae West, whom he also knew. It was the middle of August, but she insisted it would be lovely to have a roaring fire when Miss West arrived. The fire was lit, and even with the air conditioners at full blast, the room was an inferno. By the time Miss West entered the house, Miss Davis had had a few and was almost incoherent. According to this gentleman, Miss West conducted herself with grace and dignity as Miss Davis fell asleep, drunk and sweaty.

"Poor thing," Mae said, as she left.

In her later years, I watched her give sadly mannered performances in B films and descend into the worst of her nature, as she physically shrank and began to decay. Beset by major illnesses, including a stroke and cancer, she defied death time and again and repaired herself, it seemed, through the sheer power of what appeared to be operatic rage. And toward the end of those days, I would at last have the privilege of meeting her.

It was now the late 1980s. I was staying at a hotel on Sunset Boulevard in Los Angeles. At about 2 a.m., I was at the desk,

picking up my messages, and as I walked toward the elevator I saw a tiny, tiny woman moving slowly toward the front door in a black and white polka-dot dress with a wide black patent leather belt cinching her infinitesimal waist. The dress billowed out like those crinolines worn by high school girls in the 1950s. On her head sat a broad-brimmed black and white polka-dot hat, and from her arm swung a white bag with a polka-dot handkerchief peeking out of its opening. Step click, step click, went the sounds of her feet and cane tapping along the marble floor.

I fell in behind and moved slowly forward to catch a glimpse of the profile. Before I could get even with her, that famous voice boomed out of that munchkin body to her female companion:

"Get the car."

Those three words might as well have been followed by . . . "or I'll kill you!"

The venom with which she spoke them for some reason made me laugh. She was oblivious to my presence as the young woman sat her down in a chair near the front door and left to do her bidding. The lobby was completely empty. There I was, alone at last with Bette Davis. Alone with Regina Giddens from *The Little Foxes*, Margo Channing from *All About Eve*, Charlotte Vale from *Now, Voyager*, Crazy Jane from *Whatever Happened to Baby Jane?*, and the man-eating Mrs. Skeffington. I stood at a discreet distance and watched. And, lo and behold, she performed, just for me, the definitive Bette Davis scene.

Click! The bag opened! The handkerchief came up to dab the lips! Back into the purse it went! Out came the cigarette case! Click! It opened! Into the white-gloved fingers went the cigarette! Click! The case closed! Plop! Into the bag! Out came the lighter! Snap, light, close, plop, puff, and click again! The

urge to yell "Cut!" overcame me, but instead I walked up to her, now seated in a cloud of billowing smoke.

"Miss Davis?"

"Yes!"

"I'm sorry to disturb you, but I just want to tell you that I think you are the greatest actress of the twentieth century."

"Thank you!"

Time to go, I thought. She was resolutely staring straight ahead, those giant eyes barely noticeable under her large picture hat. But no! This would be my only chance to share a memory with her. After all, was she not a fan of mine as well? And when she saw me, heard my name, she surely would respond more warmly, ask me to sit down and wait with her until her car arrived. Perhaps we could even have a drink together and discuss the art of acting. I could ask her a question I'm sure no one had ever asked her before, like "who thought up the idea of Paul Henreid lighting the two cigarettes in *Now, Voyager?*"

Since she was so small, I leaned over quite far in order to get my face enough under the picture hat so that she might recognize me and welcome our moment of intimacy. In order for me to make certain she'd know who it was invading her space, I needed to bend practically in half, and in that rather awkward position, staring up at her face, I said:

"Miss Davis, it's me. Frank Langella."

She sucked on her cigarette, keeping her eyes low, turned, exhaled into my face, looked me straight in the eye, and uttered these words:

"I said: Thank you!" She then turned face front and froze me out.

———————

So utterly final was Miss Davis's "Thank you" that I backed away from her, not so much shyly as with a mild revulsion. She had every right, of course, to her privacy. But her rage at it being invaded was so palpable that I moved back in sadness and watched her from a distance for about ten minutes until her handler arrived. Ten minutes sitting alone in silence, smoking, waiting to be taken home, undressed, most likely given a drink or a pill, and put to bed. A great, great artist, living out her final days with a hired companion, heading toward her grave resolutely mantaining the courage to be hated.

Miss Davis died in 1989 at a Paris hospital, having just accepted yet another Lifetime Achievement Award from the San Sebastian Film Festival in Spain.

"She did it the hard way," she once joked should be the words written on her tombstone. And I suppose she did. It does take a lifetime to achieve pushing love away with such determined ferocity.

REX HARRISON

He was my idol. I thought him the most accomplished, technically perfect, and totally believable English actor of his time. He had enormous style, great sex appeal, humor, and charm. But Sexy Rexy, a nickname he loathed, reportedly bestowed on him by the actress Coral Browne, was a real son of a bitch.

He was at one time married to one of my dearest friends, Elizabeth Harris, who had previously been married to Richard Harris—a force of a different color. I once asked Elizabeth about Rex, and she confirmed his reputation as a divine monster.

"He was the only man I ever knew," she said, "who would send back the wine at his own dinner table."

Elizabeth was one of his six wives, along with the stunning Kay Kendall, the also stunning Lili Palmer, and the tortured Rachel Roberts. Also among his many lovers was a beautiful actress of the 1940s named Carole Landis, who died tragically at twenty-nine, by taking a bunch of Seconal after Rex allegedly refused to leave his wife for her. Rachel Roberts also killed herself with pills and then gulped down some lye to boot. With such notices, it was no surprise his at-home performances didn't run very long.

He was as resolutely heterosexual as he was resolutely homophobic, refusing to play any role that would give off a hint of his appearing light in the loafers. In 1962 the playwright

Terrance Rattigan wrote a play for Rex entitled *Man and Boy*, in which the leading character Gregor Antonescu pretends to be gay in order to gain advantage over a homosexual business partner. Rex would have none of it. Nor would the next choice, Laurence Olivier. I played this incredible character on Broadway in 2011, often thinking of what a great opportunity both of these actors had missed.

Late in his career he decided to risk the stigma in a terrible movie called *The Staircase*, playing an old queen opposite Richard Burton's old queen. Richard, who had no such worries—"I tried it once," he said, "I didn't like it"—told me one night over drinks that during the shooting of the film he opened his dressing room doors to a full bar and the crew wandered in and out at will. "Rex was directly next door to me," he said, "and never once opened his door or entered my dressing room. He deeply regretted having taken on the role, still afraid people might think he was a pouf." He was from many reports despised on that film, as indeed he was by most of the people who knew and worked with him.

Oddly, he and the actress Doris Day seemed to have found a warm rapport on a film they made together in 1960 entitled *Midnight Lace*. And it shows in both their wonderful performances. But in general he did not endear himself to very many people. The story goes that on his seventieth birthday, someone offered to give him a party and invite all his friends. "I'll even hire the telephone booth," said the man.

I met Rex Harrison twice. So brilliant had I thought him in his signature role as Henry Higgins in *My Fair Lady* that in 1956, when I was in college, I memorized his every word, inflection, and sigh. I thought his performance in the musical and the subsequent film indelible examples of how an actor could

be both theatrical and truthful and when I played the role some thirty-five years later at the Houston Grand Opera in 1991, his definitive performance rang in my ears every night.

But in the early 1970s, there he was in person, standing before me. He was the guest of honor at a cocktail reception in the home of my agent at that time, Milton Goldman. The last to arrive, he entered with his newest wife and was standing in the foyer, removing his hat, scarf, and coat. I decided that, before he was inundated with well-wishers, I would approach him and pay my respects.

As he turned to enter the main room, I came up, put out my hand, and said:

"Mr. Harrison, it is a great honor to meet you. I—"

"Thank you," he said, cutting me dead, flinging his and his wife's coats across my arm and making his entrance. I doubt that had I waited at the door all evening to say good night it would have been worth it. He didn't seem the type to tip.

My friend the English producer Duncan Weldon told me he was touring Rex, Stewart Granger, and Glynis Johns in the provinces of England in a play entitled *The Circle* in 1991. Rex was at that point eighty-three and very frail. Suddenly taken ill before a matinee, he was rushed to a doctor who told him to take to his bed for a day. Duncan saw to the understudy, then went to visit Rex in his hotel room.

"I'll be fine," he said, "just a silly bit of dizziness. I'll be in tonight."

"Oh, I'm so relieved," said Duncan. "Glynis was so worried. She sends love."

"Glynis?"

"Glynis Johns."

"Was she there this afternoon?"

"Of course, Rex. She's in the play with you."

"Oh no," he said, "that girl's not Glynis."

My second encounter with him was in 1984. He was performing in a play with the film star Claudette Colbert entitled *Aren't We All*. I witnessed him bring down the house with one word. Toward the close of the play, his character discovers something the audience has known all along. He absorbs the information, realizes he's been duped, and says in barely a stage whisper, "Well!" There were decades of expertise in that "Well!"

A friend of mine in the cast was taking Miss Colbert to supper after the show and brought me backstage for an introduction. She had starred opposite Clark Gable in *It Happened One Night*, close to my favorite film comedy. As we were waiting for her to change, my friend told me that Miss Colbert so disliked Sexy Rex that she only spoke French when in his company, just to annoy him.

Miss Colbert opened her door already dressed to leave in a black mink coat, hat, and gloves. And in the thirty seconds it took her to say hello, shake my hand, and thank me for coming, I fell in love. A great film star exquisitely turned out and gracious as could be. I forever regret not joining her and my friend for supper when they invited me, but I was on a mission. Instead I said:

"I'd like to pay my respects to Mr. Harrison."

"Yes, darling," she said. "He's that way," indicating where to go and leaving my life forever..

There was no one else backstage. Not a soul. I made my way to his dressing room, knocked, and heard:

"Yes! What is it?!"

I tentatively opened the door.

Standing alone in a silk dressing gown, looking like Rex Harrison's grandfather, he offered a wet-fish handshake and a somewhat suspicious smile. But I was not to be coerced into helping him change into his street clothes. I launched into a speech I'd been practicing for forty years and told him what he'd meant to me since I was a young boy. He stood listening patiently and when I finished said:

"Thank you. Very kind. I'm afraid I can't ask you to sit down."

And I was out in the hall. Again no tip.

CORAL BROWNE

Coral Browne was an actress better known for her personality than her talent. Although gifted, subtle, and stately, she outstripped her performances on stage and screen with her personal wit and sarcastic tongue, aided and abetted by her equally witty husband, horror film star Vincent Price.

I met her in the winter of 1978 while living in London filming *Dracula*. She was close to my good friend, the British theatre designer Carl Toms, and he arranged several evenings at the famous Garrick Club, where Coral held forth in high style.

A handsome woman, always impeccably dressed and made up, she focused on maintaining her looks to the end. With a voice that cut like a knife and a laser look that burned through you, you didn't want to be on Coral's bad side. Even though, thanks to meticulous plastic surgery, there seemed to be none. We settled into our table, ordered drinks, and she began:

"Who's in your picture, darling?"

"Well, Olivier."

"Darling Larry. I adore him. From a distance."

"And Donald Pleasence."

"Oh, God. He's a *handkerchief* actor. He'll take out his bloody handkerchief and blow his nose whenever he gets a chance or worse eat a bag of Sweeties during your best scene. Whatever you do, don't get in a *two-shot* with him."

One of the most legendary stories about Coral involved the American columnist Radie Harris, who courted and wooed the English stars through the 1950s, '60s, and '70s with long, flattering tributes in her column "Broadway Ballyhoo" in the *Hollywood Reporter*. Several times a year, Radie, who had a wooden leg, walked with a cane, and wore a brace, entertained them all in her suite at the Savoy. She would plant herself in a comfortable chair, unlock the brace, lean the cane next to her, and hold court. The story goes that Coral walked in to find Radie surrounded by the likes of John Gielgud, Ralph Richardson, Vivien Leigh, Laurence Oliver, and a bevy of simpering sycophants. She observed the scene and declared in a loud full voice, "There she sits, with all of London at her *foot*."

But my personal favorite, and the most famous, was about a phone call she once made to a director early in the morning on the first day's rehearsal of a Shakespeare play.

"I'm very upset."

"What is it Coral dear?"

"You haven't asked Phillip to be in our play."

Phillip was Coral's husband at the time.

"But Coral, darling. We're all cast. There's no part for him."

"Oh, yes, there is. Get the script. Turn to page sixty-four. You see halfway down, there where it says:

" 'A Camp—near Dover.' "

So casual was the wit, and so delightful the delivery, it often flew by in a flash. As we were departing the Garrick Club one evening a very short man came up behind us and tapped her on the shoulder. "Coral, darling," he said, "you haven't looked at me all evening."

She peered over her shoulder, gazed down and said, "You think I've got eyes in my ass?"

Coral and Vincent, whom I only had the pleasure of briefly meeting once, were, I'm told, irrepressible together. Courageous realists who during their later years, had found a beautiful rapport and friendship. Vincent was by her side all through her illness and at her death at the age of seventy-seven.

When she was close to the end, Alan Bates told me he called to speak to her and Vincent said:

"I'm so sorry. She can't come to the phone. She's just gone to confession. And she's going to be a *very* long time."

COLLEEN DEWHURST

When actors don't like each other, it is usually with a vengeance, and Colleen Dewhurst did not like me.

As I was coming out of a colleague's dressing room backstage, Miss Dewhurst was coming in and fixed me with a stare little short of contempt. She sailed past without a word and I asked my companion if I had imagined her coolness.

"Oh no," she said, "pure hatred."

What, I wondered, could I have done?

———

Colleen was popular with other actors and they generally grouped around her at theatrical gatherings. One year she was seated backstage watching a Tony Awards ceremony on closed-circuit TV with lots of people I knew. I walked over and sat down next to her. But she stiffened, said not a word to me, and eventually moved away.

I tried again one evening in 1982. I was playing Salieri in *Amadeus* at the Broadhurst and Colleen was playing in *The Queen and the Rebels* next door at the Plymouth. The walls of our stages backed up to each other.

During the second act of *Amadeus*, Salieri has a long, quiet monologue—pin-drop time—and every night at precisely the moment it began, I would hear Colleen let out a blood-curdling scream next door and storm through some dialogue.

No matter how I timed my monologue, her screams always hit at exactly the quiet moments for me.

One night it stopped.

"Did Miss Dewhurst's show close?" I asked the stage manager.

"No."

At that time, there was a restaurant on Eighth Avenue and 44th Street called Downey's. On matinee days you could find Colleen, Geraldine Page, Maureen Stapleton, Jason Robards mostly sitting by themselves in one of the round red booths, reading and eating before heading back to their dressing rooms for a nap.

So I took a chance, stopped at her table, and told her my story as she politely stared up at me.

"And now your screams are all gone. What happened?" She thought a moment and said:

"Oh yeah. I stopped! I was doing it fucking *wrong* for the last three months," and returned to her salmon.

It was the last of several attempts I'd made to engage her. I am not thin-skinned, but it's easier to deal with someone's antipathy when you know the nature of the grievance. Although I do remember asking a young actress once why our director seemed to dislike me.

"You showed up," she said.

In Colleen's case I had no clue and no mutual friend to intercede. So I accepted her animus and figured we'd never work together or know each other personally; sad, because she was a colossal actress and all her pals adored her.

Colleen's ex-husband George C. Scott was directing me in *Design for Living* at New York's Circle in the Square Theatre in 1984. During a note session in early previews, he said:

"Colleen's coming tonight."

I told him my story. He seemed little interested.

After the show, George came back and said:

"Her agent says you're an asshole."

Colleen was represented for many years by a theatrical agent whom, at the beginning of my career, I had unfairly fired. He had a legitimate grievance against me and had obviously poisoned Colleen's mind.

"What did you say, George?"

"I said, 'So what?' " He laughed.

Obviously he said more than that because flowers arrived the next day and a break-a-leg telegram on opening night. Thereafter she was the warm and caring woman I'd often heard about and with whom I would be lucky enough to share a memorable evening.

It was at an all-night gabfest in Houston not too long afterward when we'd both been asked to perform at a gala in honor of Arthur Miller. In my hotel suite Arthur, Colleen, Tony Lo Bianco, Mildred Dunnock, Robert Foxworth, Liz Montgomery, and I were gorging ourselves on hundreds of shrimp, roast beef sandwiches, french fries, mountains of dessert, and cheap champagne provided by the benefit committee.

It was enough food for thirty people, but actors are insatiable when it comes to free food, and by 3 a.m. we'd eaten everything but the paper doilies on the restaurant trays and Colleen had drunk enough champagne to christen a fleet of battleships. We all smoked in those days, and gossiped viciously. Fewer smokers today, but vicious gossip is eternal.

Colleen was our bitch leader. Dressed in bright red harem pants, tight at the ankles and billowing up to a flowing red top, she looked like a giant red pepper on stiletto heels. As the food disappeared into her mouth, hosed down by the champagne, she held forth on the dirt of the day. Hilarious vivisec-

tions of personalities and careers. I suspect the character of any actor who can't fling this kind of mud from time to time and was certain I had most likely been so vivisected by her at one point, and might be again. Grateful as I was for a curtain having been dropped between us, I knew it could just as easily be raised once more.

Arthur and his wife, Inge Morath, the photographer, left early. My wife went to bed and one by one people drifted away. It was now just Colleen, me, and her then boyfriend, Ken Marsolais, remaining. There was no more to eat, we'd systematically destroyed every reputation in the business, but she was still cooking. Ken wanted to go. She reluctantly got up, sucking on her cigarette, and staggered into the marble foyer of the suite toward the door, where she gleefully spotted a bowl of nuts on the hall table. She scooped up a huge amount, tossed back her head, flung them into her mouth, and in a second out they flew across the foyer and down the far wall onto the floor.

"Agggg!" she screamed. "It's *potpourri!*"

We collapsed into the kind of hysterical, from your guts bellowing that took on a life of its own, causing us to gasp for air, hold our stomachs, and roll around on the marble floor like drunken idiots for ten minutes. When actors lose it, they lose it bigtime.

———

Colleen and I were never intimate friends, but I was grateful she'd overcome her prejudice toward me and from then on, whenever I saw her it was free and easy. One evening I asked her how she was enjoying her reign as president of Actors' Equity. She stared hard at me and said: "Big fucking mistake."

ANTHONY PERKINS

Tony Perkins was, among other complicated things, gay. He died after a long battle with AIDS in 1992 at the age of sixty, having finally confessed his secret. But I doubt it was a confession that gave him much relief.

He was five years my senior, and a huge rising star when I came to New York in 1960. A total original in looks, voice, and style, he was long, lanky, and offbeat handsome. His performances in the films *Friendly Persuasion* in 1956 and *The Matchmaker* in 1958 are so winning and comically skilled that his signature role of Norman Bates in Alfred Hitchcock's *Psycho* only two years later seemed to stunt his potential and most probably sounded the death knell of his promising career. He was only twenty-eight years old and from then on appeared to be living a trapped life. An indelible character he could never shake and a sexual nature he could not celebrate.

I first met him in 1968 in my dressing room at Lincoln Center's Vivian Beaumont Theatre when I was playing William Shakespeare in William Gibson's play *A Cry of Players*. I was just thirty years old. He was thirty-five and on the make. In the acting company of the play was an eccentric guy who had a small role and lived in a teepee he had set up in the Beaumont's vast backstage area. From it came the distinct odor of cannabis and in and out of it went a phalanx of young men.

One night there was a knock on my dressing room door

after the performance. When I opened it, there stood the lovely Mr. Perkins, hands stuffed in his pants pockets, hair sweetly messy.

"Hi. I'm Tony. Can I come in?"

"Sure."

After the usual backstage chat, I said:

"You know, people keep telling me I'm a younger you, but I don't think we look alike. Do you?"

We both stood in front of my makeup mirror shoulder to shoulder and stared at each other.

"I don't see it," he said. "How big is your cock?"

"I didn't bring it with me tonight," I joked.

We turned and faced each other in silence. There is a way one man stares at another when a sexual encounter may be in the offing that is completely unlike the uncomplicated gaze exchanged with no hint of its possibility. Tony's gaze was profoundly of the former.

"I'm going back to visit Tom in his tent. If you feel like it, stop in."

———

Tom's teepee could not hold a candle to the swank New York apartments in which the gay community of the 1960s often gathered. Famous older men in the closet had secret evenings to which all the young meat in New York was invited, nicknamed towel parties. The entrance fee meant stripping at the door, donning only a towel, and spending the rest of the evening so attired. An upscale elegant steamless bathhouse at which Tony was reputedly a frequent visitor. He held a unique position, certainly, being both a celebrity and youngish meat.

I always felt in his company that he wanted to be fathered. Even though I was the younger, he related to me like a teenage boy in constant need of approval. His first impulsive

question in my dressing room that night in 1967, "How big is your cock?" may have been more than a come-on. In a little boy's mind, Daddy's is always bigger.

Skittish, compulsively flirtatious, and often sexually charged, he seemed always to be flinching from an expected whack to the back of his head.

Sweet or sour; a master game player who was often vindictively cruel, he finally lost his virginity to a female at age thirty-nine, declared he liked it, married soon after, and fathered two children.

As the years passed and his beauty faded, he appeared in awful films, a few plays, and ultimately gave in to his signature role of Norman Bates and lived on the sequels. Anger and bitterness then seemed to be the dominant elements in his personality.

Apart from a few social occasions, I lost track of Tony until one morning shortly before his death, in the parking lot of a grocery store on Santa Monica Boulevard close to Hugo's Restaurant, a favorite actor's hangout in Los Angeles.

I was loading the car as someone came up behind me.

"Hey."

I turned and saw what looked to me like a ghostly apparition, a paper-thin, wide-eyed, sallow-faced, walking cadaver.

"Tony, hello."

He did not speak. He looked over my shoulder into my car, then at me and backed away. It was a terrifying sight. Clearly dying and clearly desperate, he seemed disoriented and lost. Only his familiar crooked grin gave me the sense he knew who he was.

He kept backing away, then turned and seemed to be heading toward his car. Getting into mine I watched him instead climb the hill behind the parking lot and walk along its ridge.

Staring through my rearview mirror at him wandering around in the grass and weeds, I remembered when the world was his oyster and it seemed nothing could stand in his way; a book with such a beautiful cover on whose pages were most likely written crippling and indelible words of shame and guilt.

STELLA ADLER

"**Y**ou will arrive on time. You will not be late!"

So read the postscript on a note from Stella Adler, the legendary acting teacher, inviting me for tea at her house on Sunshine Drive in Los Angeles. It had come as a result of a tribute I'd been asked to pay her from the stage of the Mark Taper Forum in downtown L.A. in 1990. Earlier in the year I had narrated a PBS special on her life and work. Having then read her book *Truth in Acting* and found it exactly mirrored my thoughts on the subject, I readily agreed to speak.

My comments were brief, succinct, and included an observation that nowhere in the book did she, when discussing the skill, craft, and art of acting, use the words *just be yourself!* This elicited a giant guffaw from Miss Adler, seated front row center. After the ceremony she was surrounded by acolytes and worshippers—Shelley Winters, Roddy McDowall, Gordon Davidson, among them; but I decided not to join the throng.

It was several days later when the invitation arrived on deep blue stationery bordered in an even deeper blue trim. It was ostensibly a summons disguised as a thank-you note, so I set out on the appointed day from Pacific Palisades, where I was renting a house with a wife, two kids, a cat, a dog, and some birds.

As I made my way along Mulholland, I looked at the gas

gauge—just about empty. I would be late. I was about to displease the great lady before having actually met her.

I turned left on Laurel Canyon heading toward the Valley, taking my foot off the pedal and coasting down to a heaven-sent gas station at the bottom. Quick fill and I pulled up moments before my audience with Her Highness.

I would need no help in locating her, having smelled her perfume from the driveway the moment I opened the car door. I was then ushered into a small sunny room where she was sitting upright, hands crossed, resting on her lap, dressed in a pantsuit the color as bright as the lips, her strapless top revealing a good deal of décolletage. She was, at the time, eighty-eight years old; not ever, it would seem, the thought crossing her mind.

"Sit down."

"Thank you, Miss Adler."

"Stella, dear. Stella."

Stella Adler had an iconic stature as an acting teacher in New York. She was, after all, from an iconic family. Her father and brother, Jacob and Luther, were stars of the Yiddish theatre in New York. She grew up steeped in its traditions and was herself a formidable young actress. She had a daughter, whom she named Ellen Adler, married Harold Clurman, a brilliant critic and devotee of the theatre, divorced and married again. She is reputed to have said to the imposing Clurman, who ranted and raved in his sleep:

"Harold. Don't sleep like a great man. Just sleep!"

I had been a great admirer of Mr. Clurman's since I first came to New York. He was the author of one of the finest books on a life in the theater I have ever read. It's called *The Fervent Years*.

"Tell me about him," I once said to Stella.

"He saw all," she said. "One night I was going on about Mike Nichols's extraodinary early success. 'Harold,' I said, 'isn't it remarkable how successful Mike Nichols has become?'

"'He is not a success.' Harold said.

"'What do you mean? He's won a half-dozen Tonys, an Oscar or two, *Barefoot in the Park*, *Who's Afraid of Virginia Woolf*, *The Graduate*. Everything he touches turns to gold, how can you say he's not a success?' I must confess I thought he was jealous, but I underestimated him. He looked at me and said again, 'He's not a success.'

"'Why not?'

"'Because he hasn't had a failure yet.'"

When I told Mike that story recently, shortly after his eightieth birthday, he ruminated for a moment, then said, "Absolutely correct."

My visits with Stella were less than a dozen, but from them I gained a great deal. Mostly an affirmation of the pragmatic and hard-working approach I have always believed the art of acting requires. Inspiration, she believed, as do I, comes from hard work and discipline. Not an indulgence of the actor's personal neurosis.

In work, she was convinced the thing most needed to keep the spirit alive was curiosity. She was constantly researching and reading and studying. And she valued highly the notion of acting with skill, style, and imagination, but always, *always* in truth. She abhorred The Method, which she felt had nothing to do with the art of acting. She preached imagination not masturbation.

I told her I thought Marlon Brando, once her student, was the great film actor of the twentieth century. "You're right,"

she said, "but you don't want to meet him, dear. That way lies madness." I would have been perfectly happy to risk my sanity.

———————

Earthy glamour was Stella's style. She was fond of theatrical entrances and exits and I found her grandiosity a welcome manifestation of her unique persona. "You can be as phony as you like in life," she was fond of saying, "but *never* on the stage."

That sharp persona was beginning to fray by the time we were becoming acquainted. In one of our last visits one afternoon, she was looking out her window on Sunshine Drive and sighed:

"There is nowhere to go for culture here—no inspiration. You take a walk and all you see are flowers—*showing off*." She then turned from the window, looked at me with wonderment, leaned forward, took my hand, and said:

"Darling, we've been sitting here for several hours now, talking about the theatre, haven't we?"

"Yes."

"We've been discussing the art of acting, haven't we?"

"Yes."

"And we've been discussing Strindberg and Ibsen and Chekov, haven't we?"

"Yes."

"Well darling, I hope you don't mind, but may I ask—*who are you?*"

"It's Frank," I said. "Frank Langella."

"Of course it is," she said quickly, "it's just that you've lost a lot of weight."

———————

Before her final decline, she came to see me in a play in New York and we had a light supper in her apartment afterward. The production was an atrocity and my performance less than my best. She made no comment, but handed me a music box and said: "Keep this near you. Wind it up and let it soothe."

At a posthumous tribute to her on the stage of the Mark Taper Forum in Los Angeles, I wound it up tight and read a love letter to her from Harold Clurman. A bit of theatrics I think she would have appreciated.

That night in her apartment, along with the box, she gave me an even greater gift.

Having watched my mediocre performance, she kissed me good night and said: "Well that's over and done. Now we move on!"

CAMERON MITCHELL

"That was the one."

"We're cooking now."

"Put that one in the time capsule!"

These were among the many superlatives the actor Cameron Mitchell would shout out after another mediocre scene in a ghastly television series entitled *Swiss Family Robinson* in which he played a sailor marooned on their island.

The series was produced by a schlockmeister named Irwin Allen, famous for huge hit films like *The Towering Inferno* and *The Poseidon Adventure*. There was nothing, however, to recommend *Swiss Family Robinson*. It was television at its worst. Conveyor belt cheap, it ran for twenty episodes in the 1975–76 season and hopefully is now and forever lost at sea.

I was invited to do a two-episode arc playing Jean LaFitte, the pirate, the lure being a promise of my own series; but a wasted two weeks of my life wearing a false mustache and embarrassingly falling upon my aluminum sword.

Cameron had been a good-looking leading man in the 1950s, making his Broadway debut as Happy in *Death of a Salesman*, doing the film version and starring in first-rate movies with James Cagney, Clark Gable, and Doris Day.

He was now fifty-eight, a fat, jowly mess, covering his sad decline with an over-the-top wisecracking demeanor; its most heartbreaking manifestation its constancy. From the moment he came on the set everything was just *super* and *terrific* and

fantastic. His superlatives were mostly ignored by the cast and crew as he spewed them out ad nauseam to no one in particular. It was as if he dare not sit silent for a moment lest he face the depths to which he had descended. Actors who get thrown on the junk heap of our profession enter a purgatory made all the more painful by the glory that once was. And a manifestation of that glory in Cameron's case turned out to be a costume period jacket.

It was hanging on the back of my camp chair. As Cam sat next to me, eyes closed, hands on his belly, snoring, a wardrobe lady came over, picked it up, and held it out for me.

"They're ready for you, Frank," she said.

The jacket was one of a half dozen I'd tried on from the stockpile of period clothes kept on studio lots. Beautifully made, blue, as I remember, with braiding and epaulets; inside, it had a vintage sewn-in label.

"Look," I said to the wardrobe lady, "the label's got Cam's name on it."

It read: "Cameron Mitchell" and the name of the film. My guess is that it might have been from a 1954 film he did with Marlon Brando called *Desirée*.

He was slowly coming awake and about to put on his own costume jacket, when she said in a loud clueless voice, "Hey Cam, look at this." She walked over to him and held it up. "Must be twenty years ago."

He was not yet up to his bravura self and hardly registered what was happening. "Let's see if it still fits," she said.

A little group gathered round as she came up behind him, held it up, and slipped in one of his arms. Before he could protest she was pulling in his other arm and yanking the jacket up to his shoulders. People were laughing and turning him around like a top as he awkwardly modeled it for us.

Then his set persona kicked in and he began to spin around,

hold his arms out, and do a little *yo ho yo ho* strut. The laughter grew louder as he performed a kind of ridiculous jig in this period jacket now at least two sizes too small for him, making silly noises, kicking up his feet, like a vaudeville clown getting ready to throw a pie.

Everyone thought it was hilarious and seemed not to notice that, with each spin, his face grew redder and redder and his expression more and more frantic.

I walked over to him and waited for his spin to slow down. It did, and he faced me. I then said, "They need me on the set, Cam." He silently turned around and I gently pulled the jacket from his shoulders. Once it had passed his wrists he moved quickly away toward his trailer, climbed in, and closed the door. As the dresser put it back on me she said: "He's such a good sport."

The year he died, his face came up on the television screen at the Academy Awards ceremony during the *In Memoriam* section, and I remembered an overweight actor doing a desperate dance trapped in a constricting jacket that had once been tailor-made for him. His name was greeted by a smattering of applause from a room full of people no doubt misguidedly confident that what they were wearing on that particular occasion was forever going to fit.

TIP O'NEILL

Big guy! Nose, hands, belly—big!

I never really knew what a twinkle was until I met Tip O'Neill—but the look in his eyes as he greeted me could only be described with that St. Nick cliché. Along with his ruddy cheeks, red nose, and charm to spare, Mr. Claus morphed into the Speaker of the House.

We were in Washington, D.C., on a rainy day in 1992. The Speaker had agreed to a cameo role in a political comedy I was doing entitled *Dave*. The scene required him to stop me getting into a taxi, say a few lines, and leave. A piece of cake. The crew was not ready, so we were settled into a coffee shop near the set.

He took off his trench coat as several actors and assistants gathered round him, pushing a few small tables for two together to form a little circle. He was at its center and held that spot for several hours, being watched over by a female handler right out of central casting; blond, eyeglasses, sensibly suited, sterile demeanor; but thankfully unobtrusive once we were introduced.

The gathering dwindled to just him and me, but he needed very little prodding to keep the conversation going. A lifetime of politics had taught him instant camaraderie and given his endless cache of anecdotes, I remained his captivated listener.

Ninteen ninety-two. It was Clinton vs. Bush and the election was imminent.

On Bush:

"As a member of the House of Representatives, the guy spent nine and a half minutes on the floor and nine hours at the gym. The day he got elected president, my wife Millie was lying in a hospital sick as a dog. Barbara made a call and Millie got the royal treatment."

"Bush thinks the presidency was willed to him. He thinks it's his divine right. This time he's gonna be miserable if he loses and miserable if he wins. If he does win, he'll gloat. Barbara told me it's his nature."

On Clinton:

"The guy's a genius. I like him. Women go wet. Met him four years ago with a friend of my daughter. She said, 'Tip, meet the next president.'"

On limited terms for senators and representatives:

"A stupid idea. The staffs will be running Washington."

On Truman:

"My favorite guy. Got to know him toward the end. Loved him. Loved him. *That* was a president."

On his health:

"I'm wearing a colostomy bag. Look at my teeth—black from radiation. Chemo didn't bother me. I got cancer at seventy-five. I wanted to live. I'm eighty now."

———

On being an actor:

"I did *Cheers* and it went from sixtieth to first place."

This he repeated several times during the course of the morning.

"I did *Silver Spoons* too."

———

He was thoroughly engaging and never at any time did he seem unhappy to be where he was—he could play beautifully to an audience of any size and was of course used to being the Star. Until we got on camera. The Speaker was to stop me, say two or three lines, and exit the shot. We rehearsed it a few times. His only objection was to the use of the word *stroke*.

"It's too offensive."

He was powdered and ready to roll. The word *action* can freeze even the most experienced of professionals, and it froze the Speaker.

This charming, affable man became tongue-tied and wide-eyed when the clapper sounded. His lines, tailored for him, seemed forced and unnatural. After a couple of takes, I asked the director, Ivan Reitman, to just let the camera roll, and we started to chat again as if we were in the restaurant and then I casually asked him to say his first line to me. He did. I responded. He said the next line. We got it. Ivan said, "Cut. Thank you, sir."

"We got it?" he asked with a large beaming smile. "Well, that was easy."

We all gathered round him for pictures and he posed happily, his affable charm returning; the deer-in-the-headlights look gone.

I knew I would most likely be forgotten in the Speaker's memory by lunch—one of the thousands he had regaled over the years. And that mattered not at all. It was a profound pleasure to spend four hours with him. However practiced the rhetoric, there was a genuine sense of the original thinker about the man. He didn't have the perfect haircut or the polished all-purpose, politically correct drone and seemed to have no fear of being disliked. This was not a politician out of central casting. Maybe you had to be eighty or to have begun at a time when it was your very uniqueness that moved you to the top; Tip O'Neill was in a class with Harry S. Truman, Barry Goldwater, Thurgood Marshall, Lyndon Johnson, Franklin Roosevelt—clever, ruthless, charming sons-of-bitches.

After most everyone had drifted away, I thanked him for the morning chat and for being in the film.

"Nothing to it, my boy," he said with a wink as the blond lady led him away. "It was a piece of cake!"

DINAH SHORE

I'm not completely certain why I happened to call Dinah Shore a few days after I appeared on her daytime talk show sometime in the early 1970s, but I'm glad I did.

"I'd like to send you a new Joan Baez album," I said. "It's called *Diamonds and Rust*."

A note came back:

"Thank you. Oh, if I could only sing like that."

Dinah was one of the most popular women on television for a very long time; after appearing in a few minor movies, she went on to host one of the most successful variety shows on television. She survived a ludicrous scandal suggesting she had Negro blood in her; had secretly given birth to a black baby in the 1950s; and even the rumor that she was gay. That one mostly because of her devotion to the yearly Dinah Shore Golf Tournament which to this day attracts a considerable number of lesbians.

Married to a strappingly handsome actor named George Montgomery and the mother of two, she eventually divorced him and years later she and the actor Burt Reynolds became the Brad and Angelina of their day. When we met she was fifty-four, still lovely and seductively southern.

Fresh from the end of her affair with Burt, she was somewhat fragile, but there was a core strength and optimism in

her that made her consistently great company. Very comfortable around men, she quietly built her own television empire, handling the male-dominated industry with easy grace; and loved to play golf with the big boys, getting what she wanted most of the time. Never shrill or outwardly demanding, she was able to charm just about anybody, with all the greats of that era appearing on her talk show. She had a long, profitable, and elegant reign.

"Call her again, Frankie," said my friend Annie Bancroft. "She'll treat you like a king."

I had a little house, my first, that I'd just bought in Wilton, Connecticut, for the exorbitant sum of $69,000 and was fixing it up. For the next few months when she was in town, Dinah would come up with a chauffeur in the afternoons and I would drive her back to the Waldorf Towers in the early morning hours. To this day, I don't know how she did it, but she was able to cook a fantastic meal out of whatever ingredients were in my house. We never went to a restaurant or a premiere. I had no interest in being the next Burt and I think ultimately hurt her feelings by not wanting us to be seen as a couple.

This Tennessee-born woman was, however, a lovely interlude in my life, showing me enormous respect and genuine interest. My little house had, as its best feature, a big stone fireplace and we spent many hours in front of it listening to *Diamonds and Rust*.

Never once did I hear her say a negative word about Burt or her ex-husband or anyone for that matter. She pulled her knees to her chest, ran her fingers through her hair, and talked profoundly about inner strength and personal courage. She believed you made your own way in this world and any idea that because you were a woman you couldn't climb as high as you liked was ridiculous to her. A trail-blazing Renaissance

lady who also loved to look after a man. If there was a load of laundry in the basket, she did it. She cleaned up the dishes, washed down the sink in the bathroom, and made the bed before we headed back to the city.

And she did it for no other reason than the personal pride she took in doing everything the right way, making you feel she was there for you, because of you, but would never allow her essential persona to be subsumed by you. Dinah was an extraordinary example to me of what a woman can accomplish without a man and still retain her femininity. She had, without ever demanding it, real power.

It would not have mattered to me if she was one-tenth black, or all black, or a golf-club-wielding dyke. She was a person of soft and southern demeanor, full of integrity and honest curiosity. Attractive in either gender.

One night by the fire she asked me why I'd bought the little house in the woods. I told her I was reclusive by nature and liked coming there to retreat. "Retreat from what?" she asked.

In the most gentle and nonjudgmental way she then patiently lectured me on the subject of fear. Its corrosive power and its uselessness; and that conquering it was the single most important factor in how anyone should conduct their life.

"Nobody's gonna come up, knock on your door, and drag you outta here," she said. "I think you have to figure out what you're hiding from."

I bristled, and dismissed her insight, not yet ready at thirty-three to absorb her wisdom. Ultimately she gently and gracefully pulled away from me. She needed a better man than I was at the time. My loss.

GILBERT ROLAND,
RICARDO MONTALBAN, *and*
YVONNE DE CARLO

In 1974, when I met them, Gilbert Roland was sixty-nine, Ricardo Montalban fifty-four, and Yvonne De Carlo fifty-two. I was a measly thirty-six. We were to spend about five weeks together shooting a remake of *The Mark of Zorro* for television. I would play Don Diego Rivera, aka Zorro, a part that had been made famous by both Douglas Fairbanks and Tyrone Power.

Born in Mexico, Gilbert, having started in silent films, was a genuine movie star of the Latin-lover, sloe-eyed-smoothie type. He would be playing my father. Ricardo, a serviceable Latin-lover wannabe who'd partnered many of the leading ladies of his time, often backstroking alongside swimming star Esther Williams in B movies of the 1950s, would play the sheriff. Bringing up the rear, playing my mother, was Yvonne, who had been a bona fide B-movie queen of the sultry, spitfire variety generating enough testosterone for the four of us.

"You think he's too young to fuck me?" Yvonne said to Gil, putting her arm in mine on the first day.

"Well I'm not too old," he said. Ricardo was desperately on the phone nearby, trying to secure a contract as spokesman for Chrysler cars on television. He landed it and eventually became ruthlessly imitated by every late-night T.V. host say-

ing, in the heavily rolled-*r*'s Montalban style, "Corrrrinthian leather." Several years later, he would star in the famous long-running TV series *Fantasy Island*.

Yvonne had hit a certain kind of paydirt as Lily on the TV series *The Munsters* from 1964 to 1966, and went on to introduce the iconic song "I'm Still Here" in the 1971 Broadway production of *Follies*. For the rest of her career, she valiantly struggled through mediocre film and television projects, and Gilbert rested on his former fame in grand old movie star style, making rare guest appearances on television.

"I fucked them all, you know," Gil said, as we sat on canvas chairs outside his trailer on a hill in Tucson, Arizona. He then proceeded to give me a rundown of his specialties, detailing the sexual peccadilloes of every female star I'd grown up with. In a completely dry and analytical style he'd report:

"First I . . . for a little while. Then I . . . Then I . . . And then . . . !" He was so matter-of-fact and businesslike about it that I began to laugh hysterically as he described sex acts the way one man might tell another the order in which to oil, polish, lube, and wash his car. The more I laughed, the more explicit he became, not once cracking even the slightest smile. With one arthritic, distended, misshapen hand wrapped in a silk scarf, and explicitly gesticulating with the other, he regaled me with scenes of sexual acts in which he costarred with some of the most famous women in the world.

Even more hilarious were stories of acts declined on nights before early morning close-ups. "Those cunts," he said, "I told them it's good for the skin. And you know, Frank, the purer they were onscreen, the more of a whore they were in bed. And *really* beautiful women are lousy sex."

An assistant director ran up the hill calling out, "Gil, would it be okay, since you're sitting out here talking to Frank, if I used your trailer to change two extras real quick?"

"Roland dresses with no one," he intoned.

As the guy slunk away, Gil turned to me and said:

"I have to do that. It's expected of me."

No smile! No irony! He just stared at me in regal grandeur. His acting too was of that style: stoic, sincere, corny. He was grand, imperious, and totally engaging; appearing always to have just flung back a tent flap after ravishing a maiden and heading for his horse. I just loved every moment I could grab with him.

———

Ricardo was Gil, made in Japan. A studied, empty vessel, concerned only with his profile and his panache. He managed to maintain a solid career, even as he was burdened with one crippled leg which he artfully kept concealed from the camera. Once in front of it, he was completely prepared, professional, and staggeringly boring. But a decent man protecting his franchise. Many years later, when I ran into him at a drugstore in L.A. and asked, "How are you, Ricardo?" he looked at me, raised his chin, and said:

"Still doing crrrap," rolling his r's in the Corrrinthian tradition.

———

Yvonne turned out to be the real gunslinger of the trio. Playing her role warmly and shyly, totally against type, she was by far the best actor, and the most committed of the three. On the set she was bawdy and provocative until the camera rolled. Then she became a warm and caring mamma; but with

a healthy set of balls. "Again?" she'd say to the director when he asked for another take. "What the fuck for? We got it."

When the day was over, she wanted some action, and she was determined that we should perform a certain sex act, or, more specifically, that *she* should perform a certain sex act, to which she was convinced I would give a standing ovation. She treated me like a pretty girl in the back seat of a convertible on a hot summer night on a college campus. "What's the big deal, baby? Come on, just give it up. Close your eyes and think of somebody else, I don't give a shit."

We were, after all, on the road. So late one steamy night in my motel room at the foot of my cast iron bed, she stood with a Scotch in her hand, happy and satisfied.

And then at my request she performed an encore. This time in song. I was given my own private rendition of "I'm Still Here."

There was an infectious nobility about these three people. They knew the score, fiercely played the game, and took no prisoners. All of them, in fact, managed admirably to stay afloat and tread water in the fluctuating currents actors swim. And all three survived for decades; creatures of eras long gone whom I still think of with great fondness. Totally original personalities, keeping up appearances, resisting the pull of the "I'm just a regular person" propaganda that has come after them.

In years to come, I would refer to Mom, Pop, and the Sheriff as my three caballeros. Tough old birds they were! Both men hanging on to eighty-nine, and Yvonne still there till eighty-five. There is, after all, no matter the goal, something to be said for perseverance.

JACQUELINE KENNEDY ONASSIS

I did two extraordinarily stupid things to Jackie. The first was forgivable. The second was not.

———

We were both weekend guests at Paul and Bunny Mellon's house in Cape Cod, Massachusetts. It was the summer of 1968. Sitting one night on a Syrie Maugham couch in their living room when everyone else had gone to bed, we were nursing our wine and talking about a two-week run I had just completed opposite Anne Bancroft in *A Cry of Players* by William Gibson at the Berkshire Theatre Festival in Stockbridge. I told Jackie that we'd had an odd incident one night at the theatre.

"Bill wrote a memoir and in it he said things that offended some cousins of his and was receiving threatening phone calls, so we hadn't seen him at the theatre for several days. Annie and I decided after one performance to drive over to the Gibson home to see what was going on. We drove down the long dirt road to their house, and as we got closer, we saw there were no lights on—none. It was pitch black. Not even the usual small walkway lights leading to the steps. I pulled the car around into the driveway and the second I turned off the lights and cut the motor, my door was flung open, a hand reached in,

grabbed my neck, and a gun was put right at my temple. The same thing happened to Annie on the passenger side. We both froze and the guy by me said, 'FBI. Identify yourself. Who are you? What are you doing here?'

"I said we were actors in Mr. Gibson's play and were worried about him. Annie said she was so scared she almost burst out, 'Anna Maria Italiano from Class 2B2' as if she were still six years old."

But Jackie did not laugh. She was looking at me intently, completely calm and relaxed. It was only then that I realized in the heat of my story, I had animatedly raised my hand in the shape of a gun and was pressing my finger against her temple. There was maybe a split second of silence and I lowered my hand.

"That must have been very scary for you both," she said.

Jackie and I were not far apart in age. She was just nine years my senior. But our backgrounds could not have been more dissimilar. She was born in Southampton, New York; I in Bayonne, New Jersey. Jackie had been raised always knowing the right thing to do and the right thing to say. I, on the other hand, had been raised by a pack of Italian wolves who hadn't known a demitasse from a debutante. And this debutante very gracefully handled what had been a totally stupid but unconscious blunder on my part. A woman with an unerring sense of control and discipline.

Shy is one of the words most often used to describe Jacqueline Kennedy Onassis. But that is not the woman I knew. *Canny*, it seems to me, would be more appropriate. She was certainly shrewd enough to choose Bunny Mellon as one of her closest friends and confidantes; a woman she knew would never betray her and who lived in rarefied and private king-

doms provided by the limitless wealth of her husband, bank-
ing heir Paul Mellon. It was in the two particular kingdoms
of Antigua in the British West Indies and Cape Cod that my
relationship with Jackie flourished, beginning in the immedi-
ate years following her husband's assassination.

The days and nights on Cape Cod were lazy and luxuri-
ous. Rarely did any of us have breakfast together formally, but
when Bunny's door was open we might end up sitting on her
bed or the beautiful couches and chairs in her room looking
out over the water, playing someone's favorite song or reading
magazines. Jackie was always barefoot, without makeup, and
up for anything. We drove into town or had lunch down by
the dock, or wandered next door to the "Dune House" that
Bunny had built for herself. A gorgeous path of high dune
grass led to this white and gray small house. It was completely
appointed, as if constantly lived in, but was there only as one
of Bunny's projects, a "hideaway" a hundred yards away from
the Main House.

The Mellons' world was my first taste of a life where
money is truly no object and Jackie was the first but not the
only woman I've known for whom money is an aphrodisiac.
I rarely, if ever, saw her carrying multiple shopping bags or
taking things off racks or shelves, but I witnessed her quietly
point, indicate, and say "there" about sweaters in all colors,
pots and pans, candles, pillows, dishes, and furniture when
we went shopping. I once quietly calculated $50,000 worth
of purchases in twenty minutes, but Jackie signed nothing and
left empty-handed.

She was certainly not empty-handed when it came to jew-
elry. One late afternoon I came upon her and Bunny laughing
like hyenas in a little silo-like studio on the grounds of the
Cape House, another of Bunny's hideaways used to paint or

write. They were both sitting on the floor surrounded by small and large gift boxes with tiny white cards scattered nearby. Their ears, fingers, wrists, and throats were covered with what seemed to be several million dollars' worth of watches, rings, bracelets, and necklaces in emeralds, rubies, diamonds, pearls, etc. On each of their heads sat a few tiaras. A good deal of it was sent from Aristotle Onassis to Jackie during the period he was trying to persuade her to marry him.

As I stood in the doorway, staring down at them, Jackie looked up at me and said: "See anything you like, Frank?"

"You could sail around the world on just one of those baubles," I said.

They sat there, giggling like schoolgirls, exchanging rings, tiaras, and necklaces like so many pieces of penny candy.

"I don't know what to do with all this stuff," Jackie said.

It appeared to mean absolutely nothing to her as she began taking it off and throwing it into a large velvet bag. She then tossed the bag into a larger canvas one, got up, and said, "Well, now I have to go and write a thank-you note to the pope."

Jackie's public image was certainly of an unadorned woman.

No "dripping in diamonds" look for her. And at the Cape she was lovely. Clean-scrubbed face in the mornings, barefoot, simple shift dresses, shorts and halters, a large straw carryall always holding a book, a scarf, and some bare essentials. Mostly, though, she carried nothing.

One hot August night at sundown I was tunneling through the tall grass toward the Dune House and, over the sound of the wind, I heard a heavier noise of feet running toward me

and strong breathing. Jackie ran right into me, hair loose and flying, face flushed. She always spoke in that famous, hushed whisper, whether across a table or a room; but the voice had a deep throaty sound to it that made it carry. She came upon me fast and my hands went up to her shoulders, breaking her stride. Beautiful in the dusky light, I'd caught her in one of those moments we all have when we do not expect to be seen. Had she been crying, calculating, or just having a run? I couldn't tell. We sat down in the dune grass.

After a few words about the "magical night" and the "caressing air," she said:

"Why do you suppose they're doing this to Ali MacGraw?"

It was about the time Ali had left the producer Robert Evans for the actor Steve McQueen. "They just hate her now. Why?"

"She was the golden girl who fell off the pedestal," I said.

"But nobody has the right to do that. They should leave her alone." She fell silent and stared out toward the water.

"Do you want to talk?" I said.

"No." It was dark now, only the sway of the dune grass and the gentle lapping of the water.

"We better get back now," she said. "I'll go first."

———

Those Cape days and nights all blend into one another now. As do the conversations and games, hellos and good-byes, and the reminder that I was, when there, living a kind of storied life. I would return to my four-flight walk-up on 61st and Third in New York and pursue my acting career. Then again hop in a waiting limo, go to the Mellon private plane, arrive, met by a limo, go to the house, unpack in my room, and join the privileged.

If the Cape was a simple and basic lifestyle, the Mellon house in Antigua was exotic and sultry. Giant yucca plants, swaying palms, and air like in no other place I'd ever been. It soothed your skin and made you feel constantly caressed and stroked. I spent a number of my birthdays (January 1) there. Usually flying down around December 26 and staying for one or two weeks. Jackie was often there and at other visits during the winter months.

The guest rooms were slightly away from the main residence down by the pool, which overlooked the Caribbean. Next to the pool was a little house with French doors, decorated as impeccably as the main house, with oversized couches and chairs in sailcloth fabrics. It was in that little house that we would often have dessert.

Antigua was hot in the day and warm at night. All senses heightened there. We would often take midnight swims and lie under the stars in silence. Jackie always occupied the same room overlooking the pool; mine changed according to houseguests but was often next to hers with a little back corridor adjoining them. She was an avid reader and we left books in each other's rooms at night. Sometimes she'd leave a sticker in a page of poems for me to read. One book we shared over a particular visit contained a collection of love letters written by English monarchs to their lovers and husbands, and Jackie particularly liked a letter written by Victoria to Albert showing such passion and adoration that Victoria sounded as if she were a teenage girl. She was, in fact, an old lady when she wrote it, and Albert had long been dead.

John F. Kennedy was assassinated in 1963, Robert Kennedy murdered in June 1968, and Jackie married Aristotle Onassis in October of that year. When she married him, she took John-John and Caroline to a huge private jet to fly off to the wedding. Bunny accompanied her to the airport. She told me that when they got on the giant empty plane sent by Onassis, the kids ran up and down the aisles. Jackie said, "Your seats are 6D and 6B. Keep them during the trip."

"She understood discipline and boundaries," Bunny said. "She was a wonderful mother. 'Why are you doing this,' I asked her."

"I have no choice," Jackie said. "They're playing Ten Little Indians. I don't want to be next."

Clearly Onassis was going to be the bodyguard, but it was Jackie who would be put on salary.

———————

I never asked Bunny to reveal any more about her friend than she wanted to tell me, and I never asked Jackie any questions about her husbands. It would have been pointless. She was a woman extremely skilled in the art of mystery and allure. Never unguarded, never tears. One night, years after her death, a male friend and I were talking about her and he told me that after the night they'd been together she sent her driver with a small brown paper package tied with string. It was the nightgown she'd worn.

"What did she expect me to do with it?" he said.

———————

In private she was good company, but in public she was a genius. Everywhere we went she was mobbed. One afternoon we flew on a puddle-jumper to Martinique to shop and have lunch at a small restaurant. Bunny made certain Jackie and I were never photographed sitting next to each other. When we came out of the restaurant, the little square was jammed and the local police had to muscle her to the car. Her radiant smile intact, she moved through the crowd slowly, eyes unfocused and enigmatic. Once back on the plane, she settled into a quiet sleep.

When we swam in the sea in the day, she never got up too near. We'd tread water and talk from several feet away and if I swam close she gently drifted away, not wanting a long lens to capture us in the water.

———————

The second stupid thing I did to Jackie was unforgivable. A lot of wine had been consumed and I fell asleep in the small pool house. I woke up to the sound of the birds chirping. The French doors were wide open and little banana twits were landing and picking up bits of food from our late-night snack. When I looked out, Jackie was lying on a chaise in the early morning sunlight, her eyes closed. I crept up slowly and stared at her face. In repose her features were hard and strong, but still lovely. No makeup, hair damp.

I leaned in close and, like an idiot, said, *"Boo!"*

She leapt up so fast and let out a shout so loud I was completely caught off balance; and what should have disabled us in laughter became a quiet standoff, neither of us speaking. She looked down at the patio floor for a long time and seemed to be waiting for her heart to stop beating so quickly.

"Jackie, I'm so sorry," I said.

She didn't answer me or look up at me. She was in a private place, calling on her enormous will to calm the terror that I had stupidly provoked. Then she reached down, picked up her things, and passed me with just the faintest smile. I didn't see her for the rest of the morning, but at lunch she warmly touched my arm before we sat down as if nothing had happened.

My favorite memory of Jackie was actually a public one. One afternoon at lunch in Antigua, one of the many wonderful local women who worked and lived on the property came out and whispered to Bunny that the cook was feeling poorly and she was worried about her.

Bunny said, "You must tell her to go and lie down."

"Thank you, ma'am," she said.

This particular lunch was just Bunny, Jackie, and me and we all got up and went into the kitchen to see how she was. The moment we looked at her, we knew she had what the natives called "the color." She was quite jaundiced.

"You go right away to bed, Cora," Bunny said.

We returned to the dining table and Jackie said:

"We all better get a shot," as calm as could be.

I drove us into town in an open Jeep to the small clinic Bunny had helped organize for the locals. We stood in line on the steps leading to the porch as one by one the doctor gave us a shot of gamma globulin. When I came out of the clinic, Jackie was sitting on the steps with a beautiful local child on her lap; she had removed her scarf and was tying and untying it around the little girl's head, as the child's mother sat on the ground nearby. The child scampered off her lap and went

back to her mother to show off her present. Jackie sat smiling, holding her knees. Even with the possible threat of jaundice hanging over her, she seemed utterly relaxed and content.

Back in the car we were laughing about who was going to turn yellow first and should we coordinate our clothes at dinner to whatever shade we turned. The cook and the rest of the staff were all given shots. She recovered fully and thankfully the rest of us were spared.

———————————

It was only in Antigua and the Cape that I spent private time with Jackie. I almost never saw her in New York except occasionally at a small restaurant in the East '90s called Sarabeth's. Ari was dead. It was 1985 or so. I was now married with two small kids and she'd settled into her New York life as an editor and lived with financier Maurice Tempelsman. One wintry afternoon I ran into her on 86th Street, just around the corner from her Fifth Avenue apartment. We stood in the nearby doorway of the service entrance; her tucked inside, my back to the street, arms folded in front of me to keep warm. She rested her hands on them.

"You've made a great success," she said. "I've seen you in your plays."

"Why don't you ever come backstage?" I asked.

"Oh, you're too famous for me now," she said.

When I got home to our new apartment on 83rd and Madison, my wife told me that Bunny Mellon had just called. It had been a while since I talked to her. I called back.

"What a coincidence," I said. "I just ran into Jackie."

"Oh really?" she said. "Why don't we go to her Christmas party together. I'm sure she'd love to have you."

"Can I bring my new wife?"

"Was that your wife I spoke to?" she asked.

"Yes," I said.

"Oh, there's my private line. I'll call you back."

She never did. And I never saw Jackie again.

———————

During the time I spent with her, Jackie was arguably the most famous woman in the world and in complete charge of both her public and private personas. There was nothing of the victim about her. Nothing remotely fragile or tentative. My feeling was always that she relished her fame, her power, and her mystery, and knew exactly how to market and exploit it. Fate had intervened in what might have been the normal privileged life of an attractive, well-mannered, educated young woman and catapulted her to the center of the world stage. And she was going to rule her place on that stage whether as First Lady, the wife of a tycoon, or a book editor at a publishing house. She possessed an enormous inner strength and steely surety that had little to do with, it seems to me, where fate had brought her. Jackie, as I knew her, would have done just fine no matter where she landed. Like the small-town magician whose balloon took him off course and drifted down into the Land of Oz, Jacqueline Kennedy Onassis enthusiastically embraced the role of Wizard bestowed upon her by the populace and made the most of it.

Unlike him, though, Jackie was equally adept both in front of and behind the curtain. Her face could go from that famous radiant smile to solemn and blank in a second. Nobody was better at playing dumb than Jackie when she wanted to.

One afternoon, shortly before she married Ari, she, Bunny, Liza, and I were having lunch at a tiny restaurant in Hyannis. Jackie was without makeup or jewelry and dressed unobtrusively in a simple top and slacks. We had come in unannounced and all the proprietor could provide was a table in the back next to the kitchen. She was perfectly happy to sit there out of sight of most of the patrons.

We were in happy, animated conversation when a man passed by on his way to the restroom. He stopped, turned around, and came back to the table. "Aren't you Jackie Kennedy?" he said.

"Am I?" she answered.

"You are! I know you are!"

"Well then, you didn't have to ask, did you?"

She was not impolite, rude, or dismissive. Her face, however, was dark and impassive. The man grew uncomfortable but seemed frozen in his place, staring at her. Jackie offered nothing. He then made to leave, saying: "Oh, I'm sure it's you. I'd bet anything."

"Well," she said, "when you find out, let me know."

After she died, I rummaged around in my memorabilia for a small item she'd given me on the Mellon plane coming back from one of those idyllic trips, but never found it. She was walking up the aisle back from the john and plopped down next to me.

"You know, I don't have any way of getting in touch with

you other than through Bunny," I said. She reached into her bag, pulled out a small white matchbook, and wrote on it "J," and a phone number, stuck it in my shirt pocket, then started to leave.

"Don't you want mine?" I asked.

She took out a small leather book, wrote it down, dropped the book in the bag, and said:

"There. Now I've got everybody's number!"

HUME CRONYN *and*
JESSICA TANDY

Married couples, it seems to me, have enough trouble surviving the institution without the extra burden of their names being publicly attached to each other like frozen Popsicle sticks. Hume Cronyn and Jessica Tandy, Alfred Lunt and Lynn Fontanne, Eli Wallach and Anne Jackson, Jerry Stiller and Anne Meara, Anne Bancroft and Mel Brooks—all long-term marriages that somehow thrived and survived the two-for-one sales. Hume and Jessie had a number of advantages. They were wealthy, aristocratic, and equally matched as actors—neither a great, but both highly skilled and intelligent.

In their case, I was fairly certain it was Hume who was the diva and Jessie the go-along. The impression began when I was in college. Sometime in the late 1950s they came touring through Syracuse, New York, where I was attending the university. I don't remember the play. But I do remember getting myself backstage quickly even before their curtain calls had finished and being able from the wings to watch them take their final bows. With my pen and program ready, as the curtain hit the stage, poised to ask for an autograph, the stars were quickly wiped from my eyes as Hume whirled on Jessie and said: "That cannot happen again. Not again!" and came directly toward me. His face was purple with rage as he flew past, unaware of my presence. Marching down a hallway, his

voice echoing behind him: "No, no, no. Disgraceful."

Jessie, dashing not far behind, was calling out, "Please, please, let me explain." He went in and slammed the door as she was coming toward it. She knocked, entered, and the battle raged on.

I left bereft, but at nineteen years old, certain I wanted to be wherever something was that passionately important to someone. I thought they had been wonderful in the play, but magnificent in the hallway.

———————

In the 1977–78 season, the first *I Love NY* commercial was shot and premiered at the now defunct Tavern on the Green restaurant. I closed out the spot as Dracula with the line, "I Love New York! Especially in the evening!" When the lights came up to wild applause, Hume shouted out to the crowd:

"Well, if we'd known we were all going to be supporting Mr. Langella . . ." and then came over and kissed me.

———————

That was the beginning of a lifelong friendship. Once you're inside the New York theatre community, you are a forever member, no matter the exigencies of your career.

One night Hume called and said, "Pick us up after your show and I'll take you to dinner." They were appearing in a big hit, *The Gin Game,* at the John Golden Theatre and I was enjoying playing the Count at the Martin Beck Theatre.

Hume and my former wife were deep in conversation across the table, while Jessie and I started talking about sex in the dressing room. We both agreed it was right up there with a standing ovation. "What are you two laughing about?" Hume asked.

"Nothing, dear. Just sex in the dressing room."

"Sex in the dressing room? Never heard of such a thing."

"Well, you haven't been listening," Jessie said.

That season the four nominees for a Best Actor Tony Award were Hume, Jason Robards, Barnard Hughes, and me. At the ceremony picking up our nomination certificates and taking photos, Hume said, "Well this is a waste of time. We three have all got one. It's Barnie's."

And it was!

I sent Jessie some flowers as a thank-you for handing me an award one afternoon, and she sent this note:

"When are we going to play Hamlet and Gertrude?"

I wrote back: "I'm too old and you're too young." It was only one of dozens of opportunities missed by me over the years.

Late in Jessie's career she became a film star with *Driving Miss Daisy* and won an Oscar. Hume also had a success in the film *Cocoon*, but edgily regarded Don Ameche's winning a Best Supporting Actor Oscar for that film as typical Hollywood Bullshit. "Imagine," he said, "if I had done that backflip."

He was referring to a moment in the film when, having taken a magic potion, all the old men become young again. Don's character, feeling a new energy, gets on the dance floor with Gwen Verdon and performs a stunning backflip. It was, of course, done by a stunt man, with Mr. Ameche afterward in a big close-up, beaming broadly. "That's what did it," said Hume. "The least popular guy on the set wins a fucking Oscar."

But despite his displeasure, never during Jessie's renaissance did he seem anything but delighted for her. Nor do I think he ever took Ameche's win seriously to heart.

A year or so before Jessie's death, she sat in front of me as we watched a terrible performance from one of her contemporaries long past her more youthful skills and desperately trying to recapture them. At intermission, she turned around and I leaned forward. She had a fan in her hand and tapped my arm with it. "You would tell me, darling, wouldn't you?" is all she said. She was age appropriate to the end.

Hume became ill and then reclusive in his final years and all entreaties to come visit him were rebuffed. We had one phone call toward the end. I had sent him a film script in which he would play just one lovely scene. He called: "Frank, darling. How kind of you to think of me. But I'm afraid I could not live up to your expectations."

Not possible. From that night, at nineteen years of age, when I first stood in awe of them backstage in Syracuse, New York (an incident not recalled by either), in my eyes, neither one had ever disappointed. Over and over they come back, giving the theater the integrity and glamour it deserves. How privileged I feel to have seen them live and in person and to have them as role models.

They and their colleagues were all members of an elite generation; including the likes of Jason Robards, George C. Scott, Jo Van Fleet, Kim Stanley, Mildred Dunnock, Irene Worth, Geraldine Page, Colleen Dewhurst, Eli Wallach, Anne Jackson, Maureen Stapleton, Julie Harris, Anne Bancroft, Marian Seldes, Fritz Weaver, Angela Lansbury, Alfred Lunt, Lynn Fontanne, Christopher Plummer, Rosemary Harris, Gwen Verdon, Ethel Merman, Carol Channing, Richard Kiley, Chita Rivera, Alfred Drake, Mary Martin, Tammy Grimes, Barbara Cook, and so many more.

Gallant souls every one of them, and shining examples of an often underappreciated breed: the New York theater actor.

RAUL JULIA

"*G*reat."
 "Oh my God, that's *great*."
"Isn't that *great?*"
"That's just *great!*"

It's incalculable the number of times Raul Julia used that word to describe an event, a person, a feeling, or a thing. And he said it each time with genuine gusto and total commitment. Everything to Raul, it seemed, was *great*.

I may as well confess at the start that I was in love with him. If he were a Puerto Rican woman, he would have been called a spitfire. As a Puerto Rican man he was close to a bonfire and the heat he generated could have comfortably warmed a small country town.

Which, in fact, is where we met for the first time. It was the early seventies at the Williamstown Theatre Festival in Massachusetts, during its halcyon days under the leadership of an irrepressible Greek tyrant named Nikos Psacharopoulos. If you were welcomed into that family, you looked forward to the time in late June when you would throw some scripts, jeans, and a few packs of condoms into a bag and head north on the Taconic Parkway to tackle great roles in whirlwind productions and wrestle as many apprentices as you could into bed: male, female, or both, depending on your proclivities.

To an apprentice, sex with an Equity actor was indeed, splendor in the grass. And most of us did as much mowing as the fresh pastures would allow. It was a glorious time to be in your twenties. For the next two decades carousing through the halls of the Adams Memorial Theater were, among others, Christopher Walken, Sam Waterston, Richard Dreyfuss, Christopher Reeve, Raul, myself, and an equal number of our female contemporaries. Life in Williamstown for actors was idyllic. Serious work and serial sex.

Raul was a stunning young man. Indisputably masculine, with a strong, natural physique that never saw the inside of a gym. He had a massive head with a forest of luxurious, dark hair; his delicious accent, ready laugh, wide-open face with gigantic eyes, made him catnip to the girls. Born and raised in Puerto Rico, surrounded almost completely by women, he accepted their adoration as his birthright.

When he entered charmingly and sinuously into a room or onto a stage, temperatures rose. In this era when most young male stars seem a sexless set of store-bought muscles set below interchangeable screw-top heads with faces of epic blandness—sheep trying to look like bulls—Raul defined real masculinity. His unself-conscious beauty was without compare and it was virtually impossible for him to be mistaken for any other man. If an errant seed of his had managed to fly to Spain on its own and find its way into a local woman, it would have impregnated the mother of today's only candidate for his crown, Javier Bardem.

Appropriately the summer we met, Raul was playing Mack the Knife in *The Threepenny Opera*, trying to be heard above the swoons that wafted through the audience and out onto the grass surrounding the theatre.

We spent only a few times together during that period and

never shared the stage or an apprentice to my knowledge, but went about working our own territories.

It would be twenty years before our friendship began in earnest, when in 1984 George C. Scott cast us opposite each other and Jill Clayburgh in Noel Coward's *Design for Living* in New York. That was when I fell.

As we walked back to my apartment after the first day's read-through of our play, neither of us doing well in films at the time, he said:

"I'm living on loans."

We each had a wife, two children, and a mortgage. We ate something at the kitchen table and talked about the play. My wife was not at home at the time, and in the back of the apartment my kids were laughing and playing in their rooms with a sitter. They were then three and one.

Somehow the conversation turned to underwear.

"I hate boxers," he said. "There's too much material."

"Well, I don't like briefs anymore," I said. "Too confining."

"Oh, well, I found these great ones. Not loose like boxers. They're like a bigger brief with a pouch. Come on, I'll show you."

So into the bathroom we went and he dropped his pants and displayed them. They were indeed tighter than boxers, but lower on the thigh than briefs and designed with a comfortable and sexy pouch.

If he had already sensed I had a crush on him, he was completely unself-conscious and unbothered by our somewhat homoerotic moment. He may as well have been showing me a new tie. As he left my apartment, he said:

"I want us to be friends."

"Me too," I said.

Design for Living was a big hit. During its run when we got together with our families, Raul landed somewhere on a couch, glass in hand, like an immovable stone Buddha, as the rest of us ran around preparing food, wrangling the kids, or cleaning up. His one contribution to the fray would be to hold out his arm, proffer his empty glass, confident that someone would fill it, and return to his leisure. Our children climbed all over him as if he were a human jungle gym and he was a wonderful pied piper until he'd had enough.

"Merel," he called to his wife, "take them away." And they were pulled off him like so many cuddling kittens. It was during that time I nicknamed him "Principessa."

At least four nights a week, Raul and I went out alone together after the show and we usually ended up someplace where he was King. The maitre d' and the waiters would race around doing his bidding, and constantly filling his glass. Bottle after bottle of wine would be consumed followed by a good grappa or port. And at some point, he would rise up and sing, full voice, in his glorious tenor/baritone, to the delight of the stragglers.

Nothing of importance was ever discussed. I stayed sober. He got drunk. He was resolutely closed to any discussion of his drinking and there was no doubt in my mind that had I suggested he slow down, our time together would have ended. When I finally got him home he would say at the door most nights in that irresistible accent:

"Good night, I love you—you are my boyfriend."

Merel was always up, took him from me and put him to

bed where he would remain late into the day. When the play closed, the nightly ritual ended but we stayed in touch.

On a Friday morning one winter weekend he called:

"What are you doing?"

"Nothing."

"You want to come to the farm with me and Barry? Just us."

"Sure."

So a few hours later Raul, myself, and our great friend Barry Primus drove to Raul's farm in upstate New York. Barry, who still, as of this writing, remains a close and dear friend, is an irrepressible guy with a compulsive and infectious personality that usually sets the tone for any gathering. And we three had a bachelor weekend of delicious relaxation.

"There's no food in the house," Raul said. "We better stop and get some sandwiches."

"Take me to the supermarket," I said.

"I don't know where there is one."

We asked around and found it. Raul peered into the market in wonder.

"This is *great*."

We never bathed, nor made a bed or left the house the entire weekend. But it was clear to me that I would have to be the wife. Neither Barry nor Raul had a clue in the kitchen.

I cooked the entire weekend. When the dishes finally ran out I said:

"Raul you wash. Barry you dry."

Standing at the sink, singing opera at the top of his lungs, he stopped and said:

"You know, Merel wants me to get her a dishwasher, but I'm not going to. This is *fun*."

Soon his career took off with *Kiss of the Spider Woman*, for which his costar, William Hurt, won the Oscar. Raul told me that one day in rehearsal, Hector Babenco, the director, asked him and Bill to switch roles as an experiment. It became clear each would be better suited to the other's part. "But Bill," Raul told me "knew he had the greater role and resisted the change."

"I should have played his part," he said, "but I couldn't have done it."

"Why not?"

"It would have been impossible for me to play a *maricón*."

His Puerto Rican background would have made his playing an openly gay man unacceptable to his family. But he was genuinely happy for Bill when he won the Oscar for his performance.

It was during this period that Raul fell under the spell of Werner Erhard and the *est* movement, something I found hilariously absurd. Another guru, another fad appealing to emotional masochists. Following a visit one afternoon to Erhard's backstage dressing room after watching him perform, I spoke vehemently on the way home about what a charlatan I thought he was.

"All I know," said Raul, "is that the more money I give him, the more money I earn."

I kept hammering him about the negative aspects.

"I just don't see what you see," I said.

"That's because you see where you're *at*," he barked.

In the early 1990s I moved my family to L.A. and Raul and I drifted apart again for a time. But we had begun a telephone ritual that we kept up until his death. My phone would ring no matter where I was and it would be Raul.

"Do you know what I said today?"

He was calling me from halfway around the world on a film location.

"What?" I said in earnest anticipation.

"I was on a horse and I had to say to Mel Gibson, 'Get out of town or I'll kill you!'"

Then I would tell him some ludicrous piece of dialogue I had uttered.

And he would start laughing helplessly in his little-boy giggle, "Oh, that's *great*," and we'd hang up.

One night he appeared backstage at a play I was doing at the Music Centre in downtown Los Angeles. My boyfriend was back and we picked up as of old. At dinner he did not drink, ate very little, and was less than communicative. As I was driving him back to his hotel, he said:

"Stop the car, fast," quickly got out and became sick on the sidewalk. As he was bent over, his hands on his knees, I rubbed his shoulder and said:

"Was it my performance?"

"Something I ate."

I called the next day.

"I'm *great*," he said.

Again time passed. In 1994, I was preparing to leave for Malta to start a film. One day the phone rang.

"I'm here. Come and see me."

At eight o'clock that evening I drove to the Beverly Wilshire Hotel and had dinner with the ghost of Raul Julia. He was probably less than one hundred pounds, pale, weak, and subdued. Barry Primus joined us and while we had room service, Raul ate from containers of macrobiotic food. There was no discussion of his illness.

After dinner Barry left and I said to Raul:

"I want to tell you something. A few months ago, I awoke in the middle of the night. I was not dreaming and I was not hallucinating but there were three angels floating over my wife's head—three amorphous golden creatures who peacefully floated above her for one minute or two and then wafted past me and out into the night. As they sailed over me, one beautiful face looked into my eyes and without words said: '*It's time that you believe in us.*'"

Raul listened in silence—but said nothing. We talked about other things and I left. I knew that he was leaving the next morning at 10 a.m. At 7 a.m. I awoke with a start, got dressed, took down a copy of a book I had bought on angels after my experience, inscribed it to Raul and drove to his hotel. He opened the door and said "Hi" as if he had expected me. I gave him the book—"Great," he said. We ate breakfast together in silence, then he put down his fork, looked at me, and said:

"I have been thinking about your angel story. I have been thinking about all the people sitting on the mountaintops waiting to see something—anything—some proof. You haven't got a spiritual bone in your body—but this fucking angel comes and appears to *you*. It is just *great*."

He was up on his feet gesticulating, passionate, happy for me. We embraced, made a promise not to lose track of each

other again, and I took him downstairs and put him in the limo. He was sitting on the edge of the backseat as I stood by the door holding onto his hand. I leaned in to kiss him good-bye; he then slowly moved his emaciated body back into the darkness and disappeared from my sight. When I closed the door and turned into the unforgiving California sunlight, I knew it would be the last time I'd see him. We spoke a week later.

"I read the angel book," he said. "It was *great*."

I had only just arrived in Malta to start my film when I learned of Raul's death. Uncannily, as I hung up the phone his voice was singing out on my tape player. I left my hotel, got a car, and began driving around the city. After parking it I wandered into a large antique shop filled with paintings, and I must have looked at and held up some thirty or forty as the owner told me of their age, period, value, etc. After an hour of this, he said, "I have a sense of your taste now. I have something to show you." We went to a small room upstairs at the back of his shop and he opened the door of a tall cabinet, stood on a chair, moved aside some books, and took down a large white folder.

"I have had this for four years," he said. "It requires a special customer. I think this is for you."

No matter if this was his usual pitch, because as he lifted one side of the folder, I found myself staring incredulously at a painting of a striking Spanish nobleman, beautifully dressed; on his head a large grand hat with plumes and in his big dark eyes an expression of sweet peace. From both his shoulders sprouted a pair of white wings. After some friendly negotia-tion I bought it and it is hanging in my home as I write this.

Unconsummated love between men can be as powerful as any love between a man and a woman; and equally if not more powerful than physical love with either. However passionate and exciting sexual intimacy can be, it does not linger in the mind with the same intensity as does the indescribable feeling of love one human being can engender in another. And there is something to be said for that kind of love's endurance and the ability to conjure it up more vividly than any remembered sexual pleasure.

Raul Julia's physical beauty was no match for his ebullient nature and sweet soul. He was a man who loved life, work, family, and friends. And to be one of them was a joy that, in remembrance, makes me wish I did believe in angels.

He was gone at fifty-four. His beautiful wife Merel and two exquisite sons, Raul Sigmund and Benjamin, lost a husband and father far too early. And I lost my best boyfriend.

IDA LUPINO

Standing alone in the center of the frame as the camera pulls back at the end of the 1955 film *The Big Knife*, Ida Lupino is pleading "Help! Help! Help!" She was that rare actress who exuded not only a strong sexuality but a fierce intelligence and a kind of dark magic that, for some reason, never resulted in major stardom, but left an indelible impression on the viewer. She reminded me of the phrase often used about special actors, "Too good for the room." Miss Lupino was a first-rate Hollywood pioneer who had been only the second woman to be welcomed into the Directors Guild. And I was very excited at the idea of working with her.

In 1976, a beautifully dressed, heavily perfumed woman wearing a hat and a pair of white gloves walked into the rehearsal hall. Introductions were made as the actors gathered round to read the Tennessee Williams play *Eccentricities of a Nightingale*, which would be receiving its television premiere. During the reading, when it came time for her character to speak, that familiar husky, whiskey-sour voice resonated around the room and back came my memories of so many of her performances in films during the 1940s and '50s.

The body was thicker now, the voice even deeper, and there was a pained fragility in those huge, keen, alert eyes. Her mind, however, was razor sharp, and her instincts infallible. She gave a clear, decisive, powerful reading, and I was thrilled to have her playing my mother. Our director treated her with distant politeness and pro-forma efficiency.

Miss Lupino's character was that of an overly possessive, genteel southern woman made of the kind of stuff used in the pillars of the Greek Revival houses to which she often referred—a fair description of the actress as well. She had a reputation for knowing her craft and taking no nonsense. One could not imagine her facing any crisis with either sentimentality or tears.

When you've been at the game as long as she had, you develop a keen instinct for survival and she intuitively knew at the end of our first reading that she was in trouble. Her probing, incisive questions were not greeted with the excited interest they should have been, and her bullshit meter was so sensitive she knew that, rather than deal with her searching mind, our director was going to shy away from her in an impatient, self-protective manner.

What she needed more than anything else was confidence and support. I saw nothing of the diva-like, demanding sensibilities I'd found present in the more passive-aggressive younger actresses I'd worked with. She did not try to ingratiate or charm or behave in any way that said, "Oh, help me, please. I'm just a fragile flower who needs to be loved." I found her admirable, brave, and enviably independent of mind. She was no longer "the money" on any project in which she was involved, but had joined the ranks of distinguished older names, valueless to the "suits."

In 1976 Miss Lupino was fifty-eight years of age, and she was put together in the way that heavy drinkers, particularly women, organize themselves: impeccable hair, makeup, clothing; a tidy house of cards. But, as the first few days passed, the structure began to weaken. She was perfectly behaved, gently polite, but it was clear that she was going to have trouble remembering her lines and repeating her moves. She was, however, in my eyes, going to be worth every second of the care and extra time she would need to build her confidence, com-

pletely understand her character, and play it without an ounce of concern for appearing sympathetic or likeable. And she was, I thought, going to be a glorious bitch in the part. Her character's obsession was her son. This was a mother who wanted no one near her boy; and because most of her important scenes were with me, she focused all of her attention in my direction.

"Sit by me, honey," was her opening line on days two and three.

But as our producers and director grew more impatient with her measured delivery and investigative journey, her survival instincts sniffed out animus; she became skittish and slowly lost confidence. At the end of the fourth day, as I walked her to her car, her gloved hand in mine, she turned to me just before getting into the backseat, the makeup too heavy for sunlight, and said:

"They're gonna can me, honey."

They did fire her. And when I placed a call to offer my condolences she did not return it. She most likely felt there was nothing to say and preferred to take her lumps in silence.

Miss Lupino's need was of no interest to our director and his producers. When I asked them why they had let her go, they said: "Oh, she's brilliant, but we just don't have time for her."

It is generally true in my profession that a faulty camera or an incorrect prop will often be given more attention and time than a worthy actor in need. And also true that idiot actors who come on the set stoned or drunk with petty or moronic demands are far more indulged than ones who calmly ask intelligent questions. Management likes to feel superior to actors and Miss Lupino's searching mind was clearly intimidating to them.

What a shame a tiny bunch of cowards didn't have the patience to look after a first-rate artist crying out for help.

DAVID BEGELMAN

David Begelman had been my agent for about a year in 1972 and had brought me next to no work. I say "next to" because he did bring something that might as well have been no work.

One evening a script arrived in a chauffeur-driven limousine to my small house in Wilton, Connecticut. "From Mr. Begelman," said the driver, handing me a brown manila envelope with a handwritten note inside from David.

"This is The One," it said. "The film really begins on page 25." He had placed a large paper clip there where my character entered, with another note from the film's producer slipped beneath it, which read as I recall:

David,
Bob Mitchum and Rita Hayworth are so hoping Frank Langella will agree to be in this film with them.

And I fell for it.

Within weeks I was taking horseback riding lessons in Wilton, learning how to fire a gun, and memorizing lines for my first western. All thanks to David.

If not the worst film I've ever done, in which I give one of the worst performances I've ever given, *The Wrath of God*,

perfectly titled, certainly belongs in the top—or should I say bottom—three.

The best of that experience you can read about in my chapters on Rita and Bob. The worst was my performance, terrible dialogue, and a horse who hated me.

When the film finished, I returned to Connecticut, a mortgage, and unemployment. My calls to David were either returned five minutes before the end of the business day as his switchboard closed, or responded to by a secretary with a sinister but brilliant routine that went something like this:

"Mr. Langella. I have Mr. Begelman calling for you. Please hold."

Sixty seconds would pass.

"Mr. Langella, I'm so sorry. Just as he was about to pick up, we had an emergency. May we get back to you?"

"Yes you may."

Silence for days, then:

"Mr. Langella, are you all right? Did you not get Mr. Begelman's message?"

"I'm fine. I didn't get any message."

"Well, shall I have him call you?"

"Is he available to speak now?"

"Not at the moment, I'm afraid."

More silent days. I called him.

"Hello, it's Mr. Langella, may I speak to Mr. Begelman please?"

"Of course."

Sixty seconds pass.

"I'm so sorry, Mr. Langella, he's behind closed doors. May we return?"

"Yes, thank you."

Another few days pass.

"It's Mr. Langella."

"I'm so sorry, he had to make a quick trip to London. I'll put you at the top of his return calls."

These kinds of calls are by no means unusual occurrences in the actor/agent relationship. The difference today being the ubiquitous use of the word "actually."

As in, for example:

"Is Mr. Begelman available?"

"*Actually*, I don't have him at the moment."

It appeared to me as if I was never going to have David again, so one afternoon from a phone booth near his office I called.

"Would you tell Mr. Begelman that I'm downstairs and would like to come up? It's urgent!"

"Oh, of course, one moment, please."

Silence for sixty seconds. Then David's voice:

"Frank. My God you're a hard man to get hold of. Are you okay?"

"Yes, David. Can I come up?"

"I'm dying to see you, but I'm just about to pick up on a conference call—don't want to keep you waiting."

"I'd be happy to wait."

"I wouldn't hear of it."

"Can we have lunch?"

"You bet. I miss you. Gloria, what have I got?"

"You have next Tuesday."

"Wonderful. I can't wait. Gloria, make the arrangements. Frank—I want to tell you about something I hope you'll consider, it's . . ."

"Mr. Begelman, I'm so sorry, but you have Mr. Wasserman on two."

"Oh Jeez. I better take that, Frank. I've been talking to Lew about something for you. See you Tuesday. Can't wait."

Standing at the bar in Raffles, a club downstairs at the Sherry Netherland Hotel, David is writing something on a piece of paper. As I approach he says to the bartender:

"That's the only name you're allowed to tell me might be calling. Otherwise I don't want to be disturbed during lunch with Mr. Langella."

We're shown to a table. As we sit down, he reaches for my hand and says: "There's no one I'd rather be having lunch with today than you."

"David, are you all right?"

"It's been a bad morning. I had to put both my parents in an old-age facility. My mom's incontinent and my father's heart is giving out."

"I'm sorry."

"No, no. Being with you is good for me. You look wonderful. Mitch loved working with you."

"David, you know that picture is all I've done since I came with you and—"

"Mr. Begelman," said the bartender, "you have a call, sir."

"Is it the name I told you?"

"Yes, sir."

"I'm sorry, Frank. I've got to take this." There was a telephone conveniently plugged in on our table. "Hello, Doctor."

Long silence.

"Yes, yes."

Silence.

"Yes, I'm on my way! Thank you."

"What is it, David?"

"I don't think my dad's going to make it. I've got to go back out to the facility."

He got up and gave me a long embrace.

"Pray for me," he said. "Please call Gloria and we'll re-schedule soon." To the waiter: "Give Mr. Langella whatever he wants and put it on my tab."

"David, what about that project with Wasserman?"

"What? Oh . . . Not good enough for you!"

———————

And he was gone. Not only from the restaurant, but from my life. I fired him that afternoon. He made no protest. And as far as I know, his father could still be alive.

Soon after, he was appointed head of Columbia Pictures. Years eariler he had masterminded a comeback for Judy Garland at Carnegie Hall, coaxing her back onto the stage and report-edly playing fast and loose with her monies while also reportedly coaxing her out of her clothes when offstage. He then became the subject of a big scandal, accused of forging the signature of the actor Cliff Robertson on a $10,000 check in 1978. David was painted as the victim, and Cliff Robertson was rewarded for turning him in by being blackballed in Hollywood.

One night in 1995 at Matteo's restaurant in Santa Monica, there he was seated across from me. I hadn't seen or spoken with him for close to twenty years, but as I passed by his table on the way to the men's room, he silently reached up, took my hand, pulled me down to him, kissed my cheek, and looked deep into my eyes with an injured smile. I continued on to the restroom.

Several weeks later, alone in his room at the Century Plaza Hotel, he shot himself in the head. I'd had no idea I meant that much to him.

JO VAN FLEET

"**A**tta girl!" Susan Hayward barked at Jo Van Fleet as Jo successfully stole a two shot in which they were sparring during the shooting of the 1955 film *I'll Cry Tomorrow*.

"Susan taught me how to fight and stand up for myself," Jo told me.

Tough. Tough. Tough. Tough as nails she was. A ball buster, my Italian uncles would have said. No one was going to get the best of her. Jo was one of the finest dramatic actresses of her time. She is most remembered now as James Dean's mother in *East of Eden*, for which she received her one and only Oscar.

She ate our director for lunch and tried to have me as dessert. The year was 1966. I was appearing opposite the actress Gloria Foster in Garcia Lorca's *Yerma* at Lincoln Center. The play was about to close and I was asked to reprise a role for television that I'd done off-Broadway in a play called *Good Day*, about a young man who applies to an old lady for a job and is slowly sapped of his youth and energy as she grows younger. My costar had been Nancy Marchand, who achieved her greatest success in *The Sopranos* but died in 2001 of the cigarettes she couldn't leave alone.

At the time Jo was a big star and the network offered her Nancy's role. I called Nancy and said:

"I don't want to do it without you."

"Don't be an asshole," she said, and hung up.

Jo was belligerent, hostile, and brilliant. She couldn't put a foot wrong in the part. Her steely intelligence and razor-sharp delivery suited the role perfectly.

"Good morning, Miss Van Fleet," the director would say.

"What's good about it?" Jo barked.

He made a suggestion:

"You want me to do *what*?"

I'd try a new move somewhere:

"Is he gonna do *that*?"

There wasn't enough time for her to find all the depths of her character. There never is in television, but she worked tirelessly. She was a towering presence as an actress, but a woman so desperate for love, that all she could do was push away any kindness that came her way, for fear of admitting how much she needed it.

After we taped the show, I walked over and told her she was one of the greats.

"Yeah, yeah! Stop blowing smoke," she said.

Years passed as she descended into a drunken recluse, making enemies of just about anybody who could give her a job and she became virtually unemployable. She could often be seen wandering around the Upper West Side of New York, looking like a bag lady talking to herself.

In 1984, I was appearing opposite Dianne Wiest in the Arthur Miller play *After the Fall*. Jo came to a matinee and told the stage manager to come and get me. I changed quickly and found her sitting on the stage in one of the permanent benches on the set, looking out into the house. I stood in the door for a few seconds remembering her thrilling performance in *Oh Dad, Poor Dad* . . . some twenty-five years earlier and wondering what she must be thinking. And then

I walked down the aisle to greet her.

"Hi Jo."

"Hey, baby. Geez what a fucking crybaby Miller is."

"Well, Marilyn was no picnic."

"He didn't *have* to marry her for Chrissakes."

Dianne knew she was there and came through the house down the aisle to pay her respects. In her little-girl voice she said, "It's such an honor—"

"Yeah thanks," Jo said and cut her dead. Dianne excused herself and disappeared. When she was gone I said:

"Jo, you didn't have to do that."

"What?" she said.

"Treat my leading lady that way."

"Don't give me that shit. *I'm* your leading lady."

She said nothing about my performance or the production; but sat there and railed against Arthur and his treatment of women in the play.

"The guy's a chauvinist asshole," she said.

It was now about 5:30 and I wanted to eat and take a nap before the evening performance. Jo fell silent and stared at the floor.

"Is there anything I can get you, Jo?"

"Yeah," she said. "A job."

ROBERT MITCHUM

Bob Mitchum was testing me. And if I didn't pass, the next seven weeks in Mexico were going to be hell.

The Wrath of God was my first movie western and I was going to have to ride hard, shoot a gun, and act with the legendary Mr. Mitchum. My second day's shooting would be with him. The action would require me to gallop full speed through a dusty town at the head of a gang of Mexican thugs, rear my horse in front of a church, command him up the steps, and bring him to a halt in the chapel, confronting Mr. Balls himself with my gun drawn.

It was 1972. This was only my third picture and I rode about as well as a six-month-old baby. I took a dozen lessons before I got to Mexico and I could stay on, stop and start, but I wasn't fooling the wranglers.

"Fucking New York actors," I'd hear muttered, as I spent most of my time in the saddle at a forty-five-degree angle, holding a gun about as convincingly as a nun.

I had managed the long gallop through town (eventually cut from the picture) pretty well and come up to the church door. All outdoor shots completed, I was to rehearse with Mitchum at the end of the day to prepare for shooting the scene inside the church the next morning.

Still in costume, dirty and tired from a full day, and uncharacteristically nervous, I watched Mitchum come strolling out of his trailer, wearing an oversized fur-lined hooded

jacket, and take his place behind the pulpit, some script pages in his hand. Ralph Nelson, the director, introduced us.

"How do you do, sir," I said.

"Hey," he said to Ralph. "Proper, ain't he?"

"Why don't we have you enter on the horse, Frank," Ralph said. "Do you want to take him up the steps yourself?"

"Yes," I lied.

I mounted, kicked, and pushed, but my *caballo* did not want to pray. He came up to the steps but stopped dead. I could see Mitchum, at the end of the country church, standing by the pulpit waiting to say his first line. By my third attempt, he'd sat down on a tall camp chair to wait it out.

The wrangler said, "Why don't you just walk him up the steps. We'll work on it later."

"No," I said, circled round, and rode to the back of the square. Then I kicked hard and went into a gallop. We got to the steps, I kicked again, and up he sailed, carrying me and my balls to victory—short-lived as it was. I landed in the center of the church, shifted back to the center of the saddle, awkwardly drew my gun, feeling and looking about as comfortable as the New York stage actor I was.

My first line, shouted at Mitchum across the echoing hall, rang out:

"Priest!"

His response was to be:

"I am here, Tomas De La Plata," my character's name.

Instead, I heard:

"Yeah, motherfucker."

A loud chorus of whoops and laughter came from the crew gathered around watching as I dismounted. I played the scene exactly as written, while Mitchum ad-libbed one profanity after another. I never laughed, never ad-libbed. Somehow I knew that if I allowed myself to find Mr. Mitchum funny or took on

his dismissive attitude to the work, he'd own me. So I pressed on, speaking admittedly terrible dialogue with complete conviction. It was a tense and difficult ten minutes. When I said my last line, walked to my horse and started to mount, he said:

"Let's run it again." He then put down the pages and played the scene flawlessly, just like the Movie Star I had so admired. I'd passed.

From that day on I adored every minute I spent around Robert Mitchum. The epitome of a macho movie star, hard-drinking, drug-taking, and womanizing, he attracted every man on the film to do it with him. After a day of shooting, Mitchum partied until dawn. Coming to the set from an all-nighter, he showered in his trailer and worked all day. While the rest of the guys were vomiting or hungover, he was fresh as a daisy and ready for bear. I knew I could not handle those kinds of nights and did not join his coterie.

Mitch was an extremely generous man, flying in thousands of dollars of food from Chasen's in Hollywood for a Friday night party, picking up the tab for one and all on those binges, and giving expensive gifts to the Mexican women who favored him.

But his greatest gift was his ability to just stand in front of the camera and "be." He could memorize a full page of dialogue at a glance and play it perfectly in one take. I never saw him flub a line and he was a great mimic—devastatingly funny about men like David Lean, the director, ruthlessly mocking his preciousness about "the art of cinema," loving to tell the story of coming up behind Lean while he was looking through the lens during the shoot of *Ryan's Daughter* and sniffing about his head.

"What are you doing, Robert?" Mr. Lean asked.

"There seems to be a terrible odor of cunt about you, David," Bob said.

And he would often pass by me, tossing off a casual one-liner, as in:

"Get out your pencil, Frank, and take this down. Herewith a list of the ten dullest actors in Hollywood. They are: Gregory Peck." He whiled away his time spontaneously breaking into song, reading poetry, boozing, puffing, fucking, and sleeping.

I envied Mitch his easygoing, seemingly carefree, rangy masculinity. I was not, nor will I ever be, the kind of man he was. And by not trying, I established a rapport with him that I might not otherwise have had.

I do not presume to understand the reasons he developed a persona that presented to the world a man who cared very little about anything and just indulged his senses. I found him to be a man who, in fact, cared deeply, but chose not to display it. Most likely he found our profession somewhat unmanly. He did not suffer fools and was not unaware of how he was perceived. If you took the time to penetrate the laissez-faire attitude he adopted, he responded with warmth and compassion. Clark Gable had always been my favorite movie star but Mitch was giving him a run for his money. A nonjudgmental dad who seemed to practice tough love. And his no-shit cynical approach to the business of moviemaking was both instructive and delicious to watch.

He had a cool defiance of authority, insisting he return to his trailer to take a leak when it was five miles away from the place we were shooting. Each leak cost the company time and money until they got the message and brought his trailer nearer every setup, but still he took his time.

And further, he refused to wear squib packs, the small plastic bags of fake blood put under your costume to make it look as if you'd been shot.

"Use a fucking double," he'd say, "I'll be in my trailer," costing the company more time and money. I never saw him raise his voice, be rude to an underling, or be unprepared.

The word on Robert Mitchum was that he was really a great actor who'd never gotten the right role in which to display his full talent. But I don't think that was the case. He was a great movie star with a singular presence, but personally seemed, in my experience of him, to suffer from an ennui he couldn't overcome. So he polluted himself with drugs and liquor, and relied on his formidable masculine sex appeal and quiet charisma. He was by no means a hack, but a sensitive man with a caring nature who had developed a deadpan delivery and an ability to stay afloat in the studio system.

One day, waiting to finish a ridiculous sequence in which he would fall on me while tied to a stone cross, thereby crushing me to death, I told him how much I liked a small film he'd done called *Going Home.*

"Thanks," he said. "Great story, good kid, Jan-Michael Vincent. MGM pissed all over it. Dumped it."

The assistant director came over and said they were ready for us.

"I gotta take a leak," Mitch said. "I'll be in my trailer for about an hour." He glanced at me as he got up.

"MGM's producing this turkey too," he said.

"This piss is gonna cost 'em another million."

PRINCESS DIANA

Being completely true to the spirit of this book, I should not include Princess Diana. But her death touched my life on a day I will always remember. It forced me to reassess this unfortunate woman and to wish I had in fact been able to meet her.

Up until the tragedy, I had paid very little attention to her. She was not, in my opinion, a great beauty. At certain angles pleasing to look at. Stylish, yes. A good body for clothes. But not a drop-dead stunner like Julie Christie or Lesley-Anne Down. And I was not sympathetic toward her problems, which struck me as fairly typical: spurned wife, insensitive husband, clever mistress. Pure soap opera. But fate intervened, and I had, at last, to take notice.

I sat down in an oversized comfortable chair in the living room of my suite at the Regent Hotel in Berlin where I was finishing a film; the first for the famous *Cirque du Soleil*. It was 2 a.m. and I began to channel-surf. First I saw Diana's image on German television. Then French. Then Italian. And still it did not dawn on me. When I hit CNN, the words "The Princess died at . . ." were the first I heard. I woke my companion, and she came and curled up with me in the same chair as we watched till sunrise. We had been planning to go to London

on the weekend to spend time with our friends, the producer Fred Zollo and his wife, Barbara Broccoli, producer of the James Bond franchise, who were planning a possible dinner with Diana and Dodi Fayed. We kept those plans, with the exception, of course, of the promised dinner.

The morning of the funeral, September 6, 1997, we woke at 7 a.m. and from our windows at the Savoy Hotel, saw over the Thames to Big Ben, a rare early morning sight in London: a completely blue sky. Not a cloud in sight. It was going to be a brisk, sunny day. Fred and Barbara were going to watch the coffin move through the streets from the balcony of Barbara's offices on Piccadilly and asked us to join them. We left our hotel at 9 a.m. and began to walk the barren streets.

Most of the cafes were empty, the proprietors staring out the windows at us as we passed by. Few cars. As we walked along Piccadilly, the crowds grew more and more dense. Fred and Barbara were standing on their balcony and waved down to us; we went upstairs and from there we could see people streaming across Green Park toward Constitution Hill.

In an open triangle of road we would be able to see the horse-drawn gun carriage, carrying Diana's body, move by us. A dozen or more people came in, quiet and somber, and on the floor a small five-year-old girl sat coloring pictures in front of the TV. On it we could see the coffin beginning its journey, and we watched as it came closer to our location, then we moved onto the balcony again moments before it passed. There was total and utter silence on the street. In the basement of Barbara's offices was a screening room with some twenty-five seats. Some of us went down there to watch the coffin make its way to Westminster Abbey on the large screen. These are the sights and sounds I remember:

The broken faces of her sons.

The quiet determination of the pallbearers.

Luciano Pavarotti leaning on his children.

Diana's sisters' dignified readings.

The hymns.

The almost unbearable heartbreak of Elton John singing "Candle in the Wind" as those in the screening room wept uncontrollably.

The heroic and passionate speech of her brother, Earl Spencer, in his last noble public moment.

But most of all the sight of the word "Mummy," written in a young boy's hand on an envelope resting on her coffin as it slowly moved through the streets of London in a human silence so profound that the clip-clop of horses' hooves became the only audible sound.

When it was over, I went outside alone and tried to get as close to that triangle as I could to watch the hearse go by on its journey to Althorp, Diana's country home. My companion wanted no more part of this spectacle and returned to the Savoy. I made my way toward Buckingham Palace, and for the next two hours I was able to experience firsthand this historic day up close and personal. As I walked through Green Park, I stopped at a large tree that had, all around on the ground, messages, drawings, and flowers from a class of children. I picked up one poem, and read its last two lines:

"Now Diana's in heaven with all the good, and Jesus is loving her like he should."

Once near the palace, I wandered into the crowd and got as close to the flowers laid against the gates as I could. Here are a few of the things I overheard:

"She's dead, love. We've got to get used to it."

"You know, an enterprising bloke could gather up all these flowers, sell them, and be a millionaire overnight."

———————

"I like the Queen."

"So do I, but she's got nothing to do with my life."

———————

A large woman had gathered around her a crowd of some thirty people, her King Charles spaniel seated in a baby carriage: "A complete stranger loaned me this," she said to the crowd as she picked up the dog and posed for photographs. Everywhere were black plastic bags blown against the barricades, photographs and posters of Diana, discarded blankets and coats, bottles, newspapers, fast food boxes. I stopped to listen to two young girls who were sitting on the ground holding a book and singing "Amazing Grace." One had shaved her head on both sides, her punk top dyed a bright red. The other in a bedsheet-white pageboy. When they finished, a few people applauded as they smiled and one said to the other, "Pretty good, love."

Approaching Admiralty Arch, I saw four stepladders facing toward the palace, each with a professional photographer perched on top taking photos. Behind each ladder, there was a short line of more photographers waiting their turn. Walking through Admiralty Arch, back toward Trafalgar Square, up the Strand toward our hotel, I noticed the pubs beginning to fill, the shops opening, and people speaking in normal tones again. Almost everyone was holding a camera.

Once back at the Savoy, sitting in the window seat of our River Suite, I thought that but for the heavy foot of a driver named Henri Paul and a pack of wild animals in pursuit of her, she'd be alive on this lovely day. And I thought of the expres-

sion on her face as she came out and reentered the Ritz Hotel in Paris before going to its back door and stepping into her waiting coffin. There was a look of sad resignation in her eyes as she moved in and out of swinging doors, turned quickly this way and that, seemingly like a blind person, without a stick or a guide dog, being steered in someone else's direction.

Diana had lost not only her virginity to an English prince but her innocence, her anonymity, and her way. Now, divorced at thirty-six years old, made unhappy by an insensitive husband in love with someone else, she was grasping at an ambitious playboy, making a run for her life, and about to lose it.

RODDY McDOWALL

I doubt it exists now as strongly as it once did, but there thrives in Hollywood and New York what is known as the "Gay Mafia." And it helps if one of your agents or your manager or someone on your team plays for the other one, so to speak. I can remember in my young years my gay agent telling me not to be as concerned with my acting audition, as to be certain not to wear underwear when I was going up to meet a renowned producer/groper.

Roddy McDowall, although secure in his position as a member of that mafia, was nonetheless congenitally concerned with his place in the Hollywood firmament. As a child actor he was adorable, somewhat winsome, growing into a lithe and androgynous teenager, and a somewhat effete man.

His social connections, more than his acting chops, were what kept him working constantly—not to mention his lack of concern for what he did or who he did it with. He was a charming, willing, and adaptable mate to many a diva, including Elizabeth Taylor, Lauren Bacall, and a very-old-timer named Anna Lee. "Isn't she beautiful!" he would say of whatever woman he was walking or wheeling. His dinner parties were sought-after invitations and his ability to ride the waves and occasionally the husbands or boyfriends of some of the ladies made him the all-purpose Extra Man of his set.

Roddy was impossible to dislike. Rather like Peter Lawford with his crowd, he was able to facilitate secret meetings, clandestine love affairs, and introductions to just about anyone. Through him, needy luminaries could find each other in the secret shoals of a town where still waters run shallow.

One other important quality that did not appear on his resume but was certainly in his basket of goodies was the fact that he was very well hung. Never hurts—unless in a good way. He was available, ready to serve in any way he could, and agreeable to the disparate needs of both sexes. Perhaps growing up on a film set, and from an early age being trained to please, had made him such an adaptable companion.

One evening at the home of composers Marilyn and Alan Bergman sometime in the early 1980s, I watched him work the room like a cordless vacuum cleaner, sucking up celebrity droppings. At one point he came up behind me, put his chin on my shoulder, and cooed seductively. I picked up a shrimp, popped it in his mouth, and he contentedly moved on.

His work ethic was phenomenal. He'd happily throw himself into every role with complete conviction. He was, unfortunately, an average actor and an equally average photographer, an avocation he used as a catalyst to get more connections and guaranteed dinner invitations.

"I've *got* to photograph that face," he would say about a prospective A-lister.

I don't know that his particular brand of smoothing the waters is required in today's Hollywood. While still a provincial company town, the lines between gay and straight are far less drawn than when he or I was coming up. The Bi-Brigade is a lot more populated than it was, and the younger generation

seem less interested in needing to define themselves sexually. Orientation is, rightfully so, of little concern on the current battlefield. Everyone is swimming in increasingly treacherous seas of doubt and imminent demise. Being gay is no longer a secret shamefully kept within the industry. The public is still somewhat protected from the naughty truth, but mostly for fear of shocking that most lethal judge of all: the box office.

Since most of today's biggest stars cling to being boy/men and girl/women, it does seem a bit disingenuous to go on protecting the ticket buyers. Like pubescent girls wetting themselves over androgynous rock stars, the general public these days seems to care less about indisputable heteros and more about the somewhat all-purpose packaged pinups. Male movie stars are less clearly macho than they used to be and the females have grown tougher and more aggressive.

Roddy would have had no trouble in today's climate scampering in both directions sexually and platonically and would certainly manage to offend no one while doing it. A dear-hearted man and a clever chameleon, he had developed an ability to appear available and agreeable to the needs of his colleagues.

As I sat next to him one evening at a tribute to the acting teacher Stella Adler, he never referred to himself or his career but offered anecdotes about each celebrity's love life and career choices as they passed through. Never bitchy or cruel, just deliciously entertaining, pleasant, and often compassionate, he would say: "And you, dear Frank, tell me how *you* are?" This was a man who, no matter what the occasion, clearly wanted a return invitation.

———

One evening at Hugo's restaurant on Santa Monica Boulevard in the mid-1980s, he spotted me sitting alone, waiting

for friends. Leaving his table of semi names for a brief spell, he came over and said: "Hello, darling Frank. Look at that face. I've just *got* to photograph it."

He never did. I'd had my picture taken enough times by then to satisfy my curiosity about what might develop.

PAUL MELLON

Paul Mellon owed me money and Jackie Onassis was determined to see to it that he paid up. This had been a long-forgotten memory from the early 1970s until driving back from Washington, D.C., on April 7, 1999 when I had attended Paul's memorial service in the East Building of the National Gallery of Art.

It was a perfectly glorious afternoon. The cherry blossoms were voluptuously in bloom and a steady breeze sent them wafting gently across my face as I leisurely strolled toward the gallery. The sun was shining brightly, the air clear and fresh. It was the sort of day that would not have meant very much to Paul, who, no matter where he was, seemed to be totally unaware of the elements. Whether dressed in a suit and tie or open polo shirt and slacks, he appeared always to be sealed up in the safety of untold wealth, classical music, horses, and fine art.

He was, after all, the son of the legendary Andrew Mellon, who, along with the Rockefeller and Carnegie families, had amassed a huge personal fortune before those pesky income taxes.

The ceremony was to begin at 5:30 p.m. and I arrived about forty-five minutes early. The mourners were gathering around a very long table with the letters of the alphabet printed on cards tacked to the wall behind. I went to "L" and was given a yellow ticket indicating my section. Center-Row 2. There was virtually no one seated there as I came to it. On its aisle

hung a small cord around which were tied fresh yellow flowers. I stood for a while, but as people began to move to their seats, there was no one I recognized, so I stepped over the cord, sat down, and perused the program.

Like everything to do with the Mellon family, it was exquisitely produced and understated. No doubt overseen by Bunny, his wife of fifty-one years.

On its rough-edged, thick, pale white cover was a replica of Cézanne's *Boy in a Red Waistcoat*, the first painting Paul had purchased as a young man. He would eventually amass one of the most extensive art collections in the world, beginning modestly by paying a mere $500,000 for it.

Above it in a tiny gold circle was the emblem of the National Gallery of Art USA. A blank page followed. When I turned it over, on the left was a portrait of Paul, looking to be about sixty, sitting in a chair in a suit, pale pink shirt, dark tie with pink stripes, showing just enough pink French cuffs above stubby fingers. The light blue suit also had faint pink stripes in wide square boxes. His legs were crossed and his expression was benign. The painting gives him the air of a sturdy, sexless businessman with just a touch of cruelty in the set of the mouth.

Two other works graced the pages: Degas' sculpture *Horse with Jockey*; *Horse Galloping on Right Foot, the Back Left Only Touching the Ground*, and Georges Braque's *Aria de Bach*.

When I was a young man, Paul would take me into the private rooms at the National Gallery followed by two silent men who pulled out gigantic metal racks some forty feet high, on which hung painting after painting.

"We have no room to display them all, so we rotate them," Paul said.

Gigantic works of art down to small little sketches: horses, landscapes, flowers, dogs, and portraits. His efforts to pique

my interest in great art, in those days however, failed to take hold.

Among the speakers at the ceremony would be David Rockefeller and Paul's son, Timothy. The music, mostly hymns, would be played by the National Gallery of Art's Chamber Players. And the ceremony would end with John Philip Sousa's "Stars and Stripes Forever." It appeared there were going to be no surprises and nothing out of order. Exactly as Paul would have wanted it. Waiting for the ceremony to begin I thought back to a hot summer night in Cape Cod in the late 1960s. And of a totally unexpected occurrence that lightly disturbed Paul and Bunny's ordered life.

I frequently spent long weekends with my friend Eliza, his stepdaughter, at the Mellons' incredible farm in Osterville, Virginia, or at their beautiful house on the Cape. Various people came and went during those times: Jackie O, David Rockefeller, Senator John Warner, then married to Paul's daughter, Cathy, among them. The days were lazy and luxurious. Paul and Liza tried unsuccessfully to teach me about life on the water. I could barely row a boat, but Paul was unfailingly patient with me as I tried to become a competent sailor. And worse, I was, as I have written, not much interested in great art or classical music. We were going to need some form of common ground, it would seem, if a friendship was to develop.

Sunday evening at the Cape was servants' night off. Which meant the family was on its own. Which meant that in the Mellon household all the food for dinner was prepared that afternoon, labeled, wrapped in tin foil, and set next to prechilled bottles of white wine on the kitchen counter. All that remained was for the food to be put into the oven, heated, removed, and placed on the preset dining room table. And it would be left there to be cleaned up by the servants on

Monday mornings. Breakfast was usually served in bed along with the morning papers.

This particular Sunday it was just Paul, Bunny, Liza, myself, and Paul's son Tim. A few years younger than me, Tim was profoundly shy, introverted, and awkward. He also had no real idea yet of his options in life.

One afternoon at lunch, Paul, at Bunny's behest, indicated some of them to him. Tim could have his choice of going into one or more of the family businesses, that is: heading up Shell Oil, or U.S. Steel or perhaps involving himself in the horses or art collecting. Timmy pushed his food around his plate and finally said:

"I'd like to build a boat," which he ultimately did.

At any rate, on this particular Sunday, Tim declared he was prepared at least to be in charge of dinner.

He went into the kitchen, put the food in the oven, and returned to his book in the living room. Liza was on the floor drawing, Bunny was knitting. Paul and I had found a mutual passion: the Scrabble board, and were locked in a fierce competition.

About twenty minutes went by and Bunny said: "Hadn't you better see if the food is hot, Tim?"

He got up, went back to the kitchen, and a few minutes later came a very loud noise. Not a gunshot, not thunder, but a heavy *boom*.

"My goodness," said Bunny. "What was that?"

"Frank," said Paul calmly, "have a look in on Tim, would you?"

I raced down the long hallway, through the dining room, into the kitchen and found Tim lying on the floor halfway across from the stove, holding his face in his hands, blood pouring down his shirt. The smell of gas was powerful and the door to the stove was hanging on by one corner. I turned

the gas off and then kneeled down next to him. His nose was badly cut and half hanging off, so I pushed it back in place, grabbed some paper towels, and applied pressure.

Paul appeared in the doorway, not entering the room, and said matter-of-factly:

"I'll call Dr. Higgins," then left as Liza and Bunny were coming in.

"Maybe we better call an ambulance," I said.

"Paul's calling Dr. Higgins," Bunny said. "He's very close by." And she too left the kitchen.

Liza and I sat on the floor on either side of Tim, who was calm and collected and told us that when he'd come back, the food was still cold and he realized he had turned on the gas but hadn't lit the pilot light. So it had been escaping for twenty minutes when he struck the match.

Dr. Higgins did appear, brought Tim into the living room, laid him down on the couch, and I assisted as he put in about six stitches across the top of Tim's nose. Liza sat close, fascinated. Paul and Bunny remained across the room. Bunny knitting. Paul reading. Tim was stoic and silent throughout. As he worked, Dr. Higgins was told the story. Paul said generously, "Frank took charge. He turned off the gas and applied pressure to Tim's nose," etc.

"Well, you did everything right, young man," Higgins said. "Tim shouldn't have much of a scar."

When he left, Paul, Bunny, and Tim went to their rooms and Liza and I raided the ice-box—peanut butter, jam, pickles, ice cream, anything we could find. We then made a goodie bag for Tim and took it up to him but he was already sound asleep.

Before I turned out my light, I thought had this event occurred in my volatile Italian household in New Jersey, the decibel level, the flinging of my body into a car, the race to

a hospital with rosary beads pressed into my hand, my mother's hysterics, and my brother whacking me across the back of the head for being so stupid, would have been the way it was handled. But in Paul Mellon's ordered and restrained household, it was as if a few morsels of dog food had been spilled out of the bowl onto the floor by an unruly puppy; and it could all be cleared up and made neat again by the servants, which it was.

The next morning, when Buds, the butler, brought me my breakfast in bed, as usual, he said:

"Mr. Mellon would very much like it if you would come to see him in his study before lunch."

"It's *Fearless Frank*," Paul said as I came in at about 12:30 p.m. "I'm going to name a horse after you: '*Fearless Frank.*'"

His smile was open and warm as he shook my hand and clapped me on the back.

"Sit down."

I sat across from him at his desk and he said in a slightly more businesslike fashion:

"The family would like to give you something for your bravery. What would you like?"

"That's not necessary," I said, looking up at a tiny Picasso hanging next to the bookcase.

"No, you need to have a reward," he said.

"I don't want anything," I said, watching him tap his leather-bound checkbook open on the desk.

"Well, you're not going to leave here without a reward."

Sitting on the edge of his desk was a small Minolta camera.

"May I have that?"

He looked surprised and said:

"Of course. Take it. What else would you like?"

"That's all," I said. "Oh, and another game of Scrabble tonight."

"All right, let's have a tournament. We'll play whenever you visit."

And so we did. And it was over that Scrabble board, playing for a penny a point, that Paul Mellon and I enjoyed a comfortable personal rapport. We played several games a night after the family had gone to bed, and it was the most relaxed and at ease I ever found him to be. No words of depth or heartfelt confessions were made. He was grateful to me for looking after Tim and I had passed a major test in the life of the truly wealthy. Other than a small camera, I had not ever asked for anything and never would.

———————

I looked up from my program at the memorial service to find my section was about full and that sitting directly in front of me was an unmistakable blond head.

"Hi, Caroline," I whispered.

Caroline Kennedy Schlossberg turned around. I had not seen her since she was a little girl.

"Hi Frank, nice to see you."

"Do you remember that your mother used to leave you and John-John with me when you were small and I'd take you for long walks on Dead Neck at the Cape?"

"Yes," she said. "You got stuck with us when she and Bunny wanted to be alone." She did not introduce me to her husband sitting beside her as we reminisced, and then turned back to her program.

The ceremony was about to start. Liza and Bunny came in and took their seats directly in front of me. I leaned forward and gave each of them a kiss.

As I thought it might be, the ceremony was dry and unemotional. When Tim got up to speak, I saw little trace of the young boy I knew thirty years before. He was in a business

suit, slightly overweight, and wearing eyeglasses. He spoke of his father with respect and honor. But no one, including his son, told a single personal story or anecdote, or made a loving joke about Paul. Reverential and formal were the memories. I half expected someone to present him with a posthumous gold watch for years of good service to the Company.

When it was over, I walked over to Tim.

"Can I see the scar?" I said.

He lifted his eyeglasses and there it was—tiny and hardly noticeable, as Dr. Higgins had predicted it would be. Tim asked me no questions and made no overtures. We shook hands, he turned to other guests, and I spent some time with Bunny and Liza before going into a private viewing, titled in the program: *Small French Paintings*. In a stunningly lit space I walked among the works of: Fragonard, Giroux, Rousseau, Degas, Vuillard, Bonnard, La Tour, Tissot, and Renoir. Just a few postcards from a man who had all his life loved and collected great art.

Staring at the Cézanne on the program cover, I wondered whether Paul chose it as his first purchase because it depicted a wistful, sad-eyed young fellow, hand on hip, in a straw hat, the bright red waistcoat his only bit of dash, seeming to be longing for something, but not knowing what. The pale pink shirt and suit in the equally melancholy portrait of Paul on the following page seemed to me the faded colors of a youth's once bright future.

I walked back out into the beautiful D.C. day, and got into the car. It was during the ride back to New York, that I recalled how, thirty years earlier, Jackie had innocently altered my warm relationship with Paul. We were returning to New York on the Mellon plane, after a long visit at their home in

Antigua in the West Indies. Paul was getting off in D.C. and Jackie, Bunny, Liza, and I were going on to New York. As we circled D.C. I was regaling Jackie with the story of how Paul's and my Scrabble tournament began.

"And, you know," I said jokingly, "he's into me for a lot of money. We play a penny a point and he owes me $11.43. I have his signed IOU."

"Well, you have to get your money," she said laughing. "Ask him for it now."

"Oh, I don't expect ever to get it. I'm his guest and we have a great time just playing."

"No," she said. "Paul would respect you wanting the debt paid. Ask him for it right now."

He was down the steps on the tarmac talking to the pilot while waiting for his luggage to be put in the back of the car. So, emboldened by Jackie's prompting, I ran down the steps and confronted him.

"You know, Paul," I shouted over the noise of the engines, "you haven't paid up."

"How much do I owe you?" he shouted back.

"Eleven dollars and forty-three cents. Look, I have your signed IOU," I joked, taking it out of my wallet.

"Let's settle after the next game," he said.

I looked up and saw Jackie, Liza, and Bunny staring out the windows of the jet, smiling and egging me on.

"I'd like to do it now," I said. "I have bills to pay."

He did not laugh, but took eleven dollars out of his wallet, borrowed the forty-three cents from the pilot, and handed it to me. I tore his IOU into little pieces and flung them into the air in a grand gesture as much for the ladies' pleasure as for Paul's; but again he did not smile or react to that small bit of theatricality. He just shook my hand, got into his car, and was driven away.

When I got back on the plane, the ladies were laughing. "Drinks on me," I joked.

It wasn't that I was at all important in the scheme of Paul Mellon's life. It was just perhaps that by chance an exploding stove, a bloody nose, and an ongoing Scrabble game had allowed him to enjoy my company with no strings attached. Strings most likely were what he understood and expected. I was part of no major merger, no winning horse, no extravagant purchase.

Jackie had teased me into demanding payment on his $11.43 debt. And perhaps once he paid it, he no longer saw our carefree time together in quite the same way; because no matter how often I continued to visit the Mellons, after our business transaction on the tarmac, despite my importuning, Paul and I never again played a game of Scrabble.

OLIVER REED

Up the stairs he came. His bloated face fixed in a manic grin, bloodshot eyes shifting from side to side, body thick, square, and unkempt, in clothes wrinkled and soiled. I thought he was going to punch me in the face, step over me, and keep moving. Instead, his outstretched fist opened wide and he gripped my hand in a painful shake.

"Nice to be working with you," he said, as he studied my face.

He seemed to be looking for some kind of attitude in me that he could challenge. I adopted an air of pleasant, subservient warmth, letting him grip as hard as he wanted, and held his gaze. He may as well have punched me in the face.

It was Malta, 1994. Oliver Reed had been hired to play Geena Davis's father in a film entitled *Cutthroat Island*, perhaps the single worst disaster in which I have ever appeared. It cost $100 million and grossed hardly $3 million. Months and months and months in Thailand and Malta, resulting in a film so brainless and worthless, it brought shame on all who had been associated with it, but not, as it turned out, to Oliver Reed. We would have no scene together, for which, having just met him, I was now grateful. His involvement in the film would only be for a few days. He had a cameo at the beginning, imparting a grave secret to Geena before he died. One

good scene, and back to England for Mr. Reed. A healthy paycheck, then over and out. Sadly he was both at that point.

The steps on which we met led into a movie house where our director, Renny Harlin, had arranged a screening of a movie starring James Spader and Kurt Russell called *Stargate*. It would turn out possibly to be even worse than our little debacle. We sat in the dark, watching Mr. Russell in a haircut resembling a miniature bed of nails, ooze intensity and Mr. Spader, in bangs and horn-rimmed glasses gently walking up to a disturbed yak, reaching out to pet him, and saying, "It's okay, it's okay." Two noble colleagues making the best of it. I felt better.

The screening was followed by a large dinner for our cast, given by our producers. It was ostensibly to welcome Oliver into the company. I sat opposite him at a long table, as he settled in between Geena and Renny, who were married at the time.

The simple idea of his one scene was that, as a dying man alone on an island, he would tell his daughter, Geena, to shave his head and on its bald pate, she would find a tattooed map leading the way to the secret treasure she and I, as heroine and villain, would be pursuing through the course of the picture. Oliver, in his by then drunken wisdom, had decided on a twist that he thought would give the picture an exciting opening scene. He gestured for Geena, Renny, and me to lean in close as he slurringly intoned his unique suggestion:

"Now, bear with me dearies, and hear me out. I do think the idea of my character's having tattooed the map on his head is rather far-fetched and improbable. It seems to me, he would have needed to murder the man who'd done it for him. And that information would need to be communicated to the audience and only complicate the scene.

"So, darlings, I think it would be absolutely fascinating if

the silly bugger had by his own hand, tattooed the map on the head of his cock. You see, he's an old codger by now, and it would simply be the last place he would assume anyone would look for it."

The silence was deafening. Three sets of eyes, fixed on the tabletop with another pair, bloodshot and gleeful, searching faces for affirmation. Quite a long time passed before someone leaned over to introduce himself to Oliver, and he mercifully let go of Renny's wrist, who used that moment to leap from the table, flash a look to one of our producers, and disappear into the crowd. Geena quickly followed and I discreetly tried to turn my attention to the person on my right. But Oliver continued to explain to me the wisdom of his idea. As totally insane a fellow as I thought he was, his desperate and sweaty demeanor was touching. He was far less disagreeable than he had been on the stairs. Now just a sloppy drunk wanting to engage; he appeared to be a man no longer capable of controlling either of his heads, and beginning to sink into a sea of oblivion. He grew more blotto with each passing second, and was literally carried out of the room within the hour.

The next day, the shooting schedule was, not surprisingly, changed, and Oliver's scene was postponed indefinitely.

Not only was Oliver sacked and paid, but after being told so, he disappeared into the bowels of Malta and was not to be located for several days. Eventually he was found in a drunken stupor somewhere in a tiny hotel, put on a plane, and sent back home. He was replaced by a more sensible actor, Harris Yulin, who kept both his mouth and his trousers zipped.

By not exposing himself to it, Oliver dodged a bullet with *Cutthroat Island*. It remains, in my film experience, the single most egregious example of excess I have ever witnessed in the movie world. Writers being paid one hundred thousand dollars a week to punch up horrible dialogue with inane jokes, private

cooks serving gourmet food to the Harlins under a cozy tent while hundreds of extras being paid less than minimum wage stood in the freezing rain for hours. Specialty makeup artists being flown in from California on a whim and dismissed days later on another. One of them said to me: "I'm costing them a fucking fortune, just to powder Geena's chest." And scenes being shot with up to fourteen cameras often placed anywhere but where the central dialogue was being said. So cynical, inept, and amateurish an undertaking was it, that one could only hope that had Oliver seen it before he died he might have been forever stunned sober.

Perhaps in a long laundry list of ludicrous events I have witnessed on film sets, the one I most treasure is watching my leading lady having her makeup and hair assiduously attended to between each take of one scene. Not unusual, certainly for lovely actresses, but mindboggling when you consider the fact that she was going to be completely *off camera*.

Having seen the finished film myself several years after making it, I'm not altogether sure that Oliver's suggestion would not have given this turkey a singular moment of originality and challenging filmmaking. Think of Renny Harlin directing Geena Davis in a two-shot in which she must copy a map off the head of her deceased father's penis. Rather than leave it to a stand-in, I'm sure Oliver would have insisted on lying there himself. No doubt suggesting that in the course of the action the old guy achieves a posthumous erection.

GEORGE C. SCOTT

Actors are image, often depicting in fantasy the very qualities they wish to possess in life. In the many times I spent in George C. Scott's company I was struck again and again by this archetypal schism in him.

When I learned of his death, the first memory that came to my mind was of his haunted, childlike face peering at me from three feet away on an airplane. It was the late 1980s and we were seated across from each other going from Los Angeles to New York on MGM Grand—a luxurious airline, now defunct. We were the only passengers in the plane's living room–like setting and had not seen each other for close to three years. George sat clutching an electronic chessboard and drinking sidecars at 11 a.m. Disappointed that I didn't play or drink, he began to talk.

Fury is the word most often used to describe the power in George's work. No one could display rage like him—not even the other great actor of the twentieth century, Marlon Brando. When George turned on that faucet, everyone drowned in the torrent of anger that poured out of him. After accepting an invitation to be directed by him in a play, my first thought had been, "Here's a guy who's going to deck me if we disagree." As it turned out he did, but in a totally unexpected way.

My first meeting with him took place several months before the planned production. I was asked to come by and say hello

and talk about which of the two men I'd like to play in Noel Coward's comedy *Design for Living*, Otto or Leo. The room was dark and belowground and George was prowling back and forth behind a desk. After a few minutes, it was clear he wanted me to play Otto and in a quiet gentlemanly style I was unprepared for, he let me know that. I wanted to be directed by him and felt either character would suit me. He knew, however, that Otto would suit me better and he was right.

The year was 1984. It was the first day of rehearsal at New York's Circle in the Square Theatre. George would direct Jill Clayburgh, Raul Julia, and myself as the play's leading characters. He deposited two packs of Luckies, a six-pack of beer, and a bottle of Scotch on the table at the read-through, and when his stash was gone, rehearsal was over. The hours he did give us, sometimes as little as three in a day, were nevertheless a course in acting worth a small fortune.

There could be no greater teacher in the world on how to play Noel Coward than George C. Scott. With flawless timing and a supreme intelligence, he had little or no time for psychological motivation and less for actors with no technique. He could do any speech brilliantly at once and felt you should be able to as well. While he often resisted the urge to show you how to do something, his natural aptitude would sometimes take over and he'd just burst forth into action. Playing any part, he would be seamlessly brilliant and hilarious. Then he'd sit back down, light a Lucky, have a beer, and look at you with the expression of a bored child prodigy whose mother had made him take piano lessons when he'd much rather have been out playing stickball.

George was so gifted and so self-destructive that his career gave rise over and over to the theory that great talent needs a kind of madness to flourish. If that were true then every alcoholic, overweight, or strung-out actor would be a candidate

for greatness, but few can ever hope to breathe George's rarefied air. If fury and rage were his calling cards as an actor, fear and insecurity seemed to dominate his day-to-day existence. As time went on, I would see the haunted stare come over his face, and know that he would be gone within moments. He'd throw some money on the table at a restaurant, or pick up his bottle at rehearsal and go, leaving you uncertain you would ever see him again. He did disappear during rehearsals for a few days, but came back deeply apologetic, scrubbed clean, sober, and brilliant as ever. Having rolled to the bottom of his particular hill of hell, he had gotten up, cleaned off the debris, and was once again climbing back up.

He was seductive and flirtatious with Jill but slightly cool and aloof with a character actress named Lisa Kirk who was causing problems with the costume designer Ann Roth. Lisa refused to wear the period dress made for her but rather insisted on wearing a 1950s gown designed for her nightclub appearances. The dress Ann created was breathtaking and she was understandably hurt and angry that Lisa wouldn't wear it. She went to George and threatened to quit if he didn't back her up. George did nothing about it, seemingly afraid of Lisa's particular brand of temperament. This was a man whose legendary battles with wives Colleen Dewhurst and Trish Van Devere, and a tempestuous affair with the feisty Ava Gardner, were show business history. Watching him run from any confrontation with Lisa marked the beginning of my suspicions about his tough-guy image.

Design for Living was a huge hit and he was delighted at our success, coming back from time to time to tinker. When you'd hit a home run, no one was more enthusiastic than George. In rehearsal he had been like the coach on the field, up and pacing, saying the lines with you, throwing his fist in the air

and shouting, "Yes baby—that's the big laugh!" He did the same thing during the performances he attended. I could see him in the lighting booth above the stage, prowling around like a tiger in a cage, laughing and applauding when it was going well, standing stock still in a cloud of smoke when it was dying. One night, I less than delighted him and unwittingly risked the celebrated fury.

Raul and I were in the middle of a scene onstage in which his character, Leo, discovers that mine, Otto, is having an affair with Jill's, Gilda. Having spent the night with Gilda, Otto is dressed in Leo's pajamas. At one point I mistakenly called Raul by *my* character's name, Otto. There was that tiny beat when you know a gaff has been made and you either sail past it or run with it. Raul and I settled on a little sprint. He looked at me and in a mock Tonto voice said,

"No! *Me* Leo. *You* Otto!"

The audience got it and began to laugh. Raul did not break, nor did I, but I couldn't resist saying when the laughter stopped:

"Are you sure, dear boy? I am, after all, wearing your pajamas." Big laugh again and this time Raul and I joined in.

My dressing room was one floor below the stage level. I raced down to make a change, stopping first to use the bathroom. Dropping the pajama bottoms to my ankles, I stood at the urinal and immediately felt a hand on my right shoulder. It whirled me around and another hand came up onto my left, holding me still. It was George—red-faced, angry, and drunk.

"What the fuck were you two clowns doin' out there? There's no excuse for that behavior. Jesus Christ, Frank— don't do that again."

I said I was sorry, but it was really funny and we just got carried away.

"Well don't be. Let them be carried away for Chrissake. Come on man. Respect the illusion."

George was unaware that I was continuing to relieve my-self on his shoes as he ranted and raved at me. Once my body caught up to the shock of his wrath, it shut down and I stood there trapped before his anger. He exited as quickly as he had entered. Later that night, as I regaled Jill with the story, she assured me he was totally unaware that I had rained on his ti-rade. She said he had come into her dressing room afterward, thrown himself onto the couch, and said laughingly, "I just scared the shit out of Frankie." Well, not quite. But close!

George sometimes took me to Gallagher's Steakhouse on West 52nd Street for lunch or for a late supper. A drink was put in front of him after he sat down and we always had steak with corn or mashed potatoes. If he didn't like an actor his criticism was sharp and astute.

I had worked recently with one whose star was on the rise. A street-smart wise guy and Actors Studio devotee. I men-tioned his name.

"An asshole," said George, "a talentless fucking asshole. The guy wouldn't know syntax if it came up and bit him. You need brains to be an actor. What the fuck is he?"

He was more incredulous than angry. Mystified that some-one with so little skill could be succeeding in the way this actor was beginning to.

"It's not *acting!*" he said. "It's just fucking *attitude*. The Method is a crock of shit."

Often the talk fell to women. Never vulgar or boasting, he would say matter-of-factly, "I had 'em all, Frankie," and of his celebrated passion for Ava Gardner, all he ever said was:

"Ava almost killed me."

George had a passionate love for great writing and great ideas. His was a delicate, fragile sensibility. This was a man of letters, courtly and polite. Truly a man's man—but not for the reasons he had become so greatly admired. At odds with his own image as a raging bull, he was nevertheless scathingly critical of anyone in therapy, referring to them as "weaklings" and "cowards." When I told him I'd been in and out of therapy most of my adult life, he said: "Well you're a coward and a pussy. Why the hell do you need someone else to use as a crutch? Suck it up!" I decided not to bring to his attention the fact that he was a drunk. If he did scare the whole world, as Mike Nichols had once said, I had come to realize that he scared himself most of all.

One afternoon between shows, George came into my dressing room carrying a drink. Having heard I was planning to do a production of Arthur Miller's *After the Fall* (a fictionalized story of his life with Marilyn Monroe) he said: "Jesus, Frankie, that play's a disgrace." When I told him I was intrigued by its questions of where the guilt lay, he looked at me witheringly and said:

"What the fuck do you mean? Arthur is guilty. He can rationalize all he wants. He's a selfish son-of-a-bitch. I hope you have better luck with him than I did." He was speaking of an unsuccessful production he'd done of Arthur's *Death of a Salesman* many years earlier. Arthur's passive-aggressive style and somewhat imperious demeanor must have driven George crazy.

Three years later, when we sat down across from each other on that MGM flight, he was noticeably older, sadly disheveled, and clearly in crisis. He had no desire to reminisce about *Design for Living* and little curiosity about others in the company

we'd shared. Why he said what he did next may have been the liquor, or the intimacy of our surroundings, or a desperate need to be known. It may also have been because I asked the right question at the right time.

"George, if you hadn't become an actor what would you have chosen to do?"

"Be a writer," he said. "But I can't write."

"What else?" I asked.

An extraordinarily long time passed before he answered me. Still holding on to his chess set and staring out the window, he turned and said in a voice clear and true:

"If I had any balls, Frankie, I would spend the rest of my life sitting at the bedside of real men in veterans' hospitals playing chess all day long."

"Why don't you do that?" I said.

"Why the fuck would they want to be bothered by some faggot actor?"

There sat a man of indisputable masculinity and power, frightened that war veterans might find him feminine and soft because he liked to play chess. It was my turn to be silent. There was a quality in George so desperate for a comfort you felt you could not provide, that it inhibited you from making any effort. He closed his eyes, leaned back, and went to sleep.

———

Ten years later, in 1996, he was playing a character based on Clarence Darrow at the Royale Theater on Broadway in *Inherit the Wind*. I was in the audience and we were due to have supper together after the performance. Onstage he was still powerful, commanding, and even quite funny in Act 1. But when the curtain rose on Act 2, there was a different man standing there. He seemed disoriented and barely audible.

Then it happened. That silence on a stage, unlike any other, when you know an actor is in deep trouble. It's not just that perhaps they've forgotten the line. It's the sense they give you that they have forgotten where they are. He put his hand out to the young actor standing next to him, Garret Dillahunt, with whom I had worked, whispered something, and they began to move toward the wings.

"I'm so sorry. So sorry," he said to no one in particular as he was being escorted offstage, Garret's hand under his elbow. "Please forgive me."

I went back afterwards hoping I'd find him resting but he'd been taken home. I stayed for a while, said hello to Garret, and chatted with George's costar Charlie Durning. "Too bad," he said, "I love the guy." He did not return to the production and died alone in a motel room in Westlake Village, California, less than three years later at the age of seventy-two.

I can tell you, without fear of contradiction, that George C. Scott was a genius because that's what he was. This powerful compelling artist, this warrior, was a fragile, sensitive man who, I think, would have much preferred to spend his life writing poetry and playing chess with war veterans. When I think about it, the last words that he ever uttered from the stage: "Please forgive me," are heartbreaking in their poignancy. His violent rages and brutish behavior were legendary, but for reasons unknown to the rest of us, it was clearly not our forgiveness he needed most, but his own.

LORETTA YOUNG

I never knew who I was going to find sitting at the counter of the small bar in the home of my friend Ronald Neame, the cameraman turned producer/director of so many wonderful films of the 1930s and '40s. He had been a collaborator of Noel Coward and David Lean and became most famous for directing *The Poseidon Adventure*, the film he liked to say gave him his *Fuck You Money*. He collected "the old dames" as he called them; actresses like Glynis Johns, Maureen O'Hara, and the great film editor Anne Coates. On this particular night in the early 1990s, on the stool close to the wall at the bar sat one of the greatest of the great dames, the legendary Miss Loretta Young.

The moment I saw her, I instantly looked up to see if Ronnie had set up a special key light for that stool. So remarkable was her aura and her beauty, you automatically felt that you were standing on the dark side of the camera watching her through a flattering lens. She was in no way theatrical, did not seem to be playing for attention, but radiated, almost more than anyone I have ever met, the aura of a Movie Star.

She had her hands gently wrapped around a glass of wine and was quietly talking to Ronnie, who was behind the bar. As his wife introduced me to the other guests, I caught her briefly glance at me.

I shook hands with them, all the while trying to find my way into her light.

"Loretta, this is our good friend Frank Langella. Be careful or he'll bite your neck."

One of Ronnie's social gifts was his ability to drop a credit of yours when introducing you to give the conversation a starting-off point. He was, of course, referring to my *Dracula* role onstage and in film. He might just as well have said:

"Be careful, or he'll slap your face."

Miss Young turned slightly, lifted her beautiful hand, and said in a polite and vaguely dismissive manner:

"Hello, how are you?" then lowered her eyes and returned to Ronnie.

I've never known a beautiful woman, either intimately or as a friend, who was unaware of her beauty and who wasn't in some way a slave to it. But Miss Young wore hers like a halo: radiant and definitive; as was her staunchly Catholic faith. She was dressed impeccably in something soft and feminine with an elegant print. Small, almost fragile earrings, the appearance of minimal makeup, her hair, colored to a pale shade of grayish brown and styled simply, was pulled back in a small chignon. She was at that time somewhere in her late seventies, breathtaking, with a kind of ladylike sexuality I found very attractive.

In addition to her many screen performances that I'd seen, I had religiously watched her successful TV series in the 1950s, *The Loretta Young Show*, in which at each opening and closing she descended a staircase or swept through a pair of doors, always impeccably groomed and flawlessly working her gowns. In every half-hour segment, she played a different character—plain or fashionable, even Chinese once. Always an intelligent, thoughtful, and proficient actress, her real magic came with her beauty and her focus. She had the gift of conviction and a reputation for a shrewdness as shrewd as any Hollywood mogul.

Years earlier I had made a TV film in which one of my col-

leagues was Alexis Smith, the beautiful, statuesque actress who played in dozens of films in the 1940s, '50s, and '60s. Alexis and her husband, Craig Stevens, invited me to their house on Fountain Avenue in L.A., which they had purchased from Loretta. Alexis described to me how, after they had agreed on a price, Loretta, with a yellow legal pad in hand, walked her through the house pointing out built-in things like Shoji screens and saying:

"Now, will you be wanting those?"

And when Alexis said, "Well, yes," Loretta quoted a price and marked it on the pad. The day Alexis and Craig took possession they drove up to the front door to find that Loretta had left them the two giant peach trees that stood on either side, but had removed the huge terra-cotta pots they'd resided in.

Once inside they found the house immaculately clean and "the largest grandest bouquet of flowers I'd ever seen on the living room floor, with a magnum of champagne and a note: 'Hope you'll be as happy here as we've been. Love, Loretta.'"

When Alexis went into the master bathroom she found a hole in the floor where the commode had been.

"She left me a bottle of champagne," she laughed, "but not a pot to piss in."

If Miss Young was in any way interested in talking with me, she was playing it very cool through the meal, giving most of her time to the man on her left, an old friend of hers, and to the guests across the narrow table. Sitting on her right, I did not press or flatter. I waited.

It was at dessert that she turned and focused on me entirely.

"Ronnie tells me you write as well."

"Yes."

"Would I have read anything?"

"Well, I recently published an article in the *New York Times* about actors and their demons."

"I'd love to read it. Will you send it to me? Ronnie will give you my address."

"Of course."

For the rest of the dinner she was mine. Totally attentive, charming, and funny. I was, of course, dying to ask her about Clark Gable, the alleged father of her daughter Judy, whom she had publicly claimed was adopted. But I didn't go anywhere near the subject of sex. Not because I sensed she was a proper, uptight lady, but because she created an intimacy between us that transcended it. She never once touched my hand or flirted or made any sort of suggestive remark. It was as if we were at a retreat or a bird-watch, observing and discussing the finer things of life.

At one point I quoted her my favorite line from the little homilies she read to the audience at the end of her television show. She would always hold a small book in her hand and say something to wrap up the evening. This night it went something like: *Mistakes are like knives. They can hurt you or help you depending on how you pick them up.*

She had no memory of it, of course.

"But it's true, isn't it?" she said.

At the end of her TV show, she would gently close the little book, look right into the camera and say, "Good night. See you next week?" Putting that statement in the form of a question seemed to me the essence of her charm.

I did ask her if the famous story about the collection box on her film *Come to the Stable* was true. Legend had it that she and Celeste Holm, who were both playing nuns, had decided no one on the set should curse and if they did they would have to drop a quarter in a little box, the proceeds of which went to the church.

The story was that Jerry Lewis or Danny Kaye or Ethel Merman (depending upon who told it) heard about it, came on the set, walked over to her and the box, and said:

"Here's fifty bucks, Loretta. Go fuck yourself."

I discreetly asked if there had been that kind of incident.

"Oh, he missed the point. [I think she said it was Kaye.] Celeste and I were only referring to taking the Lord's name in vain, not to curse words."

We got up from the table and she drifted toward other guests. A beautiful, smart, wily, and deeply religious woman and yet still one could imagine Gable saying, "Come off it, Loretta, and get over here."

The next day, I sent her the article and a few days later I received a note from her in which she told me that she couldn't find herself among the different types of troubled actors I'd encountered and writing that perhaps the greatest problem she'd had during the course of her career was that Bette Davis had gotten all the parts she felt should have come to her.

After reading that concern, I was reminded that we had met before in 1976. I was appearing as a talking lizard in Edward Albee's *Seascape* at the now-defunct Shubert Theater in Los Angeles. Word came back that Miss Young was in the audience and after a visit with Deborah Kerr, our star, she would like to say hello. I waited a full forty-five minutes in my dressing room before she appeared in my doorway, said something like, "Lovely," and drifted away.

"Was she with Deborah all this time?" I asked the stage manager.

"Oh, no," he said, "she was in the costume room. She asked to have your lizard costume laid out on a table and she took

a big piece of paper and copied the patterns on it and wrote down all the colors."

"Why?" I asked.

"Well," he said, "she's always been very interested in clothes and is going to design a gown just like it."

Loretta spent her last years married to the great costume designer Jean Louis and living in Palm Springs in splendor. She had married him, according to Ronnie, to "protect his fortune" from others. He died first. She remained devoted to the Catholic Church. My friend Carol Channing lived nearby, saw her often, and said that even while dying she was still ethereally beautiful.

The Iron Butterfly, as she had been nicknamed in Hollywood, fluttered her last, and gently passed out of existence at the age of eighty-seven. No doubt welcomed into the arms of her God, whose name she had never spoken in vain and whose forgiveness she must have sorely wanted.

Her daughter passed away just this year and the sad story of her mother refusing to admit to the world that she'd actually birthed her and Judy's pain and suffering over it, stands as a testament to a woman who, it would seem, valued artifice and religion far more than the love and comfort of her own child.

ROGER VADIM

Somewhere around 1967, I was in Rome and invited by my friend, actor John Phillip Law, to visit the set of his new film, *Barbarella*. He was shooting it with Jane Fonda at the Cinecitta Studios, directed by Roger Vadim and produced by Dino De Laurentiis. John and Jane, both at their most beautiful and fuckable, were floating high in the air on harnesses. He was playing an archangel with giant wings, and Jane, hot as a pistol in a skintight something, was clinging to his half-naked body.

I had, at that point, never been on a movie set and the atmosphere seemed to me incredibly casual and easy. There was much wine being poured, great camaraderie, and a total lack of tension. I don't ever remember hearing Vadim call *action* or *cut*. At the end of the afternoon shoot, John dropped the wings, and Jane left with Vadim, her lover and soon-to-be husband. As we were driving back to Rome for dinner I said to John, "I had no idea a movie set could be so relaxed. Is it always like that?"

"No," he said. "We ran out of film early this morning and Roger didn't want Dino to know, so we were just pretending."

Some twenty years later, Roger was directing me in an extremely explicit love scene opposite the exquisite Rebecca de

Mornay. It was the 1988 remake of *And God Created Woman*, a huge success in the late 1950s starring the French actress Brigitte Bardot, directed by her soon-to-be husband Vadim. This time there was film in the camera and he wanted Rebecca and me to do it his way.

I had seen the original film while at college, and it is impossible to explain how overwhelmingly erotic that now rather tame picture was to young men. Brigitte Bardot, an erection machine of epic proportions, never spread her legs wide for the camera but offered herself up to it with delicious humor and mystery. Most college boys, myself included, found her to be the single most masturbatory fantasy among an admittedly heavy arsenal of choices. Her breathtaking loveliness was made more desirable by Roger's appreciation of how important fantasy and imagination are in the art of engendering real sensuality and passion.

That day Rebecca and I were to do one of our three sex scenes. After the lights were arranged, everyone was asked to leave the set so it was just the three of us and the cameraman. My motivation in the scene was to perform oral sex on Rebecca, as she sat atop a pool table in a recreation room in my character's mansion. Lots of wine and we settled in to a hard day's work. As my mouth moved down Rebecca's throat, across her breasts, onto her belly, and my tongue gently slid across her thighs toward her vagina, I could feel Roger's breath on me, just off camera, urging me onward.

"Yes, Frank, yes that's it. Caress, caress, soft kisses. Now tease it! Tease it! Take your time. Yes it's good—you like it, don't you? Now licka de pussy! Mmmm!"

Most of the time, sex scenes (which are thankfully no longer required of me in films) are exhausting and a bore to perform. They are usually self-consciously shot and crowded with

makeup people, lighting guys, clapper boys, and the script girl reminding you when and how you faked your orgasm. Roger would have none of that.

Our faux ménage-à-trois continued through the rest of the day and several more, as Roger photographed me going down on Rebecca, she masturbating me in a Jacuzzi, and the two of us acting out sexual intercourse on a fur carpet in front of a roaring fire. Through it all, Roger never left our sides, urging, taunting, pushing us further and further. He wanted delirium. He wanted transcendence. He wanted orgasms. Sort of like a swimming instructor teaching you all the different strokes that can get you to shore.

Roger was not a particularly good director but I enjoyed his company and his sexual obsessions. I found his devotion to physical pleasure honest and exciting. He gave you the impression that if you were to knock on his door in the middle of the night, he'd accommodate any desire you might wish to indulge. He had with him at the time a very pleasant dark-haired woman, whose name I cannot recall but who seemed to love and understand him. There were explicit stories about Bardot, Jane Fonda, and Catherine Deneuve, three women, beautiful yes, but more importantly each unmistakable from the other and each a total original in looks and personality.

In his still thick French accent, which I found highly provocative, he held forth on womankind and sex in general. What was so much fun about him was his total immersion in and great amusement about the attitudes of the American male regarding it. He saw absolutely no reason for a male to outgrow discussing how one woman makes love as compared to another; or the size of her breasts or the tightness of her vagina. He did not see it as anti-female. Ungentlemanly, perhaps, but certainly not anti-female. I can still recall a 3 a.m. conversa-

tion in my trailer in which he suggested we make separate lists of our top ten blow jobs from famous women and then compare them as to expertise, duration, and repeat vendors. Again, ungentlemanly but definitely not anti-female. Women are certainly not shy about comparing male performance or penis size, and don't consider it anti-male. Only recently I was sitting in a makeup trailer listening to my world-famous costar telling her young makeup girl the best way to pleasure her boyfriend during oral sex with the artful use of her finger. This luscious lady would have enjoyed my conversations with Vadim as much as I did.

Roger's devotion to Bardot, Fonda, and Deneuve as women, and to their careers, was total and fully committed, and he managed while doing it, to retain his easy masculinity. After one of the marathon sex scenes, Roger and I ended up at the hotel bar where we were shooting in Santa Fe, New Mexico, and, once again, the topic was sex:

"You Americans are all pussy-whipped," he said. "You're afraid of your women; you're afraid of their passion. Women only want one thing. They want to be desired. And it's when we no longer desire them that they want our balls on a platter. I'd rather die fucking them than live being fucked by them."

And why wouldn't he? His taste was exquisite. The women he chose were not eye candy, airheads, or interchangeable generics. Secure enough to partner with strong, individual women, he set an example as a man who could love beauty, brains, talent, sex appeal, and strength in one woman.

When Roger passed away at the age of seventy-two it was heartening to see his former wives and lovers attending his

funeral. There they all were, most likely fondly remembering how much he had desired them. For however long the relationships with each of them lasted, he had been clearly doing something right.

JOHN GIELGUD

I was hoping for a morsel of wisdom. Looking forward to being in the presence of a great actor who would impart to me a revelation or two and perhaps even see in me a little bit of his younger self.

As a teenager, I had worshipped John Gielgud's voice and manner and his clear, precise, intelligent delivery of Shakespeare. So much so that I locked myself in the attic of my family house in New Jersey and listened to him deliver Clarence's speech from *Richard III* dozens of times on the recording of the 1955 Laurence Olivier film in order to eliminate the *Joisey* in me. It was, in fact, my delivery of that speech that got me into the Lincoln Center Training Program, among thirty other aspiring actors, headed up by Elia Kazan in 1962 as preparation for that company's first season.

So I was very excited when Kazan announced that the great Johnny G., his nickname in theatrical circles, would be stopping by to speak with us one afternoon. On the day, I got myself dead center in the front row of the folding chairs lined up in Chapter Hall on the eighth floor of the Carnegie Hall building on West 57th Street. "You," I imagined he would say, "I see something in *you!*"

In he came, impeccably dressed in tweeds, loafers, and a crisp white shirt and tie. *Sonorous* is the word often used to describe his voice, and indeed it was. But his mellifluous drone eventually sent me into a heavy-lidded semi-coma, and

I prayed he would not focus on my nodding head and blinking eyes. For well over an hour, Sir John seemed totally indifferent as questions were asked about motive, intent, inner life, or even style and technique. By the end of his time with us, I was left with the impression that he wished he'd not said yes to Kazan and that his approach to acting was a simple and perfunctory "Just get on with it."

Afterward he showed no interest in milling around or greeting us, but stepped off the little platform that had been placed for him, shook Kazan's hand, and passed through us as one might a group of lepers when spotting, in the distance, the last boat leaving the island.

Having sat through his enormously successful one-man show, *Ages of Man*, when he toured it several years earlier in my college town of Syracuse, New York, and been dazzled, I was now dashed by his remote demeanor and lack of passion. But he was, I thought, an old man of fifty-eight then and probably beginning to lose his marbles. Well, they bounced around merrily for another thirty-eight years, finally rolling to a stop and shutting him down at the age of ninety-six in 2000.

Sir John grew up in the English tradition that prized, above all else, clarity and precision, presenting the text to the audience beautifully pronounced. Over the course of his lifetime I saw him in a number of plays and films. And with the years he grew more honest in his work. That is to say he appeared more honest. His performance in *Home*, opposite Ralph Richardson, was superb in its minimalism and quiet intelligence. And, of course, he won an Oscar for playing Dudley Moore's butler in *Arthur*, a part that must have taken him all of thirty seconds to nail. After fifty years of playing all the great Shakespeares

and other classics, he must have found that win hilarious, adding to the Brits' natural disdain for the Americans' misguided worship of a posh accent.

We would cross paths many times over the years and he always greeted me as if we were meeting for the first time. While I no longer held his style of acting in reverential worship, I admired his resolve. He never stopped working. A devoted professional who took the risk of leaving his comfort zone and courageously joined, at one period, an avant-garde production of Peter Brook's *Oedipus* in which all the actors were asked to improvise, express their inner souls, and confess their fears. When it came John's turn to bare himself, he stood up and declared to the gathered company: "We open on Tuesday."

Unlike his contemporaries Olivier and Richardson, Sir John was exclusively for the boys, and one night found himself in the clink for having solicited a young lad in a men's room. Prior to his arrival at a rehearsal the next day, the director told the company it would be best to ignore the sordid headlines. When he sheepishly appeared in the doorway, Dame Edith Evans is reported to have sung out:

"John, you've been a *very* naughty boy!"

I encountered him one time in Cairo in 1987 while shooting a film entitled *Sphinx*—a real stinker.

"Hello John," I said. "What are you doing here?"

"Oh, I'm playing the little old man in the shop who gets his throat garroted. Just two scenes with your leading lady [Lesley-Anne Down] and home again."

I was surprised he'd taken a role so small and teased him about it.

"That's a lot of traveling just to get your throat cut."

"Well, dear boy. Someday you're not going to be pretty any longer and you are not going to be offered leading roles. Take the smaller ones but only on one condition. Make certain they're *effective*." It was an absolutely perfect and prescient piece of advice.

I have often thought of John when working with British directors and actors of his generation or mine, where the love of affect is more prized than emotional truth; sorting out the proper accent holding sway over sorting out the character's soul. The combining of both approaches is preferable, of course. The acid test, however, no matter the approach, is whether or not the audience *believes* you.

———————

When I read of Sir John's death, I remembered my most favorite moment in his company. It was 1975. I was appearing on Broadway, and into my dressing room trooped Anne Jackson, Eli Wallach, Hume Cronyn, Jessica Tandy, Irene Worth, and John.

They settled into chairs, making complimentary noises; but for the most part John was silent. Finally Annie said:

"Frank, tell John that story about how you used to imitate him in your attic as a kid."

"Well," I said, "I grew up in New Jersey and I wanted to lose my accent because I talked like this . . ." I launched into a thick New Jersey accent, using the words *coffee* and *talk* as examples. John gazed at me, stony and silent, but I pressed on.

"So I bought the *Richard III* album and copied you. I walked around my attic doing your monologues thousands of times and when I got to New York, everyone told me I sounded just like you."

A pause. And then in perfect Gielgud deadpan, he said:

"You're well over it, dear boy!"

ANTHONY QUINN

"**K**neel!" Anthony Quinn seemed to be saying when first we met.

———————

The word did not pass his lips but was certainly there in his demeanor. He was standing behind me on a line moving slowly toward the great acting coach Stella Adler. We chosen many were at the director Peter Bogdanovich's house for a party in her honor sometime in the early 1990s. Miss Adler sat on a throne-like chair raising her eyes to grace each acolyte as they came up, curtsied or bowed, said a few words of worship, and backed away, leaving the space to be filled by the next B-list ass kisser. I would come to know her better a few years later but I was there that evening just to kiss her ring and eat Peter's food.

Mr. Quinn was one of the very few major stars in the room. I had never met him before, and no one had briefed me on Quinn protocol. So I made the mistake of simply saying "Hi" as I turned around and saw him. Cold and imperious, he offered a limp handshake and prepared himself for some words of high praise along the order of "It's such an honor to . . . etc." But I turned back again waiting for my moment with Her Highness, who clearly outranked him that evening. There were audible huffs and puffs as he exited the line, followed by his handler and a cowering Mexican woman, retreating to a nearby appropriately overstuffed chair.

The handler returned to say that I had been rude to Mr. Quinn and perhaps a visit to his throne would be graced with forgiveness. My legs would not carry me there and the night passed without further contact between us.

Several years later I was at a party for my close friend Raul Julia, who possessed the gobs and gobs of appreciation for Mr. Quinn that I sadly lacked. When I arrived he was deep in happy laughter with him, both hands resting on his shoulders. As I approached, Raul gave me a big hug and said: "Tony, you know my friend, Frank Langella?"

Again the imperious look. Again the limp handshake. Picking up where we'd left off, I again said: "Hi," but no more. And again his immediate exit. For the rest of the evening he sat across from me under a dark cloud of expectation, but I spoke not a word to him. I couldn't have been more pleased at the consistency of our relationship.

I had one last chance to gain favor on a snowy evening in New York years later after some awards show. Ushered toward a stretch limo to move on to the after party, I was put into a seat facing the rear of the car. The attendant said: "You don't mind sharing with Mr. Quinn, I hope?"

We settled in. Tony, as I would only dare call him to you, sat in the middle, his handler to his right, the same Mexican woman to his left. What could I do? I didn't want to let him down. So I bit the bullet, leaned forward, stretched out my hand, and said (you got it): "Hi." And he didn't let me down either. Once more the proffered limp handshake and the glum stare. But this time he was denied his exit. We were on the move, and he was stuck with me.

For some thirty blocks we rode along in absolute silence as he stared past the Mexican woman out the window and into the winter night, in what appeared to be a seething fury.

I studied his granite face, in profile, recalling so many of

his performances in films such as *La Strada, Lawrence of Arabia, Zorba the Greek*, and dozens more. He was, after all, an iconic figure in film history with two Oscars up his sleeve and clearly one in his pants, having fathered at least a dozen children. Extremely creative, he acted, wrote, painted, and sculpted while prowling the world. But his aura was so sour and his sense of entitlement so pervasive that I was helpless to conquer my distaste for him.

Having suffered from occasional bouts of grandiosity myself, I let Mr. Quinn's pomposity get under my skin more than it should have. I like to think, with time, I've moderated that tendency, but he appeared to me to be a man incapable of an introspective thought. A big bully in the school yard or an imperious mob boss looking to get both his ring and his ass kissed unto death. It seemed to me that he was going to carry the worst of his nature to his grave expecting upon his ascendance a standing ovation and a seat very near The Throne.

I told the story of my three strikes and out with him to a renowned actress over lunch one day. And she said: "I made a picture with Tony. He was a complete pig. An animal. A rude, dumb peasant. I will never forgive myself for letting him fuck me."

Well, better than a limp handshake. Or not . . .

JOHN FRANKENHEIMER

"John Frankenheimer wants to meet you."

The year was 1968. The thirty-eight-year-old director of such films as *The Manchurian Candidate* and *Seven Days in May* was preparing a film called *The Horseman*, starring Omar Sharif, to be shot in Afghanistan.

"Be at his hotel at eleven a.m. tomorrow," said my agent. "I'm sending over the script."

I read it avidly. Sharif was the action hero; his sidekick, the part I was meeting Mr. Frankenheimer for, was a young Afghan boy. Lots of horse riding, guns, fiery women. A few of Frankenheimer's handwritten notes were scribbled in the margins. One scene read:

"They leap across a chasm. The hooves of one horse just miss the other side, and it plunges to its death."

In the margin, Frankenheimer had written:

"We'll have to kill the horse."

I showed up on time and called from the lobby. His phone rang and rang and rang. No answer. I waited. A call came down around 11:30. "Yes, sir, he's standing here. Yes, sir." The porter turned to me and said, "Please go up."

———

I had at that point in my career met very few important film directors. And at almost thirty, I had as yet to appear in one. I

was dressed neatly in a suit and tie and completely unprepared for the sleepy, unshaven man who opened the door in a hotel terry-cloth robe, stained down the front with what looked like fried egg. There was no smile, no eye contact. His hand shot out, firm grip.

"Take a seat, Frank, I'll be right back."

It was a plush, first-class suite, the usual amenities on the coffee table, large bowl of fruit, bottle of champagne in a bucket against which sat a square envelope with Mr. Frankenheimer's name on it. Both the champagne and the note were unopened. There were two overturned champagne glasses, a folded white napkin with a knife and fork waiting, as indeed did I for another thirty minutes.

Finally he emerged: neat wet hair, white shirt and trousers, bare feet, holding a newspaper clipping, and plopping himself down on the couch across from me.

"You want a cup of coffee?" he asked.

"No thank you, sir," I said.

He stared at the clipping for a while, put it down on the coffee table, and I saw it was from the *New York Times* Sunday Arts and Leisure section about me. It was my first major profile in an important newspaper; showing a fairly exotic picture of me.

I had made a success in a William Gibson play called *A Cry of Players*, opposite Anne Bancroft earlier that year, but this was my only nibble from a major film director.

"Okay, I'll tell the studio."

"Tell them what?" I asked.

"You can do it."

"You mean I got the part?"

"Yeah."

He then showed me some stunning photographs from his scouting expedition.

"Here's the kid who's doubling you. He's done some preliminary stuff with me already."

"But Mr. Frankenheimer, aren't I supposed to read or something? Have you seen me act?"

"I don't need to. You've got the face I want. You'll look good with Omar. He's average height. Thicker. You're tall and lean. Word is you're good. The part's yours. You'll make a good pair. Can you ride a horse?"

"Yes." I lied.

He got up and walked me to the door.

This isn't the way my film career is supposed to start, I thought. It's too easy. As I got to the door, I said just that.

He stopped, for the first time looked me directly in the eyes, and with a fair amount of impatience said:

"Let me tell you something, kid. In this business, an actor is in one of two positions: 'They want you or you want them.' If you want them you can be sitting on their desk, lighting their cigar, and they're not going to give you the part. If they want you, you can be in the Sahara, in a tent, fucking a camel, and the offer will come slipping under the flap."

He shook my hand and I left with my first movie role opposite Omar Sharif, no less.

A few days later my agent called and said that Frankenheimer heard that I had "crazy eyes" that couldn't work on film. I was indeed born with a condition called nystagmus, which meant that my eyes, in order to focus, vibrated slightly, often giving the impression that my eyeballs were moving from side to side. It is harmless, incurable, but at the time, thought possibly to be too distracting on film.

He told me that in order to play the part the studio heads said I would have to be put through a screen test. No acting,

just standing in front of the camera being photographed. The test would be in a week on a sound stage for a movie being shot in New York starring Gene Hackman and Estelle Parsons entitled *I Never Sang for My Father*. I spent that week rushing from doctor to doctor looking for a way to slow down my roller-coaster eyeballs for the length of a ninety-second screen test, trying prism glasses, muscle relaxers, and tranquilizers. I arrived at the appointed hour, profoundly overmedicated, standing quietly at the back of the set, watching Gene Hackman and Melvyn Douglas rehearse. On a break, the director, the just recently departed Gil Cates, came over, introduced himself, and escorted me to a spot on the floor. I stood painfully still and stared straight ahead. I overheard the assistant director say to Gil:

"What's this for?"

And Gil said, "I don't know. Studio wants to look at this guy."

The camera came in very close to my face. I stared into it for ninety agonizing seconds. It pulled back, Gil said thank you, and I was ushered out of the room.

At that point I was soaking wet, deeply embarrassed, and certain I would never appear in a movie for the rest of my life. I had, in fact, so tranquilized myself for the experience that I went home that afternoon, fell into bed, and slept through until the next morning. A few days later my agent rang and said, "You passed! Frankenheimer called and told me to tell you to start taking horseback riding lessons."

At the same time, Mel Brooks was preparing his second film, *The Twelve Chairs*, to star Alastair Sim, Peter Sellers, and Albert Finney. All three dropped out, replaced by Ron Moody, Dom DeLuise, and, to my great surprise, me. Mel asked me to play the young hero.

"What about Frankenheimer's *The Horseman*?" I said.

"That's a piece of action crap. You haven't signed anything, have you?"

"No, not yet."

"Well, call John tomorrow and tell him this is a much better part. He'll understand and let you go."

The part was indeed wonderful and would make a better film debut for me.

———————

I found John somewhere on location. It was not a good connection but I pressed on, shouting loudly into the telephone.

I began tentatively, saying more than I needed to, explaining to him that the character in Mel's film was a better opportunity, telling him I would be easy to replace—I was, after all, not a star, admitted I was not at all that good on a horse, and further opined that now he wouldn't have to worry about my crazy eyes . . . blah, blah, blah. I finally wound down, and there was a long, long pause. I thought we'd lost the connection.

"Mr. Frankenheimer, are you still there?"

Then came the following at full volume:

"You fucking motherfucking cocksucker. You are never going to work in this business again. Everybody told me you had crazy eyes that dance in your fucking head, and I was still willing to take a chance on you, you fucking faggot asshole. You better fucking show up on this picture. I've already spent money shooting your double. You cocksucker. You motherfucking cocksucker. You know what, you fucker . . . *fuck you.*"

Slam went the phone. There followed angry letters, threats, and a bill sent to my agent for $8,500 as "expenses related to Mr. Langella."

Through a friend I consulted a powerful labor lawyer named Sidney Cohn.

"You can pay this bill and wipe the slate clean," he said, "but I promise you they won't come after you. It's peanuts." He was right. They didn't come after me, and I didn't pay—at least not financially.

From that hang-up on the phone to the day he died, no offer from John Frankenheimer ever slipped under the flap of any tent in which I happened to be fucking a camel or any other mammal.

THE QUEEN MOTHER

"Come over. Paul's racing a horse at Epsom Downs," said my friend Eliza. The Paul's name was Mellon, the horse's was Mill Reef, and it was Derby Day in England in 1972.

I was working on a film in Paris entitled *La Maison Sous Les Arbres,* opposite Faye Dunaway and directed by René Clément. Faye would sometimes cause shooting delays for any number of reasons. This time, as I recall, it was her inability to decide the style of shoes to wear. So shooting shut down for a few days as assistants went scurrying in search thereof. I was now at liberty to hop a plane to London and hole up with the Mellons at a posh hotel.

I arrived the evening before, carrying my only suit and tie in a plastic hanging bag. Paul had taken a private corner of a floor and the next morning all the doors to our rooms were open and we padded back and forth, having breakfast and getting ready.

I noticed Paul donning an outfit I found rather amusing. Gray top hat, striped trousers, odd gray ascot, but I thought maybe owners of horses need to dress a certain way. The look of shock on his face when he got a gander at me took me by surprise.

I was wearing a perfectly decent suit I'd bought in Paris. A subtle Cerruti, light green.

"Oh Frank. You can't wear that," he said. "It's Derby Day. There is a code of dress."

"Well it's all I have."

Calls were made to see if there wasn't a way to get me properly outfitted, but we were due to get into the car in forty-five minutes and all hope was abandoned. It looked as if I would have to fly back to Paris and miss attending my first and only race at Epsom Downs. But Bunny, Paul's wife, said:

"It'll be fine. He won't be paid any mind. We must leave."

In several large Bentleys we joined the queue making its way to the race. Bunny had seen to baskets of delicious foods—deviled eggs, chicken and cucumber sandwiches, etc.—and buckets of champagne. When we arrived, nicely stuffed and happily high, we were taken to the paddock to visit Mill Reef and then ushered to our seats. It was a magnificent day, as I recall, with thousands of women out in their finery. An extraordinary combination of ill-fitting garish dresses and hats of enormous size in perfectly awful taste; sexless parade floats on high heels.

Then there were the men. Thousands dressed exactly the same as Paul. And me, a six-foot, three-inch follied Green Giant. It got worse. The horse won. Never mind that I had only bet five pounds. Never mind that I looked like a walking cucumber. Further indignities awaited me.

We were ushered through the crowds by a number of large women and courtly gentlemen into an enclosed area where Mill Reef and the jockey were waiting. Paul was suitably thrilled and not showing it. Bunny was, as always, perfect.

"Frank, why don't you and Eliza stand back by the fence. It's going to get a bit crowded in here."

And indeed it did. Because after a while, in came the Queen. Mill Reef was crowned, pictures were taken, and a trophy was handed over. And she was gone. I was gratefully spared the indignity of meeting her in all my bourgeoiserie.

The large ladies gathered us once more and we were again ushered up stairs, down hallways, and around corners. Finally we came to a door and were asked to wait a moment. I assumed they were bringing the cars round from some private parking area, and we were going to be put in a comfy room to wait.

The door was opened. Paul, Bunny, Eliza, and their other guest Charles Ryscamp, then head of the Morgan Library in New York, and I entered a large room, superbly sound-proofed. Coming from the excited noises of the racetrack and the shouts of the crowd, it was like suddenly being underwater in a calm sea. And who should come floating across this beautifully appointed space but Herself, The Queen of England. We were in her private box.

We formed a short line. Paul at the start. Me at the finish. The Queen was followed by Prince Philip, Princess Anne, and a jolly little lady known to all as the Queen Mum.

The absolute quiet of the room and the close proximity to the Royal Family gave me a slightly giddy Forrest Gump feeling as they chatted amicably and made their way toward me.

I may as well have been impeccably turned out and perfectly groomed because the Queen reached me, put out her gloved hand, said something like "Wasn't it thrilling? How lovely for Mr. Mellon," and passed on without removing her eyes from mine. The rest of the family followed in equally charming fashion with no one's eyes ever straying lower than my forehead.

Until along came Mum.

"How do you do, young man?" she said.

"How do you do, ma'am," I said.

She was wearing a dress gaily depicting a florid English garden, with a string of pearls wrapped round her neck. Holding them at the center bottom just above her impressive bosom,

she smiled broadly, stepped back, and gave me a head-to-toe perusal, saying with utter delight:

"My word—where have you come from?"

"Paris, ma'am."

"Oh. What have you been doing there?"

"I'm an actor. I'm making a film."

"How exciting for you. What's it called?"

"It's called *La Maison Sous les Arbres*. That means 'The House Under the Trees.'"

Only the tiniest pause and she said, grasping her pearls, with utter sweetness: "Thank you for telling me."

As if the green suit weren't enough, I had just translated the simplest of French words to England's Queen Mother. I could hear the equipment gearing up to help load my big dumb foot into my mouth.

Then came tea and crumpets, I think, but certainly booze as well and polite chat. The Queen Mum was a jolly camper, totally captivating, charming, and curious. Soon we were gently dismissed and back into the real world. Standing a level down we milled about waiting to be taken to the cars. I asked for a gents and was shown down a hall and around a corner.

Now what are the odds?

As I opened the door to leave the gents, simultaneously another door opened and England's great-grandma appeared all alone. A tiny smile and down the hall and around the corner she went in the opposite direction from which I'd come. Seconds later she popped back and said:

"Oh, dear. I seem to have lost the family."

"It's this way, ma'am."

"Oh very kind," she said, putting her chubby arm in mine.

"I'm so looking forward to your film. Is it in French?"

"No ma'am, it's in English"

"Ah, yes, of course. Easier for you I should think."

We walked back down the hallway, turned the corner, and I took her to the stairs that led back up to the Queen's Box.

"Oh, I know where I am now," she said. "I do hope I'll see it one day. Thank you so much," and she happily climbed back into the comforts of Royal Privilege.

I hope this next story is true. It was told to me by an attendant at the Palace Theatre in London, where Yul Brynner was appearing; in, most likely, his one millionth performance of *The King and I.* It seems the Queen and the Queen Mum were having words at intermission when being escorted into a private waiting room. The Queen was compulsively nattering on about something that was disturbing her. Finally, I was told, the Queen Mum turned to the Queen and said: "Elizabeth, stop it! *Who do you think you are?*"

Never too late for a good Mummy to discipline an unruly child.

AL HIRSCHFELD

Among my most treasured possessions collected during a lifetime of working in the theatre are ten original drawings of the dozen that Al Hirschfeld did of me in various roles. And but for a smudge of wet ink, I might have missed an extraordinary afternoon with him just months before this true genius left us at ninety-nine years old.

His last caricature of me was with Alan Bates from the Broadway production of Turgenev's *Fortune's Fool*, which had successfully played the 2002 season. Our producers had gifted each of us with a copy.

When the play closed, I took the drawing to be framed and noticed his signature was in a light blush color, different from all past ones. When I put my thumb over it, it easily smudged. So I picked up the phone and called his house. His wife, Louise, answered and I told her of my dilemma.

"Just a minute, darling," she said.

Then Al came on, "Hello Frank, what's up?"

"Well, I'm on my way to the framers to put you under glass, but your signature is all funny and—"

"Where are you?"

"Crosstown"

"Bring it over."

I hopped a taxi, got out at his townhouse on East 95th Street, was let in by a maid, and met Louise on the parlor floor.

"He's up in his studio," she said.

As I climbed to the top floor, I realized I had never, in all the times I'd visited for dinner parties, been to Al's inner sanctum. And there he sat in his famous barber chair, leaning on his famous wooden table, drawing. The ancient magnificent hands steady and sure and his voice strong and clear.

"Hello, Frank. Let's see it."

I instinctively leaned in and kissed him as he put down his pen and patted my hand.

"Nice to see you again."

He cleared the surface, took my caricature out of its plastic sleeve, and placed it carefully on the desk.

"Well, this is strange." And with one swift swipe of his thumb he eliminated his iconic signature as if wiping away a fresh coffee stain, and picked up his pen. I flopped onto an old worn couch and watched a little bit of theatre history being made.

So completely certain was Al of his gift and so completely in charge of his powers even still, that the sight of him, sitting at a table he'd sat at for decades, holding a pen in his hand, leaning over and making a simple, basic correction in his work, exemplified the essence of greatness to me. From those now gnarled, brown, blotched hands had come astounding caricatures starting in 1925. Some eighty years of work.

He was born with the gift, of course. Whatever force guided those hands from which flowed a few lines that evoked a smile, a smirk, a depth of persona so powerfully true, it was outstripped by the man himself who just got up every day, climbed the stairs to the top floor of his townhouse, sat down, and did the work. Nothing mysterious, nothing otherworldly or magical.

Part of his genius was his responsibility to and respect for his God-given talent. In his time on earth he recorded thousands of artists, and leafing through the unparalleled collec-

tion, there are to be seen so many tragic figures, profoundly gifted themselves to one degree or another but unable to sustain the gift throughout their careers. Al would capture their moment, bringing them a touch of immortality. As I watched him, I thought how uncomplicated and simple it must be in that head. "This is what I do. This is who I am."

He came to a rehearsal of Noel Coward's *Present Laughter* in 1996 and sat sketching me from the audience. Unfortunately, his hearing aid was turned up so high it was wreaking havoc with the sound system. But he was held in such awe that no one on the production staff would ask him to adjust it, so I went into the house and said, "Al, your hearing aid is interfering with Noel Coward's lines."

"Oh," he said, and turned it off. When the dinner break came, I ordered some food and invited him into my dressing room to continue his sketch work.

"Have you got a piece of costume or anything?" he asked.

"Yes, I've got a beautiful new silk robe."

"Okay, that'll do."

I put it on and Al sat on the couch, hearing aid back on, and did his miraculous thing while chatting about the current season.

In 2002, I was now comfortably sitting in the study of this great artist, ninety-nine and still at the top of his game. Louise came up with some tea and we all three sat and talked in the late afternoon light. Al asked if there was any banana cream pie left.

"No, darling, you ate the last piece for breakfast. Let's take a picture," she said. And I stood over Al with my newly signed and inscribed piece of history in my hand, which I treasure more than the other works of his I own, because I knew then it was going to be the last he would ever do of me.

As I was preparing to leave I said:

"You know, Al, I have a dear friend who's older than you even."

"Oh. Who?"

"Tonio Selwart, the actor. He's a hundred and five."

"Oh, dear Tonio. How is he?"

"Well, he lives alone now. Ilsa, his lady, died about forty years ago. He's totally blind, but gets up every day, bathes, combs his full head of beautiful pearl gray hair, puts on a crisp white shirt and his hand-made vintage Valentino jacket, and sits by his window. I try and visit twice a month."

Tonio had had some minor success as an actor as a young man in Europe onstage and had one good role in a film called *The Barefoot Contessa*, starring Ava Gardner, in 1954.

"Will you give him my love?" Al said.

"Why don't I call him?"

"Oh yes, do."

Tonio's phone rang and rang. I was about to hang up when his fragile but beautifully modulated voice said:

"Hello."

"Tonio. It's Frank."

"*Francesco. Cara mio. Come stai?*"

"*Bene, grazie, mi amico.* Guess who I'm sitting with?"

"Who?"

"Al Hirschfeld. He wants to say hello."

"Oh dearest Al. Put him on."

I handed the phone to Al and retreated across the room, and for the next ten minutes these two men of 105 and 99 laughed, reminisced, and vowed to get together soon.

When Al hung up the phone, he said:

"How lovely it was to talk to dear Tonio again."

"When was the last time you'd spoken?" I asked.

"Oh, about seventy years ago."

I took my precious cargo, kissed Al on the forehead, and made my good-byes. Louise saw me to the door and we made promises to get together soon.

———————

The next day I sent over a large banana cream pie. Louise called.

"Frank darling, Al wants to say thank you."

"Frank—how did you know it was my favorite?"

"I just took a chance," I said.

"Come over and have a piece with us."

"I can't, Al. But soon again. I promise."

Seventy days did not pass before he was gone.

ELIA KAZAN

"Does cigar smoke bother you, Frank?"

The legendary Elia Kazan, known to his intimates as "Gadge," was lying on the floor next to the chair in which I was sitting in the last row during an acting class in Chapter Hall on the eighth floor of Carnegie Hall in New York City. I was a member of a group handpicked by him, the Broadway producer Robert Whitehead, and acting coach Bobby Lewis for the Lincoln Center Training Program. There were about thirty of us including Faye Dunaway, John Phillip Law, Austin Pendleton, Barry Primus, and, for a brief period, Martin Sheen. It was 1962.

We were to be the nucleus of a new acting company that would perform at the yet-to-be-built Vivian Beaumont Theatre at Lincoln Center. A temporary space downtown called the ANTA would open in 1963, premiering Arthur Miller's new play, *After the Fall*, to be directed by Mr. Kazan.

At twenty-four, I was one of the youngest members of the group. I was living with a girl I had met in summer stock, and she sent my photo and meager resume to the casting people. On the day of my audition, I was sitting in one of the window booths of Howard Johnson's on 46th Street and Broadway, going over my monologue. A few minutes prior to my call time, I left and appeared at the stage door. It would be the first time I

was going to be backstage at a Broadway house. There were at least a dozen people before me. I stood in the dark and listened to howling, crying, shouting, and all manner of actorly sounds. When my turn came, I walked out onto the stage and, like a B-movie about getting into show business, I stood near a work light and began a Restoration comedy scene from a play I had performed at school. There were three figures approximately twelve rows back in the dim light of the theatre, watching me. Halfway through my presentation, Kazan sauntered down the aisle and leaned on the stage's apron.

"What else have you got, kid?" he said.

"Well, sir, I do know Clarence's speech from *Richard III*."

"Let's hear it."

He stayed where he was, leaning on the apron, not more than two feet from me.

I launched into the monologue I had done many times since I had learned it at college. It was my set piece. Toward the last few lines, I fell to my knees intoning Clarence's desperate plea to the jailor:

"Keeper, I prithee sit by me awhile. My soul is heavy, and I fain would sleep."

From my knees, I gently stretched out onto the stage floor, as if lying on Clarence's cot in his jail cell. I remained there, as Kazan turned away from me, walked back up the aisle, leaned over, and began whispering to the other two people who I later learned were Whitehead and Lewis. I could not decipher their whispered conversation but suddenly felt absurd lying on the stage floor of a Broadway theatre, looking up into the flys and straining to hear. So I raised myself back up and sat looking at the empty seats in the balcony, waiting.

Finally Kazan's voice rang out: "Okay kid, thanks."

I left the theatre and forgot about it. This was to be a ten-month training program with no pay and no guarantee you'd end up in the first company at Lincoln Center. In other words, a long audition at your own expense.

A few weeks later, on a Friday, the phone rang in my walk-up on 36th Street and Lexington Avenue.

"Is this Frank Langella?"

"Yes."

"This is Mr. Kazan's secretary. We've been trying to find you for three weeks. You didn't leave us an address, so we couldn't send you a postcard."

"What postcard?"

"You were chosen for the company. If you're not interested, we have to fill your slot."

"When does it begin?"

"Monday."

"Can I call you back?"

A long pause.

"We'll have to know by the end of the day, Frank," she said with a fair degree of impatience.

"Okay."

I called my dad, who agreed to send me a hundred dollars a week for the length of the training program. That, together with my girlfriend's salary as a nurse, meant I could afford to do it. So I said yes, which meant eight hours a day, five days a week of acting, voice, dance classes, and scene work.

Elia Kazan was all about his cock. He swaggered and posed, flicked his cigar, ran his hand down a woman's back when he talked with her, and flirted with men in a calculated feline fashion.

He was not present very often during the training program but when he did appear, it was always unannounced and casual. In he would come, lit cigar always in hand, small and sinewy, rumpled and relaxed. The women grew visibly excited in his presence, and desperately preened for his attention; even though he was cohabitating with one of them, Barbara Loden. All the guys wanted to be his buddy. He was, at that time, the legendary interpreter of great playwrights like Miller and Williams and a ballsy handler of equally great actors like Marlon Brando, Vivien Leigh, and Rod Steiger.

My manner of dealing with Kazan was to be virtually mute in his presence. I would not seek him out as my colleagues did. I would not curry his favor or ask for his advice. I thought I was being less an ass kisser than the rest, but the fact is I was scared shitless and closed off.

He, of course, knew this and baited me every chance he got. But I would not budge. I was polite, distant, and enigmatic.

He began a campaign to break me down. One afternoon I was asked by an assistant to pick up a script of Miller's *After the Fall*.

"Mr. Kazan would like you to sit in the audition and read the part of Quentin."

Jason Robards would be playing that leading role when the play opened the following year, but all the other parts were open. For the next week, I sat in a room with Kazan, Whitehead, and Miller as one by one the young actresses of the day came in to read for the role of Maggie, based on Marilyn Monroe; or for the roles of the mother, a mistress, and the first wife.

The routine was the same. Virtually every actress came through the door petrified and gave stiff, self-conscious performances. In each case, Kazan would get up, pass by me,

often squeezing my shoulder, then crouch down next to the actress and whisper quietly in her ear. There were literally dozens of them during the course of that week, and to each of them he whispered conspiratorially, holding their hands, asking questions, referring to some little secret he knew about them, often stroking their hair, patting their knees, or caressing the backs of their necks. I stayed three feet away and watched them, utterly mesmerized. Through intimate and intense mindfucking, he watered all those parched flowers and brought them into full bloom.

Some gave magnificent new readings; others limited, but better versions of their first try; and virtually all of them had emotional breakthroughs. The tears shed during those five days were oceanic. He was relentless in his search for their Achilles heel and was heartless in his desire to get what he wanted from them, for himself, and for the play.

Barbara Loden, his mistress, ended up playing the leading role of Maggie, and eventually became the next Mrs. Kazan. She was my very first taste of rampant favoritism. She was not altogether untalented, but certainly unqualified to play the role.

At the end of the last day of those auditions Kazan asked me to stay late. With everyone else gone, he said:

"Frankie, tell me what you saw this week. Who did you like and why?"

I launched into a critique of each actress as I remembered her, and he walked around the room, looking out the window and puffing on his cigar. He did not respond to anything I said. When I was done, he sat up close, knees to knees with me:

"I want you to do something for me, Frankie. I want you to

come to my office every day from now on and bug me. Hang out there. Let me know you're around. Ask me to watch a scene. Beg me to do something. Make yourself a real pain in the ass."

"Oh, Mr. Kazan, I can't do that."

"Well you're not going to make it if you can't do that," he said. "Think about it." And he left the room.

I would like to report that I even thought a little about Kazan's request. But such were my defenses and youthful arrogance that I simply dismissed them out of hand. I couldn't see beyond what seemed demeaning to me to his real purpose, which was to get me to want something desperately enough to fight for it and to reveal something of my inner emotions.

Close to the end of the training period, when I told my girlfriend I didn't think I was going to be picked for the company, she sat me down and told me this story:

"He called me up one day."

"Who?"

"Kazan."

"What did he want?"

"He asked me to come and see him in his office and not to tell you about it."

"What do you mean? Did you go?"

"Yes, I wanted to meet him."

"What did he say?"

"He wanted to know all about you. He asked about your family and your upbringing. He asked me if I ever thought you had been molested as a child. I told him I didn't know, and then he asked me if you were a great lay."

"What?"

"He said, 'Does he fuck you hard? How many times do you fuck in a week? Does he make you come? Is he hung?' "

"What did you tell him?"

"I told him everything. He made me feel safe. It was just the two of us talking about you. He really likes you a lot and thinks you have so much inside that you're unable to let out."

"Did he make a pass at you."

"Yes, but it felt like a test."

"Would you have fucked him?"

"Probably."

"What happened?"

"He thanked me for coming to see him and asked me never to tell you ever. But if he's not going to pick you for the company, fuck him."

I did not confront Kazan. I did not know then what to make of his questions. More than angry or hurt, I was flattered and somewhat perversely titillated by his interest in me.

A few days later, we all sat in a small anteroom, outside Chapter Hall, at the end of our ten-month program. Each of us would be brought in, one at a time, to be told our fate by Kazan, Whitehead, and Lewis. I remember Faye Dunaway, at the time close to Bob Whitehead, beaming as she came out of the room. Barbara Loden sat holding hands with Crystal Field, who would go on to become an iconic off-off-Broadway figure. Barry Primus walked out and said, "I'm in. I'll wait for you downstairs at the drugstore."

People came out, hugged and kissed each other, or rapidly made for the door, depending on what they'd been told. Then came my turn. Kazan was lying on the floor, resting on one elbow. Bobby Lewis sat on a straight-back chair. Bob Whitehead behind a foldout table. Bobby was looking sheepish and embarrassed and I knew instantly I was not going to be invited to join the company. It was left to Bob Whitehead to tell me how much they admired my abilities, but felt I was not quite

ready. Kazan sat up and leaned very near, almost like a lover, his mouth very close to mine:

"You're a mystery, Frankie. You won't let me in." I left the room and the building, ending ten months of intense study and work and went downstairs to meet Barry.

There was, at that time, a drugstore on the southwest corner of Seventh Avenue where members of the group would often meet. I came in, sat down, and said to Barry somewhat in shock: "Kazan told me he liked my work, thought I would do well, but wasn't going to take me."

"Why?" Barry asked.

"He said: 'Frank I don't know who you are and I can't work with someone if I don't know who he is.'"

I did not recognize Kazan's statement then as the gift it was. Fifty years later, I do profoundly understand his efforts to crack open my shell. And his rejection of me most likely helped to plant the seed for my much-needed journey of self-discovery. Of course, his motives had to be somewhat self-serving, but they were true to his method of working with actors, a profession he honored and understood more than most directors. He knew that greatness in acting cannot be reached until the actor himself is willing to tap the rage and pain inside him and mold it into art.

Several weeks later, I got a telephone call from Kazan's office:

"Mr. Kazan would love it if you could return to us during the season as a second-year trainee."

I declined.

Shortly before their season began, my career as a New York actor commenced with the starring role in a revival of Ruth

and Augustus Goetz's *The Immoralist*. In the afternoon, a glowing review of me appeared in the *New York Times*. My phone rang:

"Hey Frankie, it's Gadge. Listen, come on back to us. We're doing *Marco Millions*. You can play a coolie in it and you can be an assistant stage manager. I'll get you a little dough."

"But Mr. Kazan," I said, "why would I want to do that? Have you read today's paper?"

"No."

"Well," I said, "I'm playing the lead in a new off-Broadway show and it's a hit. I got my Equity card, and I'm getting fifty dollars a week."

"We'd love to have you back, kid," he said and hung up.

———

Those were the last words I spoke with Elia Kazan for over thirty years, until one night in a Los Angeles restaurant, I felt someone staring hard at me from across the room. I looked over, but from that distance I could not recognize him. My dinner companion said:

"Geez, it's Kazan."

I got up and walked toward his table.

"Hello, Gadge," I said and embraced him.

He beamed, took my face in his hands, kissed it, poked his finger into my chest, and said, "Frankie, my boy, you did it without me." He was right. But he had also been right thirty years earlier. I had been closed up tight as a drum and could have benefited from exposure to his extraordinary gifts, but at a price I was not, at the time, ready or prepared to pay.

I have always felt that talent such as his doesn't give you rights. Gadge was a serial fucker of women's bodies and men's minds, and used his profound perceptions about the human condition as cruel grist for his own ambitious mill. And,

worse, he deserted his friends by ratting on them to the House Un-American Activities Committee in order to save his own professional skin.

In 1999, when he was awarded an honorary Oscar, I was sitting in the front row at the ceremony. His speech was rambling, embarrassing, and out of touch. A man close to the end, who left us some great work and masterminded some extraordinary performances from some extraordinary actors.

During his standing ovation, listening to the thunderous applause being given to a singular force in my profession and a seminal figure in my life, I nevertheless remained in my seat with my hands folded.

ALAN BATES

The last words I spoke to Alan Bates onstage at the Music Box Theatre in the play *Fortune's Fool* during the 2002 Broadway season were "Give my regards to Vietrovo." They were in reference to a place his character had longed to be all his life; an estate triumphantly returned to him in the play's final moments. I said the words to his back as I watched him slowly moving into the wings, destined to spend his last days in his beloved fictional home. Alan is now buried on his beloved land in Derbyshire, England. "My Vietrovo," he would say.

He had been seriously ill during the run of our play. Pains in his legs, a gnawing ache in his stomach, and his longtime battle with diabetes occupied a fair amount of his time. Visits to my family doctor confirmed something ominous was brewing, but Alan refused exploratory tests. "I'll deal with it when I get home," he said, soldiering on, never missing a performance.

After we closed he faced hip surgery, and recovered, but ultimately surrendered to the pancreatic cancer that took him less than a year after being knighted by the Queen and winning a Tony for his consummate performance in our play.

Alan loved to act. Just as he loved all the other temporary pleasures: food, liquor, sex, gossip, fame, and spending money on expensive clothes. He bought them almost daily. One of our rituals during the play's run consisted of my plopping

down on the couch in his dressing room at the half hour call and reviewing our day. Several nights a week Alan modeled the latest suit jacket, coat, or sweater he'd purchased, often three or more of each on that day's spree.

"Look, Frankie," he'd say as he held up one of a half dozen silk shirts. "Extravagant, I know, but I'll have them for life."

"How long do you expect to live?" I joked.

He could not possibly have worn them out in the short time left to him, but he did finally wear out a fragile constitution beaten down by a broken heart. He'd lost a nineteen-year-old twin son, Tristan, in 1990 to an accidental overdose and soon after, the boy's mother to her grief. Then came the diabetes. "I think the shock brought it on," he'd say.

His surviving son, Benedick, in the play with us, was the tall tree on which he leaned. Ben and his wife, Claudia, presented Alan with a granddaughter, Sofia, in 2003. Another child was due to arrive in early 2004, close to what would have been his seventieth birthday. Children who will never know their brilliantly gifted grandfather.

They will be told that he was a great actor and it will be the truth. Alan was the real thing.

To be onstage with him was exceptionally thrilling, challenging, and now forever poignant in my memory. His technical skills were superb, but one expects that in a British actor, particularly of his generation. More dazzling was the humanity, intelligence, and humor he brought to his work, and, more honorable still, his deep respect for audiences. There was no such thing as a "saved" performance. We played full out every night. At the end of Act 1 we left the stage together, loosening our ties, removing our vests, and climbing the back stairs to our dressing rooms. We would review the act, clock what

worked, try to calculate where we might have gone too far or let down.

One early preview, I asked Alan if my character, written as an eighteenth-century fop, might be carrying on a dalliance with his constant companion, a fellow named Little Fish.

"Oh, I don't know," he said. "I think perhaps he says to himself, '*Well we've got twenty minutes.*'"

Laughter is the salve that eases the pain of strenuous parts in long runs, and Alan's capacity for it was infectious. He actually rocked with it, his face turning beet red, his eyes welling with tears. Many nights we collapsed on the stairs in hysterics over a missed cue or fallen prop. Not to mention the occasional bodily emission onstage, usually Alan's. The halls would echo with his howls of "Oh, dear me! What did I eat?"

We sometimes came close to losing it onstage as well—like kids in church with giggles threatening to erupt at any second. But they never did. It was Alan's restraint that kept us in tow.

He often came to my Upper West Side apartment on our free Monday nights and I'd cook him an Italian meal as he happily watched the telly. And at least four nights a week we dined together after our performance, often joined by colleagues in other shows. We both loved the camaraderie and delicious rivalry that goes on among actors. Alan particularly liked to tell the different ways actors can put each other down, and I would urge him to repeat my favorite stories to a new table of fresh blood. Two of the best:

A friend of his came backstage after seeing him in an Ibsen play and said:

"Bravo, dear. Bravo. I must say, you took it at such a clip. Very impressive. Nothing to do with Ibsen, of course."

Or this:

"Alan, sweetie, my host got us tickets in the last row, so we had a bit of difficulty hearing you in the first act. Fortunately there were plenty of empty seats after intermission and we were able to move closer."

We couldn't wait to review the things said to us after a show. One night I came in to see him and said:

"Guess what Madam Movie Star said?"

"Tell me instantly."

"You two look like you're having so much fun up there— too much fun."

"Silly cow," he said. "Doesn't she know how much work it takes to look like you're having fun?"

One night, Lauren Bacall and Kirk Douglas graced us with their eminence.

"Come on," Kirk said in the fractured speech he suffered as the result of a stroke, "we're taking you to Orso's."

Walking slowly behind them on Eighth Avenue, I asked Alan, "Did they say anything to you?"

"No. Not a word, dear. Oh, I know! During dinner, I'll say something nice about you and you do the same about me. They're bound to join in."

So for two hours, during war stories from Kirk about movies he'd made in the 1950s Alan and I gently mentioned each other's performances hoping for a morsel of praise from these two legends. Nothing! Kirk waxed rhapsodic about the old days and Betty ate in silence, occasionally wiping his mouth and once in while asking him to repeat something, whereupon

he would devilishly turn to her and say: "Whassa madder, Beddy, don't you unnerstand Anglish?"

Alan and I began to find their total lack of interest in mentioning either the show or our performances very funny. He would begin to kick me under that table but I avoided looking directly into his eyes. Finally, as we were getting up to leave, Betty said in her deepest baritone:

"Did you take this thing on the road first?"

"Oh yes" said Alan. "You see, our director, Arthur Penn . . ."

"Oh, Arthur directed this?" she said.

"Yes," said Alan. "He felt the play needed a bit of trimming so we took it to Stamford to shorten it. It was a bit longer than the show you saw."

Betty took an internal pause, then looked at both of us and said incredulously:

"Longer?"

We managed to get them into their car and on their way before collapsing on the stairs next to Orso in helpless laughter. Betty's one-word review became Alan's gag for the rest of the run. Every once in a while he would pass by me and in a deep disdainful basso he'd whisper the word: *"Longer?"*

His death has denied us all that wicked sense of humor and me the fun of doing *Fortune's Fool* with him in London as we had planned. Friendships are difficult to make and sustain later in life, but we forged one as colleagues and brothers.

We kept in close contact after the play closed, talking on the phone about our lives and the people or performances we'd just seen. One night he called from London and said, "I've had the tests, dear. It's the Big C."

We said all the things you say at such a moment and ended the conversation with his ideas for the London production. I

made extra efforts to call him from then on, but all too soon our conversations began to center on tracking his disease.

A few months before he died, I spent a week with him at his London house, sitting and talking in his garden, walking to the local market to collect groceries, and going every night to the theatre. Afterward we went to The Ivy or Sheeky's, favorite theatrical haunts, with Joanna Pettet, his companion, and Mike Poulton, our friend and adapter of *Fortune's Fool.* Alan was bald from the "cups of chemo," as he called them, and the radiation treatments, but jolly and gregarious as he table-hopped showing off his cue ball.

The flu felled me twenty-four hours before my planned trip to see him just before Christmas in 2003, but I rescheduled it for early January and we spoke on the phone almost daily up until five days before he died. In our last conversation, I asked if there was anything I could bring him. He answered:

"Just your presence, dear, and a few good laughs. Oh, I want you to see me in my hospital frock. Pale green—open at the rear. Mind your cold. See you in January."

At 5 a.m. on Sunday, December 28, Mike Poulton rang to say that Alan, who had been knighted Sir Alan only a scant twelve months before, was gone.

But never will he be so in my fondest memories. I will be able to see him again and again, pounding the table at dinner in helpless laughter, washing the dishes in my New York apartment while doing an hilarious Dame Edna impression, careening around the stage in transcendent drunken splendor, preening in his dressing room mirror saying, "I'm still dishy, aren't I?" or wickedly whispering Bacall's "Longer?"

I will feel him slipping his arm in mine as we head toward

Orso's restaurant, his leg giving him pain about which he never complained. I'll watch him jab a needle of insulin into his belly at a table in Joe Allen's after demolishing a bowl full of vanilla ice cream topped off with a giant chocolate chip cookie. I will hear his choirboy giggles, see the way he looked at and adored his son Ben, admire his supreme kindness to fans, and recall his humble courage under fire.

This, too, I will recall: We were walking toward the stage on the afternoon of our first preview in Stamford, Connecticut. Arthur had called us to rehearse our curtain calls. Alan stopped me in the dark of the wings and said:

"Frankie, they're going to adore you in this."

"You, too," I said.

"Let's not find out which of us they adore more."

So we took our bow together. And every night as we appeared in the upstage doorway moving toward the audience's applause, one of us would whisper to the other as we bowed low: "They just adore me tonight."

Had Alan allowed himself the final call he so much deserved, he would have known how much they did adore him. He was a gentle, loving man whose humor, grace, kindness, and humanity constantly humbled me. To watch him backstage as he struggled to his place before we took our curtain call together, clearly in pain and exhausted, then gather himself, smile at me across the way, and turn to face the audience, was a lesson in gallantry I carry with me still. No matter what, Alan was going to go on, not because the show must, but because his personal sense of integrity required it.

I'd give anything to have twenty minutes with him again.

ARTHUR MILLER

The look I saw in Arthur Miller's eyes was one I'd not once seen in the forty-two years I'd known him. We were dining at an Upper West Side restaurant in New York in early 2005. He had been in the hospital with pneumonia over the Christmas holiday, and this was his first time out in public. I arrived late, and as I bent over to give him a kiss, he looked up at me as he had done countless times in the past, and I expected to see that odd, wry, somewhat detached smile that seemed permanently fixed on his face and feel the hand that would come up, clasp mine weakly, and then return to tapping the table.

What I saw instead was a look of vulnerability and fear. He had lost a considerable amount of weight, and his eyes were sunk deep under the heavy-rimmed glasses he normally wore. His cheeks were hollow, his skin sallow, and his voice weak.

"Pneumonia all gone?" I asked.

"That's the least of it," he said.

For the rest of the evening he was quiet and fragile. Seated next to him was his companion during those last years, Agnes Barley, some fifty years his junior. She occasionally squeezed his hand, but they rarely spoke. I knew that night might be the last time I would be in his presence. Arthur stayed at his sister Joan Copeland's apartment for a time and then retreated to his home in Roxbury, Connecticut, where he died on February 10, 2005, at the age of eighty-nine.

My friendship with Arthur Miller, such as it was, revolved primarily around his failed play *After the Fall*, the story of his tormented relationship with the actress Marilyn Monroe. In the play he called her *Maggie* and named himself *Quentin*.

I met him first in 1962 when he was forty-six and I was twenty-four. I was asked by the director, Elia Kazan, to help audition young actresses for the play's debut. I read it the night before and found very little of the middle-aged hero's predicament anything to which I could relate. When I walked into the room, Arthur stood up, shook my hand, and sat back down.

I took my place in a straight-back chair slightly off to the side in front of him, and for the next three days did my job. When it was over he stood up, shook my hand, said thank you, and sat back down again.

After the Fall was badly received. The critical community found the play self-indulgent melodrama dancing heavily on Marilyn's grave. Arthur, who claimed he had written and finished it before Monroe's death, reportedly was stung by the play's reception and couldn't understand the resentment toward it.

We would meet again in the summer of 1977. I was asked to play Quentin in a production at the Williamstown Theatre Festival. I was now thirty-nine and better able to understand Quentin. But once again the vast majority of the critics loathed it.

Arthur did not appear at rehearsals, but arrived in Williamstown, saw the show, and came backstage.

"It's a monster part," he said as he walked into my dressing room. "There's a lot there to chew on."

"I can't seem to find his soul, Arthur," I said. He did not respond.

We walked to a boardinghouse in silence on the hot summer night and he joined the cast around a large wooden table in the kitchen where we normally gathered after performances. He was now sixty-one, still quite handsome, and causing palpitations among the women in the company.

Patting the chair next to him, he said to the young actress who was playing Maggie, "Come sit by me, dear." All the seats were now full and at least a dozen more actors stood against the walls, hanging on his every word. The rest of the night, he held court in an easy, detached, but friendly manner. And no one left until he pulled back his chair and said good night.

"Keep at it," he said to me, as he squeezed my hand, patted my back, and rubbed my shoulder.

———————

I would not see him again for six years when, in 1983 there being nothing of any interest on the horizon for me in the theatre, and just about to turn forty-six, the notion of taking another look at the role of Quentin appealed to me. So I picked up the phone and called the producer of the original production, Robert Whitehead.

"I want to revive *After the Fall* in New York. Do you think Arthur would give me the rights?"

"Ask him," Bob said. "Here's the number."

I prepared a detailed speech as to why I thought the play would be well received; a long time had passed since Marilyn's death, changing mores, etc., and nervously dialed the phone. He answered himself and listened patiently as I made my case.

"When do you want to do it?"

"Immediately," I said.

"Sure. Go ahead."

I secured the rights for a nominal fee and would produce it with partners that year at a theater on East 92nd Street in New York. Arthur was then sixty-eight and I was forty-six, exactly his age when I'd first met him.

We began pre-production in earnest. For several months Arthur came to my apartment at least four nights a week. I was married at the time with a son who was two and a newborn daughter. He never entered their rooms or asked to see them, was never anything but perfunctorily polite to my wife, usually just saying "Thank you, dear" after she gave us dinner and retreated with me to my office to work on cutting the play. *A View from the Bridge* was having a successful revival at the time, and Arthur was excited that *After the Fall* was going to be given a new life.

"Who knows," he said, "maybe the tide is turning for me."

If it was, Arthur was going to swim against it as hard as he could. He was completely agreeable to my cutting all the pontificating, sermonizing, and complicated plotlines involving the House Un-American Activities Committee, but totally unreceptive to any investigation into his hero's inner soul.

No matter how many ways I came at it, Arthur felt the character was not in need of any more investigation. He had been played originally by the great Jason Robards, a lifelong struggling alcoholic.

"You know these drunks," Arthur said, "they're all crybabies. I don't want that. Jason made fun of the character because he was afraid to commit to it. Typical boozer."

I asked if he would write me just one speech toward the

end of the play in which Quentin might show some remorse, perhaps shame, even a touch of self-awareness.

"I'll think about it," he said.

———————————

By now all the superfluous plotlines, extraneous characters, and Arthur's efforts to relate personal guilt to the world's guilt were gone from the play with his approval. It was a lean look into the character of Quentin and his relationship with his wife, Maggie. It was what I'd hoped it would be, a play primarily about Arthur Miller and Marilyn Monroe and their private pain.

One afternoon I went to his apartment on East 68th Street to work with him. It was a modest, small place, sparsely furnished, feeling like a struggling young writer's humble beginnings. He proudly showed me a wooden chair he'd made himself and brought in from Roxbury, Connecticut, his country home.

"So what's the anger about toward the play, do you think?" I asked.

"They can't forgive me. People can't bear to face their own aggression. But when you don't have resistance, you don't have the truth. If I don't blush from the truth, I know I'm writing badly. They accused me of being unkind, but they were very cruel to her while she was alive and idolized her after she died. No one wants to believe it but I began this play when Marilyn was alive and doing well. It's not a revenge play. And I'll tell you something, Frank, no matter what they wrote about her, they all sweat when she walked into the room. Every son-of-a-bitch sweat in her presence."

Inge Morath, Arthur's wife whom he'd met while still married to Marilyn, came into the room. She'd been the still pho-

tographer on Arthur and Marilyn's last film, *The Misfits*. She gathered up her camera equipment and headed for the door, declaring cheerfully:

"I hope you do this play while we're far away in China."

After she left Arthur said, "Just take the thing and run with it, Frank. I'll stay away."

After a long silence, he leaned forward in his rocking chair, put his hand on my knee, and said:

"Frank, I know what you're trying to get out of me. And I've got a line I think might work. How's this: 'They slept with the sword of guilt between them.' And it's true, you know, we did."

I wasn't quite certain how to respond to that line, so I got up and went into the kitchen to make some tea. When I came back I said:

"Arthur, do you mind if I speak very personally?"

"No," he said, "go right ahead."

"Tell me what you would like the play to say to an audience."

"Well, if you can pull it off, Frank, I think it can be a kind of warning. A help signal to people."

"In what way?"

"The knowledge that there are some people who just can't be saved, and you have to get out from under them and save yourself."

"But if we don't go deeper into the character of Quentin, and take a look at his responsibility, perhaps even his complicity, are we going to get that message across? It's very difficult for an audience to sympathize with a man who is so adored by everyone in the play; his mother, his wives, his friends, and a man who has had so much personal success. He'll just appear remotely curious about Maggie's plight and detached from his own emotions."

"Do you think I'm not stumbling around in the dark just like everybody else?" he said. "Maybe I can't show my vulnerability. You don't."

"But you can write about it, Arthur. You can give us something of who the man Quentin was before he met Maggie, and how her presence in his life might have changed him."

He sat silent in the living room, looking straight ahead. And then said:

"How about we have the Mother come in there and talk about him?"

I couldn't help myself. I laughed. His resolute lack of introspection was, in an odd way, charming and naïve. I thought, he must know this quality in him is part of his power over people.

It was dark now and for the first time during our months together, I said:

"Tell me about Marilyn."

I knew instinctively that he was not going to talk about their sex life, about which I and everyone else in America was curious. Nor did I think he would express any overt anger toward her. He was silent a long while. This is the story he decided to tell me:

"We were hiding out in a little place in Brooklyn. She had just tried to off herself and it had been a nightmare. The press was all over us. So we were secretly holed up in this apartment, and she did it again. I couldn't face another circus. So I looked for a doctor in the phone book in the neighborhood and called him. He didn't believe it was me, so I said I'd go down on the street and wait for him. He was only a couple of blocks away. When he got there, he recognized me and I brought him up–

stairs. He went into the bedroom and saved her life. When he came out, he told me she'd be okay.

" 'She's groggy now,' he said. He took out a prescription pad and a pen and handed them to me.

" 'Would you get her autograph for me?'

"I went in, held her hand, and she scribbled her name.

"He took it and said, 'You don't owe me anything. Don't worry. I won't tell anyone where you are.' "

Arthur was not a man to show deep emotion. But this moment was the closest I ever saw him come to genuine pain and sadness. After a few moments, I asked him for a tagline to describe the play for our ad campaign. Without missing a beat, he said, "How about: *'After the Fall*—a play about the death of love with a lot of laughs.' "

Once the production was locked in we began our search for a suitable Maggie. Jessica Lange turned us down. After a long reading Arthur rejected Michelle Pfeiffer. The next candidate, Kathleen Turner, was rejected by our director, John Tillinger. Next we offered the role to Judith Ivey, who was otherwise engaged.

Two days before rehearsals were supposed to begin we were without our leading lady. Into the room came a diminutive, dark-haired young actress. Tiny eyes, not much bosom, very thin, no obvious sex appeal. She read magnificently. Arthur said yes, Tillinger said yes, I said yes. We had our Maggie. This young actress was, at the time, seeing Arthur's agent, the legendary Sam Cohn. Her name was Dianne Wiest.

The first day of rehearsal, Arthur's only comment to John and me was "Don't lay anything on top of this play. Just do it." And true to his word, he stayed away. He came to the first preview, with Inge, and was wildly enthusiastic about what he saw. Dianne's performance would be closer to Judy Garland than to Marilyn in both demeanor and appearance, and she played the role with stunning vulnerability and pain. Arthur walked into my dressing room, tousled my hair, which was for him an enormous show of affection, and said: "You know this is a pretty good play."

We took a cab to a local restaurant to discuss it. I rode in the front, and when we arrived, Arthur, in his enthusiasm, jumped out and slammed the door just as Inge was about to step out.

"Arzhaa, Arzhaa," she said, "you slammed ze door on me."

"Oh, I'm so sorry, dear. I thought you were getting out on the other side."

"Vhy vould I vant to get out into ze traffic?" she said.

The play was being very well received during previews, and Arthur's spirits soared.

"Maybe enough time has passed," he said. "Maybe now they'll see." He was as jubilant as I had ever seen him. Not enough, however, to pick up any of the restaurant checks, which was, after all, true to form.

As we got closer to opening, emboldened by the audience's response, I made one last plea for an epiphany from Quentin. No luck.

"Well, would it be okay if Maggie slapped him?"

"Why?"

"Well, don't you think *somebody* should?"

To his credit, he laughed and said, "Yeah, yeah, okay."

The slap didn't help. Not to mention the fact that on opening night Arthur, the man who'd promised to "stay away," sat himself in the fifth row center of a small off-Broadway theatre, dominating the room. I rarely recall an opening night in which an audience sat as still and quiet as that one. When he came backstage, he said: "Tough crowd."

And I said, "Arthur, what do you expect? You were sitting smack dab in the middle. Everyone knew you were there." He seemed utterly oblivious to how inhibited the audience must have felt by his presence.

The next day, the reviews once again were critical of the lack of introspection in the central character I'd asked Arthur to investigate. And it was dismissed, once more, as Arthur Miller dancing on the grave of Marilyn Monroe. I called him late in the morning.

"They'll never forgive me," he said.

We ran for several months and closed having made not much more than a minor ripple. Arthur lived on for twenty more years. It was in that time that we shared many evenings out. I'm sure Inge's no-nonsense German stoicism must have appealed greatly to Arthur after Marilyn. The fact that Arthur was Jewish and Inge German added to the banter between them. Arthur would often say how he hated "cultural Jews—what a waste of a life," he said. "All that deep intellectualizing."

"We Germans don't have that problem," Inge said.

"No, you don't," Arthur said. "And Germany is a great country to die in."

Inge predeceased Arthur and, not long after, he began his relationship with Agnes Barley.

One evening as we were having dinner at Café Luxembourg on West 70th Street, Arthur was doodling on the paper tablecloth. After he finished, I said, "Would you sign and date that for me?" He did. I folded the paper and put it in my pocket.

"What are you going to do with that?" he said.

"I'm going to keep it and, when you're dead, I'm going to auction it off," I joked.

"Make sure you send a cut to my estate."

I still have the doodle, but I doubt auctioning it off would bring me a return on the monies spent feeding him over the years. His multimillion-dollar estate will just have to do without another dividend.

My futile efforts to get Arthur Miller to reveal the soul of his most biographical character fell on ears most likely deaf to anything but praise and adulation. My guess is he met his match in Marilyn Monroe, a troubled woman who most certainly needed a man with an available heart.

During his final decade, Arthur was not shy of accepting public tributes. The one I found most fascinating was an evening in which I watched him sitting on a dais, staring straight ahead, as his sister, Joan, sang "Bewitched, Bothered and Bewildered" to a packed house. When she got to the lyric "I'll sing to him, each spring to him, and worship the trousers that cling to him," I thought, well, why not. This was a man who, it seemed all his life, had courted and enjoyed worship. A man who, as a boy, had after all been given the nickname *God*.

ANNE BANCROFT

The most common cliché used to describe members of my profession is "Actors are babies." There are, of course, exceptions, but I would say the vast majority of us fit that description, with perhaps one additional adjective: "Actors are *angry* babies."

And I knew of no baby angrier than little Anna Maria Italiano, known to the world as Anne Bancroft; an elegant moniker about as suited to her as Cuddles would have been to Adolf Hitler.

———

We first met in the summer of 1966 at the Berkshire Theatre Festival in Stockbridge, Massachusetts. She was to star as Sabina in a production of Thornton Wilder's *The Skin of Our Teeth*, to be directed by Arthur Penn. Having been guided by Arthur to an Oscar-winning performance for Bill Gibson's *The Miracle Worker* and two Tonys—one for the play of the same title and the other for her Broadway debut in Bill's *Two for the Seesaw*, opposite Henry Fonda—she was at the top of her game, thirty-five years old, beautiful, funny, and angry. She died thirty-eight years later, still beautiful, funny, and angry.

I spoke at Annie's memorial service in New York, along with, among others, Arthur Penn, Mike Nichols, Patty Duke, and Sidney Lumet. A week or two later, Mel Brooks, her husband, rang and asked if we could meet. It took us a while,

but we finally managed dinner together in California, and I asked him how he was doing. "Still trying to please Annie," he joked, but neither of us laughed.

She was, indeed, just about impossible to please, and that flaw in her often obliterated the loving, warm, and fiercely loyal friend she was to those of us who tried hard to weather her storms.

It was the unpredictability of those storms that could lull you into a sense that perhaps time had mellowed her. Like sand suddenly rising to a fury in a benign desert, she could go from zero to sixty in as many seconds; her voice, body, and demeanor becoming lethal weapons deployed without reservation or discretion.

Potentially one of the greatest actresses of her generation, she was consumed by a galloping narcissism that often undermined her talents and forced her back into the persona of the little Italian girl she was; dancing on street corners near her birthplace on Sedgwick Avenue in the Bronx, and smiling for the customers.

She told me one day of a woman who stopped her on a street and said, "Hey Annie, I love your work."

"Thank you," she said.

"But don't smile so much, honey."

She also told me of a day she was walking through Bloomingdale's, stopped to smell some perfume at a counter, looked up, and saw a woman across the way smiling at her. She smiled back. The other woman returned hers with an even broader smile. And Annie said she felt inextricably drawn to this woman, wanting to go around the counter to embrace and kiss her passionately, until she realized she was looking into a mirror.

But in the summer of 1966, none of her narcissism was as yet disturbing, or even noticeable to my twenty-eight-year-

old adoring eyes. She, Mel, my girlfriend, and I became virtually inseparable friends. "Hey Mibby [Annie's nickname for Mel], these are the two kids I told you about from my show." The four of us spent almost every waking hour together, beginning that summer in Stockbridge, then in New York, Fire Island, and holidays for the next five years.

Our first summer together, after performances, we'd gather almost every night around a large table on a sunporch at the home of the playwright William Gibson and his wife, a renowned psychiatrist named Margaret Brenman, who was practicing at the Austen Riggs Center in Stockbridge. Those gatherings, peopled occasionally with the likes of the actress Kim Stanley, theater director Harold Clurman, and the Penns, were about as full of consistently riotous laughter as any I have ever known. Led by Mel, they were stupendous evenings of improvised insanity. I can still see Mel standing before us, singing "You're My Everything" to his imaginary penis, which grew larger and larger as he first took it in one hand, then both, flung it over his shoulder, wrapped it around his neck, tripped on it, and slowly began to roll it back in as if it were a garden hose on a storage wheel. Annie's hopeless, helpless laughter made it even funnier, and up she'd get, put on the music, and dance for us.

The production of *Skin of Our Teeth* was a giant success and sold out mostly due to her box office draw. Following that summer, Bill Gibson wrote a play entitled *A Cry of Players*, in which I would play young Will Shakespeare and Annie his wife, Anne Hathaway. It was to be directed by Gene Frankel. We first performed it at the Berkshire Theatre Festival in 1967.

Will was unquestionably the leading role, with Anne a strong support. She was doing the play because she felt a deep loyalty to Bill for *Two for the Seesaw* and *The Miracle Worker.*

After the first preview performance in Stockbridge, there was a note in my mailbox that at the second performance the order of the curtain calls would be changed. Annie had had the last call, with me preceding her. But from then on it would be reversed, with me taking the final bow.

I went to her dressing room, truly chagrined at the turn of events, and protested that I couldn't do such a thing. She was a big star, I was the new kid on the block, blah blah blah. She was putting on her makeup, brushing her hair, and generally avoiding my gaze in the mirror as I stood over her protesting. Finally she said:

"That's the way it's gonna be, Frankie. You got the bigger hand last night. It's your show, and I'm gonna look like the gracious star giving it up to the new guy. Now get the fuck out of here and let me get dressed."

So on she sailed, took her bow, turned, and flung both her arms out to the wings and presented me with a giant smile to the audience. There was no price to pay in our friendship, and a valuable lesson to be learned in how to understand and survive the playing field.

We then took the play to the Vivian Beaumont Theatre at Lincoln Center in New York where it was only moderately well received, but enough to keep us in the safety of an institutional theatre for a limited run.

Acting with Annie was another valuable lesson for me. Prone to the theatrical as I was, she helped by example guide me to a deeper, more truthful performance. She played for moment-to-moment honesty, never a gesture or a line reading just

for its theatrical value only, and she had an unerring sense of comedy, nursing every laugh she could find. There was, however, one moment in the play that she played with her eyes oddly placed. Somewhere in the second act, when it becomes clear that young Will is going to leave Anne for good, she says to him a line something like: "I love ya, Will. Don'tcha know that? I love ya."

Annie played it with heartbreaking honesty every night, her voice quivering, eyes welling with tears, standing about two feet from me. But she resolutely never looked into my eyes, rather focused deeply on the second button down of my shirt. I never asked her until well after we'd closed why she'd done that, and when I did she said, matter-of-factly:

"Oh, that's about where Mel comes up to on you."

———————

The play closed, having been personally quite successful for me, and she sent me a note at the final performance that read: "Congratulations Frankie. You've arrived! Now you're just another banana in the bunch." Her pragmatic advice did not stop there. When I was in Paris making a movie, I wrote to her jokingly that I was the toast of the town. She responded by telling me that too often a piece of toast can become a pile of crumbs. And when I was particularly miserable on another project, she wrote this: "Don't be afraid to fall on the floor and cry when you're unhappy, Frankie. Someone will pick you up. And if nobody's there, eventually you'll pick yourself up."

———————

Annie and Mel owned a townhouse on West 10th Street in New York, and my girlfriend and I lived in a four-flight walk-up on 61st Street and Third Avenue, for which we paid the exorbitant rent of $70.04 a month. For the next few

years we lived a best friends' life between the two places; daily phone calls, long late night visits to each other's homes, takeout, endless games of Scrabble, cards, charades, and trips away to exotic beach locations. They willingly climbed the four flights to our modest rabbit warren of an apartment, and we made an equal number of visits to their luxurious Village townhouse.

Annie was enjoying great success during this period, with several TV specials, starring roles in films, and, of course, her signature performance as Mrs. Robinson in *The Graduate*.

Pure coincidence caused us to rent a house together in Los Angeles in 1967 while she was shooting that film. I was cast in *The Devils*, the first production of the just-built Mark Taper Forum at the Downtown Music Center in Los Angeles, and the four of us took a house on a street in Beverly Hills called Bunting Way. Mel came out on weekends while he was editing his first movie, *The Producers*, and it was in that house that I began to see patterns in Annie's behavior that would rule her life and that she seemed never able to conquer.

Most evenings she, my girl, and I had dinner together after her day's shoots and before I would leave to do my show. Those meals were filled with set stories about the young Dustin Hoffman, Katharine Ross, and Mike Nichols.

"Mike's giving them most of the attention. He knows I don't need it, but the kids are really nervous. Dustin's got a lot of balls. Scared shitless but he'll try anything. Mike stuffs a handkerchief in his mouth to keep from laughing at him and ruining a take, but I don't think he's that funny. We did a scene where he's gotta come over and kiss me impulsively. I'd just taken a puff on a cigarette, and Mike said: 'Hold in the smoke while he's kissing you and blow it out after he lets you go.' I thought it was a stupid idea, so I just blew the smoke out thinking, 'This is a stupid idea.'"

One night she said: "Well, Dustin's not *that* nervous. We did the scene in bed and he was as hard as a rock . . . Short Jewish guys."

"By the way," I asked, "does Mrs. Robinson have a first name?"

"Yeah," she said without hesitation. "Queenie!"

Toward the end of the shoot, Annie had an accident on the set during the church scene. Doctors were called, an ambulance arrived and it took her back to the Bunting house. Up the driveway she came, ambulance lights blaring, with Mike and Dustin behind in another car. Both jumped out looking terrified and worried. As she was being carried upstairs to her room, Mike told me that she had fallen over backward while shooting that day. X-rays were taken, pills dispensed, and she took to her bed for a few days.

It would be an event that in one form or another took place on most every project Annie did through the years. It was her back, or her throat, or her legs, and always there would be panic, pills, tears, and bed rest.

One night at the Bunting house, I saw her give in to those fears in a profound way. Arthur Penn stopped by to say hello, and we sat in the living room talking until Annie returned from the set. When she arrived, still in Mrs. Robinson's makeup, looking just gorgeous, she joined us. She made a drink and launched into a description of the scene she had just shot. It was the hotel bar, where Mrs. Robinson and Benjamin meet clandestinely and then go upstairs to a room.

At about 11 p.m., the phone rang in the den. I took it.

"Frank. Hi, it's Mike. Is Annie still up?"

"Yes, she's right here."

"Can I talk to her?"

"Annie!" I called out. "It's Mike."

As she came toward me in the den, I saw a look on her face I can only describe as hostile panic. I gave her the phone, quickly left the room, and closed the door.

A few minutes later, she came out in a rage.

"Jesus, fuck. The fucking film got destroyed and we gotta do it again. They're still set up. I gotta go back. Fuck."

She grabbed her drink, went to her bag, fished around for a pill bottle, took out two Valium, and chugged.

"I'm not gonna be able to get it again like I did."

"Sure you will," Arthur said. "Forget what you did and do it fresh."

"What the fuck," she said. "Mike's only watching Dusty anyway."

She sat down in an armchair to wait for her car, and spat out a series of slights she felt she'd endured during the shoot and then began to sob uncontrollably, like a little girl who'd been told by her mother to stand in the corner before she could explain that whatever had happened was not her fault. Arthur, who had seen her through two plays and that Oscar-winning performance in *The Miracle Worker*, was brilliantly sympathetic and comforting. The car came, she went, reshot the scene, and the result was and is superb.

Annie would again work with Mike and George C. Scott in Lillian Hellman's *The Little Foxes* for Lincoln Center, a role for which she was totally unsuited, and again she would cover her anxiety with an imperious disdain. My girl, whom Annie managed to have understudy Maria Tucci, playing her daughter, told me that at the dress parade, as Annie stood on the stage in full regalia, nobody was paying attention. Finally, in a thunderous voice, she shouted out across the footlights, "Well?"

There was a deafening silence and Mike said:

"I'm not sure about your eyebrows."

"Yeah!" she said, "I know. They've held me back," and stormed off.

As the years passed, Mel's career zoomed higher. He won an Oscar for *The Producers*, but Annie had not gone with him to the ceremony. When his name was announced, she called our apartment in New York from their house in the Village.

"Oh Jesus, Frankie," she said, "he won. I was scared he wouldn't. I couldn't face it."

In 1969, she accompanied Mel to Yugoslavia, where we shot his second film, and my first: *The Twelve Chairs*. She was a great and loving pal throughout the shoot, warming my feet in the dressing room when I'd come in from the cold, watching dailies, giving great notes to Dom DeLuise and me and generally keeping everybody's spirits up. I had ended the relationship with my long-term girlfriend before filming began and Annie mothered me through an on-set affair.

The Twelve Chairs and *A Cry of Players* also ended my working relationship with Anne and Mel. But our friendship continued on for another twenty-four years. In that time they became fabulously wealthy, holding on to their house in Fire Island, buying another beach house in Malibu, an apartment in New York, and building a magnificent seventeen-thousand-square-foot home on La Mesa Drive, one of the most beautiful streets in Santa Monica. I married in 1977, had two children, and Annie gave birth to their one child, Max. A huge phalanx of assistants, nannies, gardeners, and secretaries looked after their every need.

Lifestyle was now a dominant factor in her life. A multi-tiered garden, trips to London ("Max needs silk underwear," she'd laugh), and purchasing fine art became all-important to her. She ventured onto Broadway with not much success in William Gibson's *Golda* and other plays, but the conditions had to be perfect, the roles central, and the director and other actors needed to pay homage or she'd fly into a rage, at one point famously throwing a full cup of coffee at an actress who'd disagreed with her. Everyone, she felt, was either intimidated by her, jealous of her, or not talented enough to keep pace.

One day, she called and asked me to come over and read a Shakespeare play with her.

"Olivier wants me to join some company he's forming," she said.

We read it out loud and she grew increasingly irritated.

"I don't get it," she said. "I just don't get it."

Finally she took the script, tore it in half, and flung it across the room.

"Fuck it. No way I'm doing this shit."

The narcissism did not abate as she grew older, and her need to control her environment became more and more stultifying to me. One night in a Malibu restaurant the dam broke. It was 1991; I'd moved my family to Los Angeles earlier that year. We fell into a reminiscence of our time in the 1960s, and the fun we'd all had at the Bunting house. I started to tell my wife the story of the late night phone call from Mike Nichols, Annie's anger, then fear, and her drowning two Valium with a glass of Scotch. I pointed out how wonderful Arthur Penn had

been with her, and how she'd gone back to the set to do the scene perfectly again. There was complete silence as I spoke, and Annie stared at me incredulously, storm clouds gathering. The sound of the waves outside were then muted by her furious explosion.

"That never happened," she said. "What the fuck are you talking about? It never happened!"

The voice was gaining in power and volume.

"Annie," I said, still easy, "Arthur was there. You went back to the set and did a great scene."

"It's a fucking lie, Frankie," she said, and flung her napkin across the table into my face. "I know it probably makes a great story for you to tell your friends, but . . ."

And all the years of accommodating her rages finally overwhelmed me, and I said, in full voice, like a bad movie when other diners stop and stare, things I shouldn't have said, ending with a bitter insult that was out of my mouth before I could censor it:

"And it's not even a good story I tell to my friends, Annie. Nobody cares about Anne Bancroft stories anymore."

And I was gone, out into the Malibu night. My wife chased after me as I found our car and had to endure an hour of ranting on the drive home. When we arrived, the phone was ringing. It was Annie and her apology was typically non-introspective and self-serving.

"I've been going through a rough time lately," she said.

I was unsympathetic, getting off the phone as quickly as I could.

Our friendship never fully recovered. In 1995 I sold the house in California, divorced, and moved back to New York. Annie and Mel loyally came to every play I was in and saw every movie; but that night in Malibu was a death knell for the thirty years of intimate togetherness.

And when the death knell of cancer sounded inside her body, she managed to keep it a secret from most of her friends. She did not reach out to me in her final years, and I was unaware of the extent of her illness until one afternoon in June 2005 when my phone rang. I was shooting a film entitled *Superman Returns*, and living forty miles outside of Sydney, Australia, on a hill overlooking the Pacific Ocean. It was a friend calling.

"I'm really, really sorry about Anne Baxter," he said.

"What do you mean," I said.

"Oh, I mean Anne Bancroft. She died."

After we hung up, I opened the French doors to the patio and walked out listening to the Pacific, remembering the night thousands of miles across it in Malibu that I had thrown away a close relationship with a woman who could be so funny, warm, and smart, but a friend I could no longer tolerate. Any relationship in which one party feels even the slightest sense of diminishment had become for me a relationship not worth enduring. I did not so much regret my decision to pull away from her as I did bemoan the demons that held sway inside her; they becoming the friends she most listened to and believed.

I have never asked Mel if Annie found some respite during her final years. I hope so. All of the good in this remarkably talented woman deserved to.

MAUREEN STAPLETON

Implicit in Oscar Wilde's *The Picture of Dorian Gray* is the notion that physiognomy is destiny.

By her own admission, Maureen Stapleton was fat and homely and needed to "become somebody else" to survive. The somebody else she would become in her first film, *Lonelyhearts*, would be a fat, homely woman. It was 1958. She was thirty-two and she would get an Oscar nomination for her performance. Already a star in the Broadway theatre by 1950, playing Serafina in Tennessee Williams's *The Rose Tattoo*, another fat, homely woman, this time in love with a truck driver, she won a Tony for her performance.

In Mo's case, the Wilde reference was sadly prophetic, but she was not someone for whom I ever felt sorry. She was tough, funny, shrewd, talented, unsentimental, and not without sex or love. She married a guy named Max Allentuck, had two kids, a ten-year affair with the eighty-year-old Broadway producer/director George Abbott when she was in her forties, and married again after that. A lusty Irish lass.

She finally, after four nominations, won an Oscar for *Reds* in 1982, but "so what," as she was fond of saying of just about anything. Famous for her fear of flying, she almost didn't get that Oscar, needing to get to the location in Europe by boat and back.

————

We were never close friends, despite the many times I spent in her company. There would invariably come a point when she passed into a place that I found repellent and I slipped away from the party or the actors' hangout. She did not inspire in me the need to protect or save her; but more the desire to take her by the shoulders and shake her like a beer can until it exploded. Had I tried it though, she most likely would have attempted castration.

Ditzy though she may have appeared, she was nobody's patsy.

When a young actress kept upstaging her in a play's previews, she did nothing. One day when a friend who'd been to see the show mentioned it to her and asked:

"What are you doing about it?"

She replied, "I'm killing the cunt with kindness."

And she could be outrageously and irreverently funny.

At a wrap party for the movie *Bye Bye Birdie*, which would introduce the luscious eighteen-year-old Ann-Margret to the world, she sat through a bunch of speeches from the director, producers, and studio heads paying tribute to her and costars Dick Van Dyke and Janet Leigh. All of them spent an inordinate amount of time praising Ann-Margret's talents and predicting a stunning future for her. Mo got up to the microphone and said: "Well, I guess I'm the only one here who doesn't wanna fuck Ann-Margret."

My personal favorite is a drunken ride home she had with the agent Milton Goldman. Openly gay and openly alcoholic, he was a mainstay in the New York theatrical community. The story goes that on a rainy night in winter, they were return-

ing from an event, drinking heavily in the back of a limo and singing Irish folk songs at the top of their lungs. When the car door opened at Mo's townhouse, they tumbled out into the gutter laughing hysterically. As the driver picked them up, put Milton back in the car, and dropped Mo at her door, she is reported to have called back to him:

"Milton, I love you! If you ever want to fuck a woman, I'm your man!"

————————

I had my own drunken rainy night with her as well, which did not end with much hilarity.

We shared a stage at the New School one evening discussing various approaches to acting for an invited audience. She was totally sober and brilliant. Her basic advice: "You gotta mean it baby." No artifice, no method or system. Just be honest and do it. And she resisted all attempts from a questioner to idealize her or the profession. A good, solid, talented woman who could not be drawn into preciousness or mystery. "I'm a worker," she said.

We were deposited in the back of a limo. It was pouring down rain, the traffic was brutal, and we both needed to be dropped far uptown.

"Geez, I'm not gonna make this ride, Frank. Hey, driver, around the corner is a place I know. Pull up there."

She jumped out in the rain before he could come round to her door with an umbrella and ran in. Fifteen minutes later, she returned, visibly altered and carrying a carafe of white wine and two glasses. All three were tightly covered with plastic wrap and filled to the brim. She got in, handed me one glass, put the carafe between her legs, and told the driver to stay still for a few minutes as she delicately uncovered her glass, brought it slowly to her mouth, and sipped its contents

so as not to lose one drop. For the rest of the trip we rode in bumper-to-bumper traffic as she consumed her glass, mine, and the full carafe.

With each block, she grew more incoherent and scattered, but still funny. She was then appearing in *The Little Foxes* on Broadway with Elizabeth Taylor, whom she adored.

"She thinks that shit Burton loves her," she said. "Boy, everybody and his cousin came to see Elizabeth in that turkey."

Of Betty Bacall, with whom she worked, she said, "I stay out of her way till they feed her."

By the time we reached her house she needed my help getting out of the car, finding the key to the door, and going up the stairs. I left her leaning on her banister looking down at me as I returned to the front door. When I turned back she had sunk to the floor and was out like a light.

When riding in the back of the car with her earlier that night, at some point I started talking about our work; the endurance a life in the theater needs, the concentration it takes, and the insecurities of being an actor. Lying with her head back on the seat, the glasses and carafe empty on the floor at her feet, she looked over at me and said, "Who gives a *fuck!*"

WILLIAM STYRON

"What can you say about a man?" Marlene Dietrich once intoned in an Orson Welles film entitled *A Touch of Evil.*

I can't say much about Bill Styron. But what I can say, I think most men will understand and all women indulge.

Reading his obituary in November 2006 brought back a lazy afternoon at the Pierre Hotel in New York sometime in the mid-1970s. It was the only time he and I would ever meet. We did not look into each other's eyes, we did not even shake hands, but I certainly took his measure.

That particular day, I was happily making love to a luscious young French woman. The Pierre was where our clandestine liaisons always occurred and always in the afternoons. Our affair had been going on for several years, starting in Paris where we met, then in Los Angeles, New York, the South of France, the Italian Riviera, anywhere our work schedules and her other liaisons would allow. This lady collected lovers the way most women collect shoes and she had very little interest in either the institution of marriage or the practice of monogamy. She was a sexual outlaw and I was very happy to be another notch on her garter belt for as long as she'd let me.

Contrary to belief, women do talk. This one certainly did. Her reminiscences were vivid, explicit, and detailed, and her

adventures were worth listening to: a British actor, at the top of our profession at the time, gay before she brought him across. An heir to a food chain fortune, impotent until she found the key to restore his manhood. Actors, athletes, rock stars, politicians—all had entered her pearly gates and found salvation. And, oh, yes, writers too.

As the lady was running a hot bath, I picked up her see-through negligee and, for a gag, slid naked into it. It flowed to the floor on her, but on me just made it to the knees. I reached around to grab the sash and tie it but felt a large double knot on one end. I was beginning to pick at it as she came into the bedroom.

"Oh no, dahlink! Don't do dat! Dat's Bill's knot."

"What?"

"Bill Styron. He put it dere! It's de size of his cock. He told me to tell my next lover to say hello for him."

"*The* Bill Styron?" I asked, holding his message in my hands.

"Yes dahlink!"

"Pulitzer Prize winner? Author of *Confessions of Nat Turner*?"

"Yes dahlink!"

"Hard or soft?"

"I don't remember!"

It certainly didn't weigh very much, and I let it drop, slipped off the negligee, and hit the shower. But once the soap was in my hand, I began to wonder. So I went back into the bedroom, while she luxuriated in her bath, to test possibly more dangerous waters.

She could have been joking, of course. Mr. Styron could have put the knot anywhere he chose and I could have not picked up the gauntlet. But there I stood mauling and measuring myself against a man I had never met, with whom I had little in common, but who had succeeded in baiting me into a futile and childish competition. Having satisfied myself that

we were, like the majority of men on this planet, equal, at least in adolescent behavior, I undid the knot and retied it to my own specifications, perhaps coming in just a stroke above par. Later as we sat down to our meal, I told her I'd taken his challenge.

"Ouf! You men!" she said. "What does it matter?"

———————

Sadly, this enchanting creature left the planet in 2011, leaving a great many men the better for her lack of interest in their penis size. It profoundly stopped mattering to Mr. Styron, of course, at the time of his passing. There is, I suppose, something to be said for dropping dead before it does.

BROOKE ASTOR

No question about it. Brooke Astor had pheromones.

One evening her daughter-in-law, Charlene, rang to ask if I might like to have dinner with her and her husband, Tony Marshall. "His mother will be joining us," she said. "I'm sure you know it's Brooke Astor." I did not. I was then cohabitating with a woman at 151 East 79th Street, who traveled as much as I did and was away at the time. The Marshalls occupied the second floor. We met in the elevator and exchanged numbers. Also in the building lived Dede Brooks, then the head of Sotheby's. Both Dede and Tony would later be involved in infamous scandals. She accused of price fixing, he of trying to steal his mother's fortune. But this was 1998 or thereabouts and both were, as yet, pillars of society, valued dinner guests, and innocent until proven . . . !

The Marshalls, Mrs. Astor, and I gathered in a local restaurant and in less time than you could say, "Show me the money," this doyenne of New York society was vamping me and inviting herself up to my apartment, which was some dozen floors above the Marshalls'. I opened a bottle of champagne and she asked for some music. "Something we can dance to," she said.

And dance we did—on the floor of my black and white marble foyer. Graceful and light on her feet, she let me lead, moving with the confidence of a woman fifty years younger. Then she departed with Tony and Charlene in tow. The next morning her chauffeur delivered a small bouquet of violets

with a note written in a bold, firm hand that ended with the charming phrase "I'm looking forward to a long friendship."

An invitation for dinner at her Park Avenue apartment arrived soon after and I accepted.

At most dinner parties, the host or hostess is there to greet you whether you are the first or last to arrive. At a dinner given by Brooke, as she asked to be called at our first meeting, it was the reverse. She did not make an appearance until everyone invited had gathered. The servants were dressed in white jackets for the men and traditional black and white French maid uniforms for the women. They were discreet, soft-spoken, and invisible. And the guest list was an interesting mix of people: Joan Ganz Cooney, creator of *Sesame Street*; David Rockefeller; Philippe de Montebello, director of the Metropolitan Museum of Art; Kofi Annan, then secretary-general of the United Nations; and other such luminaries.

After the supporting cast was gathered, Brooke's butler would quietly announce that Mrs. Astor was about to arrive and we took our places in the foyer. Down the hall she sauntered, swinging a newspaper clipping, her diminutive figure beautifully gowned, hair elegantly coiffed, jewelry expensive and tasteful. Ninety-five and totally with it. A small woman with big style. She engaged with each of us, asked a personal question, then handed the clipping over to someone. "I thought this was interesting," she said. It was then passed around among us.

We milled about the living room, being served drinks and canapés. If you were a man, at some point you found yourself at Brooke's side and the absolute center of her attention. When dinner was announced Brooke put her arm in the guest of honor's, on this evening it being the secretary-general. He led the way to a beautifully lit and exquisitely appointed dining

room. The conversation was lively and spirited and the food delicious. At dessert, Brooke tapped her glass and the subject of the night was raised.

This particular evening was a few days after George W. Bush's first inauguration.

"I'd like to hear what everyone thinks of the new man."

And round the table we went, some sixteen people, offering their opinions of how they thought the President might do. This was pre-9/11 and the comments were, for the most part, pro or guardedly cautious. When it came my turn, I said:

"I didn't vote for him, but he's my President and I'll keep an open mind. I did hear though that the day after his inauguration he came into his first cabinet meeting with a large, irregular reddish purple mark painted on his forehead and when asked what it was, he said:

"'I had a meeting with Gorbachev last night and I asked him what it would take to be a great leader. "Well, Mr. President," Gorbie said, pointing to his forehead, "first you have to have something up here."'"

It was the first Bush joke I'd heard and it received a mild and indulgent reception from the gathered, mostly Republican guests. Brooke then asked the secretary-general to speak and he stood and delivered a beautiful tribute to her and his hopes for the future of the United Nations. After dinner we gathered in her library: the walls painted a deep red lacquer. Over the mantel hung the infamous painting, *Flags Fifth Avenue*, by the Impressionist Childe Hassam, which Tony had later reportedly sold and from which he was reputed to have kept a large commission. Coffee was served and we were out the door no later than 10:30 p.m.

I enjoyed a few more evenings at Brooke's apartment. The guests were always stimulating, intelligent, incredibly successful and gifted people. As for the newspaper clippings always

proffered, my favorite was one Brooke had spotted for a shoe sale in New York the next day. "It looks very good," she said. "I'm planning to go."

My relationship ended and I was in the process of selling 151 East 79th Street when an invitation to Cove End, Brooke's beautiful house in Maine, arrived. There were several guest houses on the property and I was invited by the Marshalls to stay in one of them. The house is unpretentious, beautifully cared for, and very comfortable—if you are no taller than five feet. All the furniture is scaled to Brooke's size and I would find myself sitting in the living room or at dinner on chairs that would have challenged Alice at the Tea Party.

One Friday in late May, I drove up and stopped at the main house to be greeted by a lovely woman who told me that Mrs. Astor would like me to stay there for the weekend rather than in a guest house. I was ushered into a small ground-floor bedroom off a hallway leading to a large reception room. The living and dining rooms were just off the main entrance, with a door leading out to a patio facing the road and the water beyond. It had been Brooke's residence for some forty years or more, purchased for her by Vincent Astor after their marriage.

"Mrs. Astor is having a walk, but would like you to make yourself comfortable," said the woman.

I unpacked, fixed myself a tonic water from the tiny bar by the patio door, and wandered the downstairs. Beautifully appointed, elegantly simple, and utterly safe in design: low ceilings, Lilliputian furniture, pale yellow flowered prints. Animals depicted everywhere in paintings, porcelains, pillows, rugs—mostly dogs and horses. Many evocations of her two dachshunds. In the hallway there was a small sketch in watercolor. On it, it said "Brooke's Boulder, August Moon

74—Truex." There was a painting over the mantel in the living room of five boys, two on bikes watching a baseball game. And another of five pigs, the last one being the fattest, with a caption reading, "Last But Not Least."

The house, the furniture, the art, all said: "we practice safe sexlessness."

Into the door came Brooke with a glint in her eye and a spring in her step. Dressed all in beige: straw hat, exquisite cardigan, open white blouse, tan skirt and shoes. Around her neck a string of pearls. And over it all a long brown coat. Pulling off her gloves, she proffered her cheek.

"Are you comfortable? Is your room all right?"

The maid appeared with a pair of slippers, kneeled at Brooke's feet, removed her shoes, and slipped them on for her.

"Don't forget to tell the girl in New York to FedEx that dress special delivery. I want you to have it," Brooke said.

"I will Mrs. Astor. Thank you," she said, gathering up the coat, gloves, and hat as she left.

"I think I'll have a nap," Brooke said. "No, I'll stay and have some tea with you. Would you like some cookies?"

We sat on the patio. Everything about her was ultrafeminine and alluring—a not-beautiful woman in her late nineties, legs crossed, her hand flirtatiously up under her chin, totally there and full of life. Her manners were impeccable. Curious or not, she wanted to know all about me—my work, my drive up, future plans, etc. A man's woman.

"I'll see you down here for dinner," she said. "It will be just the four of us. Tony, Charlene, you, and me. I didn't want to inflict anyone new on you for your first night." She mentioned a couple coming by for drinks the next day.

"You'll like them. They're amusing."

Down she came at 7 p.m. in a fitted jacket with a leopard collar and cuffs over a pleated black and white skirt and high heels. The buttons on the jacket were replicas of little white dogs.

We sat around a small table in the dining room on tiny cane-back chairs, then moved to the living room for coffee. Charlene whispered to me:

"Would you mind sitting with Brooke awhile? Tony's exhausted and we've had her every night this week. Don't worry. She'll go up early."

And then they were gone.

Brooke and I sat in two chairs by the fireplace. She perfectly in scale. I with my knees to my chest. After an extended silence I decided there would be no point in making any further attempts at polite conversation.

So I said:

"Tell me how you lost your virginity!"

Her expression did not change, nor did her physical comfort. She sipped her drink, took a moment, and we began a conversation that went on for over three hours. This still vital, still available woman seemed desperate to share herself with a man, desperate to be desired.

"I was seventeen," she said. "His name was Dryden and he couldn't do the business on our honeymoon. He spent every evening downstairs getting drunk. I couldn't join him because my maid had forgotten to pack my evening gowns. He came upstairs drunk and thought he'd done it, but he hadn't. When I got home, I ran to my mother in tears and said:

"'Mother, why didn't you tell me?'

"'I couldn't, dear,' she said.

"She took me to a doctor and he did it. Then I got pregnant with Tony and that was the end of Dryden. I married a man called Charles Marshall. Not much better, but he gave Tony his name. We had a house in Portofino and I took an Italian

lover. One day Buddy (Charles's nickname) said, 'I'm going to clean my gun.' After a while, I went to find him. And I thought he was passed out. I called for help and when the local doctor came, he said, 'How long has this man been dead?'

"I got hysterical. He wrote a letter saying he couldn't leave me anything. I had to sell the house. Became an editor at *Town and Country*."

There were memories of her childhood from ages seven to twelve in China, where her father worked—then afterward in Haiti. "Father ran that country," she said.

She told me she was a "gray lady" in the war. She worked as a volunteer and remembered a man lying on his stomach in a canvas sling, his face suspended through a hole as she sat on the floor feeding him.

"When I met Vincent, everything changed. He walked through this house once and bought it for me. After he died, the greatest joy of my life has been my foundation. I love going to Harlem. I love the blacks. Never given me one bit of trouble. I dress up for them. My most expensive clothes, good jewelry. Want them to see me as I am—not pretending to be someone else. You know I wasn't raised to seek out people with money, but people with character. 'Who *are* they?' my grandmother would say to me."

Brooke's physical and mental decline began soon after that time and I was never to spend another evening alone with her. On the occasions I visited or went out with her and the Marshalls, it was more and more disheartening to watch her fade away into a vegetative state, become a recluse, and be abandoned by most everyone except her two dearest friends, David Rockefeller and Annette de la Renta.

I will remember the spirited woman I knew for a few years,

walking into town at Cove End, alone, in her nineties, to "look for a new dress," dancing in my foyer, embracing a man her own age in the village in Maine, smiling at him like a sixteen-year-old. Until she mentally left us, she was an exquisite example of good breeding, perfect manners, and committed citizenship. But she was not without a strong and profound bitter anger.

One weekend Tony, Charlene, she, and I flew back to New York on her private plane. Two cars were waiting on the runway. As Tony and Charlene, who had been very solicitous of her all weekend, were loading their car, I walked Brooke over to hers and thanked her for the visit. Before she got in she turned to me and said in an impatient tone I had never heard before: "Did you notice? She didn't say a word to me all weekend. That woman is a horror. What does Tony see in her?" A life raft, I thought.

I sold the apartment, resisted Charlene's efforts to have me speak with Tony's lawyers about testifying on his behalf, and thereafter they stopped speaking to me. I had enjoyed the private time I spent with Brooke Astor, but I certainly wouldn't have wanted her as a mother. She was a totally self-involved, nonmaternal narcissist who had very little time for her one and only child. Tony told me one evening that his mother had lunch and dinner dates every day of her life for as long as he could remember. And that it was necessary for him, when he wanted to see her, to make an appointment with her secretary. Watching him enter and leave the courtroom during the scandalous trial over her fortune, I felt enormous compassion for a man who wanted a mother to recognize her son as not just a name in her appointment book.

"Do you have any brothers or sisters?" Brooke once asked me.

"One of each," I told her.

"I loved being the only child," she said. "I got it all!"

DEBORAH KERR

"**D**o you suppose she might agree to see me?" I asked the young man across the table at a dinner party in London sometime in late 2006. He had introduced himself by telling me he was a relative of Deborah Kerr, a woman to whom I owed a profound apology. "I'm not certain," he said. "She's not always able to comprehend, but she has spoken of you fondly over the years and I'll try."

I was appearing in London that season in a play entitled *Frost/Nixon* and enjoying the social scene. That particular night I was deep in conversation with the diminutive Judi Dench, the Mighty Mouse of English actresses with a keen, delicious presence, a ready laugh, and a seductive demeanor. I stayed late, not wanting to lose a second with her, but found time to scribble my number and give it to Deborah's relative.

"Please try to convince her to see me," I said.

Driving home in the early morning hours I thought of Deborah and of my boorish behavior toward her some thirty years earlier. Before our first meeting, she had shown me a simple act of kindness and professional generosity she needn't have, and during the course of the six months or so I spent in her company, I did not repay it in kind.

The year was 1974 and she was to star in the Edward Albee play *Seascape* on Broadway. Edward offered me the role of Les-

lie, a lizard who comes up from the sea with his young wife to teach an aging couple, having a day at the beach, that life is worth living. The husband has gone dead of soul and his long-suffering wife is trying to convince him not to give up on the glories of the here and now. The husband would be played by Barry Nelson, a charming second-string leading man in films of the 1950s, and my wife was to be played by a young, gifted actress named Maureen Anderman.

Seascape was to be my Broadway debut. The starring roles were Deborah's and Barry's. Maureen and I were clearly supporting players. But I had stubbornly and arrogantly promised myself I would not appear on Broadway until I could go there as a Star above the title. The producers said no. Edward said no. I passed. Deborah said yes. She did not know much about me but later I was told she had said, when asked if she would allow me to have billing with her and Barry over the title:

"If Edward wants him to play the role and the billing means that much to him, well of course."

———————

The first company meeting took place in Edward's posh New York apartment. I was the last to arrive. She was standing by a window, holding a drink and chatting to someone; and when I came into the room, which was occupied by fewer than a dozen people, she smiled radiantly, put down her drink, and came toward me.

"Hello, I'm Deborah. I'm so very pleased to meet you."

She was an exceptionally lovely fifty-four. Beautifully tailored, her hair a soft blonde, complementing her perfectly featured face; her milky white skin practically devoid of makeup.

She had retired from films in 1968, publicly declaring that she no longer could abide the prevalent sex and violence, and

was now exclusively devoting herself to the theatre. She lived with her husband, Peter Viertel, in Klosters, Switzerland.

Nothing much happened at the party. Edward gave a brief speech. We made small talk and went our separate ways. The first rehearsal was to be in the next day or so. As I was preparing to leave, again Deborah came over to me.

"I'm so looking forward to our working together," she said.

"Well I'm going to be spending a lot of time leaping around you as a lizard," I said.

"Oh but you're young, darling. You're young."

Edward had given me a long piece of driftwood he'd collected near his house in the Hamptons. "It's Leslie's stick," he said. "You can bring it up with you from the primordial ooze."

––––––––––

From the first day of rehearsal to the play's closing performance, Deborah Kerr was a model of professionalism, poise, and discipline. Never less than polite and accommodating, generous and available, she endured a series of hardships and setbacks during the run of the play with grace and style in her stoic Scottish nature. I was a total pain in the ass. Strong willed and stubborn.

On that first day after we read the play, Edward as director/author told us he'd decided to make a cut.

"Take up your pencils," he said dryly. "Go to Act Two—cut it."

"The whole act?" I said.

"Yes."

"But that's the main reason I wanted to do the play," I said.

"It's gone. We don't need it."

Deborah silently and resolutely did as she was told and we read through the play again. Edward was right.

Unfortunately it didn't and couldn't save us. We rehearsed for three weeks, played Philadelphia, Washington, Baltimore, came into New York for two months, then Los Angeles for eight weeks, and it was over and out. Approximately a six-month gig, in which I missed opportunity after opportunity to avail myself of Deborah's singular and exemplary character.

She never once disagreed with Edward in rehearsal. Whatever he suggested she did without question or pause. If she didn't like the note, she never let on. "Oh yes of course," she said often and politely. And onstage she delivered a beautifully intelligent, perfectly modulated performance. I, on the other hand, was selfishly involved in my own performance, stubbornly resistant to Edward, and somewhat callous in my behavior toward her.

Her dressing room was impeccably in order and always smelling of a lovely fragrance that wafted onstage with her. Her assistant and companion, a woman named Hazel, was a no-nonsense broad who tended to Deborah's needs in a fiercely protective manner. It would take me at least thirty minutes to wriggle out of my lizard costume and wipe off my elaborate makeup, and in every town we played, I would pass by her dressing room and hear Deborah and Hazel in gales of laughter sharing a bottle of champagne. I rarely stopped by or entered her universe.

Once we were in New York, her dressing room was visited by the Greats of the era. In and out would pass the likes of Henry Fonda, Olivia de Havilland, John Gielgud, Helen Hayes, Irene Worth, Katharine Hepburn. On one glorious afternoon, Greta Garbo was quickly ushered into Deborah's dressing room, and Edward was summoned to meet her. He told me that in the few minutes he was in the room, she said to him: "Oh Mr. Albee, I did not know I was going to meet you. I have nothing prepared to say."

Here is what I most remember about the Lady Kerr ("Rhymes with Star," as her early press releases would state):

She was coming down the stairs of our theatre out of town, slipped on some wet stuff, sailed on her back through a plate glass door, was rushed to the hospital, given multiple stitches and painkillers, and played the show.

She longed for more personal and helpful direction, but realized early on she was not going to get it, so she did her work and played the show.

The reviews were mostly respectful and dismissive. No major accolades for her, no nominations or kudos, but she played the show.

She had an obstreperous, inconsiderate, and selfish young leading man but she played the show.

One stormy winter night in Washington the company gathered at someone's apartment for a late night supper. She sat, legs tucked under her by the fire. I was sick as a dog with the flu and she spent the evening bringing me tea and honey, feeling my forehead, and tucking blankets around me. She was no less sick than I, but she played.

At each stop on the road, expensive gifts arrived from Saks or Neiman Marcus with sweet handwritten notes and when I was nominated for a Tony, an exquisite pearl-handled cane awaited me in my dressing room with a bottle of champagne and a note: "Bravo, darling." I didn't respond.

On our opening night in Washington, a party was given for the cast and crew. It dwindled down rather quickly and there was just a handful of us standing about in a huge reception room at the Eisenhower Theatre. Deborah was drunk. Very drunk.

"Come dance with me darling," she said. She took my hand and instructed the pianist to play "Shall We Dance" from *The King and I*, one of her many hugely successful films, and round and round we went, faster and faster, her laughter rising to an uncharacteristic, almost uncontrollable pitch, and then suddenly her eyes welling with tears, she shouted:

"Six fucking nominations, and I never won."

Beautifully gowned one evening in New York she was nervously moving toward her car and I toward the subway.

"The car is taking me to '21,' darling. He can drop you home if you like and come back for me."

On the way to the restaurant, she was nervously tightening her pearl earrings and pulling on her long white gloves; her elegant full-length dress was dotted with hundreds of small beads.

"I can't be late," she said to the driver.

"Who are you meeting?"

She mentioned a name I did not know. "He's one of the largest investors in the English theatre and I'm thinking of doing a revival in England next year."

"Relax. He'll wait."

"Oh, darling," she said, "they don't wait long anymore."

By the time the play was winding to a close in New York

and the producers had secured a booking in Los Angeles, Deborah had lost patience. She was never less than polite, but her dressing room door was no longer open to me.

And who could blame her? Even my then agent, Eddie Bondi, gayer than gay, of the William Morris office said to me one night: "Honey, they love your work! They love your looks! But they *hate* your personality!"

Also looking after me in L.A. at the time was a young man, straighter than straight, five years my junior, and coming up fast in the agency business. He called one morning and asked to come over to my hotel. I remember we sat on the floor in my tiny room and he said: "A group of us are leaving William Morris. Come with me."

I decided to stay with Eddie and missed the opportunity to have my career looked after by the young Ron Meyer, who helped the CAA agency rise to historic power and is currently the head of Universal Studios. Still close friends after thirty-five years, he no longer needs to sit on hotel room floors; but, he does allow me now and then to grab a seat on his private jet.

The night before we were to close in Los Angeles, I missed one performance in order to fly back to New York for the Tonys. The play and I were the sole nominees. I won. And when I flew back for the last show there was a magnum of champagne from Deborah waiting in my dressing room. At the wrap party, as she was leaving, Deborah put her hand on my arm and managed a "I'm so sorry we didn't do better, dear. But how lovely for you," and she was gone.

It would have been lovelier had I been less involved with myself and more attuned to my costar. These days, I give self-involved young actors a profoundly wide berth when I work with them. Tunnel vision is the nature of the beast, I suppose, and I'm not altogether certain it is completely unavoidable.

———————

A year or so later, she had an even worse failure in a play by David Axelrod. It closed after only a few performances and I ran into her in L.A. at a star-laden Swifty Lazar party only days after the debacle.

"Hello darling," she said. "How are you?"

She was none too steady on her feet.

"How are you?" I asked.

"Oh dear. Well, you know how much I'd been hoping we'd do better with Edward's play and then I took this one and my instincts were to work on it first, but we rushed into production, and now it's gone in less than a week."

And suddenly, standing there, surrounded by her peers, who were paying little attention to our conversation, she burst into uncontrollable tears. I put both my hands on her shoulders and drew her to me. Perhaps the first truly unselfish thing I'd done with her, minor though it was.

"It'll be all right," I said. "Have you got anything coming up?"

"Oh, I don't know darling. I don't know. Peter and I thought maybe—*Rio!*"

———————

Deborah was afflicted with Parkinson's disease late in her life and struggled on with it, moving from Switzerland to a small cottage in Suffolk, England. Her husband did not join her there, and she died a year after I requested my visit; quietly and gracefully, I'm certain. Had she agreed to see me and known me, I would have apologized for my selfish and obstreperous behavior. But she most likely would have forgiven me instantly and said something like: "Oh, but darling—you were so *young!*"

CHARLTON HESTON

It was always fascinating for me to watch Chuck Heston in action—but not, unfortunately, onscreen. He had an original jawline, I'll give him that, and was very well-built. But he possessed about as much sex appeal as a railroad tie and was about as humorless as a CAT scan.

"I just don't feel right," he was reputed to have said while trying to work out a moment in the film *The Agony and the Ecstasy.*

"*He* doesn't feel right," murmured Rex Harrison, his costar. "How does he think the rest of us feel?"

———————

Chuck's accomplishments as a great movie star cannot be dismissed, of course. But, aided and abetted by his wife of over fifty years, Lydia, he was under the impression he was also a great actor. He had extraordinary vigor, appearing in film after film opposite movie star ladies for several decades. *Ben-Hur* is a spectacular film in which he acquits himself outstandingly. In one of my favorite films, Orson Welles's *Touch of Evil*, however, he demonstrates just how weak a piece of wood can be.

Clearly, the roles he played—Moses, Michelangelo, El Cid, and most certainly God—got to him. He was fond of beginning his public speeches at various dinners and award shows with:

"Did you like the weather today? I did my best."

At whatever function one attended, he would greet you as if he were the host.

"Glad you could make it."

"Wonderful of you to come."

"Oh you're here. Lydia, look who's here."

This could be at the Oscars, Golden Globes, or a dinner at someone's house. It was as if he had appointed himself the forever Numero Uno on the call sheet of life.

Always polite and well-mannered, he accented a room like a polished marble floor and was fond of holding forth on the First Amendment and the Freedom to Bear Arms. So endemic to his personality was a certainty of his place on the planet that you tended to look for twisted, thick roots emerging from wherever it was he was standing.

When I rented a house near his one summer on Hidden Valley Road up Coldwater Canyon in Beverly Hills, his new neighbors were erecting a not-intrusive wall between their properties. Chuck could be seen, at his window or wandering the site, carrying his rifle.

Sometime in the early 1980s, I was sent a script for the stage, an area Chuck inhabited with the same studied gravitas he brought to the screen. After the first act curtain of *The Crucible*, which he played in Los Angeles, my companion turned to me and said: "Do you think it's possible to make a citizen's arrest?" Not likely. Chuck was on the board of the theatre. At any rate, the leading role in the script I sent along to him was that of an errant priest being hounded by a group of townsmen, then standing trial, refusing counsel, and defending himself in court. Can you say Charlton Heston?

The writer asked me if I'd be good enough to pass it on to

him and I sent it with a short note, saying I thought he might respond to this either for the stage or screen.

He wrote back promptly, most likely having just turned enough water into wine for expected dinner guests, thanking me and modestly stating that he would "throw it on the pile."

As the pile dwindled over the years, he carried on appearing in mediocre television and B movies in a bad hairpiece.

On the last occasion I was to see Heston, we were part of a group of actors paying homage to by now *Lord* Laurence Oliver, at Lincoln Center. Those of us who had appeared with him either onstage or film were asked to speak. The house was full, perhaps some fifteen hundred people, and prior to the event, there was an intimate dinner for the guest of honor somewhere upstairs.

"Nice to see you. So glad you could come," Chuck said at the door.

At dessert time came the clinking of one glass as he held up another. We, the gathered peasants, silenced ourselves, like the rabble waiting on shore before our leader parted the Red Sea.

"Did you like the weather today?" he said. "I did my best."

He then launched into a ten-minute tribute to his Lordship that basically centered on Chuck's description of what it took to be a great actor.

"When I played . . ." was a familiar phrase. Others I recall:

"Larry, I know you know what it's like . . ."

"One accepts the loneliness of courage . . ."

And my personal favorite:

"Very few share what Larry and I share."

The check! I hoped.

When it was over, to a polite, restrained applause, the hand next to me was squeezing mine in more than affection.

I looked down at the white knuckles belonging to Maggie Smith, my dinner companion, and before she could speak, Tony Curtis said aloud to our little table:

"Doesn't Chuck make great speeches?"

"Oh yes," said Maggie. "He should never be allowed to do anything else."

PAUL NEWMAN

There are countless examples of the lengths so many once-beautiful women go to preserve what is impossible to re-capture. Great male beauties don't suffer in quite the same way, but they suffer nonetheless. There are, of course, com-pensations in old age: wisdom, family, good friends, achieve-ment, wealth. But my experience of the great beauties I have known, male and female, is that each would forfeit those perks to be magnificent once more.

Paul Newman's beauty was original and mesmerizing and, in my experience of him, he was master of and slave to it. I first met him when he was casting a film in which his wife, Joanne Woodward, would star and he would direct, entitled *Rachel, Rachel.* The year was 1967. Paul was forty-two. I was twenty-nine.

Twenty minutes late getting to their Upper East Side apartment from their house in Connecticut, he came through the door, dropping bags, deeply apologetic, pulling off his sunglasses, and there they were—those compelling baby blues, completely and utterly beautiful; as was the rest of him. I didn't get the part but I did come to know Paul, after a fashion.

I doubt there was much in life that Paul was denied. To watch women in his presence was to forever put to rest the notion that men are shallow, only caring about a woman's face and body while women look for those deeper substitutes like

"a sense of humor" or "kindness." Physical beauty takes the cake with first meetings. Getting past it is another matter. And it was hard for most people to get past it with Paul.

He certainly did everything he could to distract their attention; changing his looks for roles, goofing around on talk shows, dressing with no particular flair. But apart from not having much of a behind, he was male perfection.

Over the years he stayed gorgeous with the help of intelligent plastic surgery and a vigorous health regimen. He loved dirty jokes—the dirtier the better. When I knew he was coming to a show, I made sure to have at least three ready for him. And he liked to hear conquest stories. "Did you score?" was his usual question about any mentioned leading lady I'd worked with.

He was a great audience, a true lover of acting and actors, and wanted, I believe, to be thought of as a great actor. He wasn't. But he gave everything he had to every role. As his movie star days faded and he turned to mostly stage and television projects, his limitations became more apparent.

As indeed, they were in life. After dirty-sexy jokes, shop talk, cars, or politics were exhausted, Paul was a pretty dull companion. Never rude or unkind, just dull. The lights would go out and he was in for the night. He had drunk enough beer or heard enough jokes and that was it.

But he was so beautiful, people thought it must be their fault if he went silent or just emptily gazed at them.

Apart from his many visits backstage, I was in his company perhaps only a dozen times over the years I knew him. And I was always the first to leave the scene. You knew you were with a deeply feeling man, a decent man and a man of principle; his establishing and funding a summer camp for kids with cancer called "The Hole in the Wall Gang" was certainly the act of a man of great humanity and kindness. But like the statue of David, there he stood, physically perfect but

seemingly emotionally vacant. There were so many arenas in which he would not play that eventually I did what I could to avoid any prolonged contact with him.

Another reason I did not pursue a friendship of consequence with Paul was that I felt to be his friend meant being many things I was not. Those being a beer-drinking, sports-loving, charity-driven, race-car-junkie acolyte. It seemed to me that, in the end, he could only go so far inside himself and could only be with people who could tolerate that limitation in him. Even when he didn't want to be, he was the center of every universe and his circle continually waltzed around him, accepting their leader on his face value, so to speak.

In 1991, I was appearing in a play at the Long Wharf Theatre in New Haven, Connecticut. It was about a raging tyrannical actor at the turn of the century named Junius Brutus Booth. Paul came to see it without Joanne or one of his usual cronies. He walked me to my car in the almost empty dark parking lot and as we strolled along he put his hand on my shoulder, then moved it to the back of my neck, squeezed it hard, and shook it.

"Where does all that anger come from, Franco?"

"I wouldn't know where to start," I said.

"You scared me tonight up there."

"Well, you know, it's acting," I joked.

"Yeah, but you can at least let it out. I can't."

"What's your anger about?" I asked.

"I wouldn't know where to start."

Paul loved the craft of acting but the burden he carried was not, in my opinion, his good looks. He had no danger. And

it is essential for a great actor. Non-beauties like Jack Palance and James Cagney had it. And Paul's major rivals in his early years—Montgomery Clift, Marlon Brando, James Dean, and Steve McQueen—all had it. And all self-destructed. Paul lived to eighty-three years old within a healthy lifestyle, and I'm convinced he knew he was without greatness. And that very lack of danger in him may explain why, as beautiful as he was, he personally had very little sex appeal.

The last time I saw him was in a small off-Broadway lobby. It was a windy, wintry night. His illness had begun. He was standing behind me.

"Franco, my boy."

I turned around and looked into the baby blues I'd looked into some forty years earlier. An old man now, face thin and ravaged, a beard for his next role, fine sparse hair blown around by the wind.

"Paulo," I said, and instinctively reached up to put his hair in place, smoothing it down with my fingers and making it neat. I then moved my hands down to his cold cheeks and kissed them both. He fixed me with a look of heartbreaking tenderness and I thought for a moment he might be fighting back tears.

"There. Now you look like Paul Newman," I said. "And what man wouldn't want to look like Paul Newman?"

It occurs to me now, as I write this, that perhaps he might have been that man.

WILLIAM GIBSON

A tall, rangy man came loping down the aisle carrying a manila envelope one afternoon during the summer of 1966 in a break from rehearsal of Thornton Wilder's *The Skin of Our Teeth* in Stockbridge, Massachusetts. He handed it to our director, Arthur Penn, who was sitting in the front row. Arthur did not get up, but opened the envelope, looked over its contents, and began a conversation with the man who stood dutifully in front of him.

The visitor, dressed like a handyman or janitor, had a handsome, craggy, face with a slightly protruding jawline and possessed atop his friendly eyes, a pair of shaggy-dog brows. He and Arthur had a five- or ten-minute conversation, during which he never sat down. I assumed he was the theatre's all-purpose old codger. He was, in fact, William Gibson, author of *The Miracle Worker* and *Two for the Seesaw*, two enormous Broadway hits, and he was at the ripe old age of fifty-two.

Bill and his wife, Margaret, lived in a house ten minutes from the theatre, halfway down a long, unkempt dirt path called Clark Road, at the end of which lived Arthur and his wife, Peggy.

Bill and Margaret's house was a broken-down, big two-story rambling mess. It was painted deep dark green with white trim lattice work covering the windows, and had a circular driveway over which there was some kind of wooden arbor. An unkempt stone-laden front patio, with a stock of

fireplace logs Bill had cut himself, was overrun with weeds. At its rear was a white door taking you inside to a kitchen and office, which led to an indoor pool set inside a jungle of plants and vegetation of all kinds. Broken-down chairs and small tables sat around a gigantic stone fireplace and the slanted, heavy plastic sheets that covered the whole environment were constantly dripping from the condensation that was never solved in all the years I visited there. It was steamy hot in the summers and ice cold in the winters. A wooden spiral staircase ascended from it to the upstairs bedrooms. Past the kitchen was another porch, the heart of the house, where everyone gathered to eat and talk just about every night.

Bill sat through those nights in his favorite rocking chair, pipe in hand, with an expression of bemused delight and often hilarious comment. He was, the more you came to know him, a complex and sly fellow. His long, thin, perfectly proportioned body gave him a country-boy sexuality and his great charm lay in his seeming unawareness of his physical attraction. The ubiquitous pipe protruding from his mouth added to the cozy package.

Not far from the house was Bill's work studio. It was there he had written *The Miracle Worker* and *Two for the Seesaw* and was then writing a biography of his family life called *A Mass for the Dead*. I was asked to visit that studio from time to time, and in its tiny quarters, sitting opposite him in front of a small woodstove, I listened to chapters, talked plays and playwrights, but mostly loved the company of a man who was never thought of as a great writer, never celebrated much in his lifetime, and suffered that slight more profoundly than I had realized in the early, heady years of getting to know him.

There was, indeed, a certain preciousness about his writing, a sort of self-conscious, somewhat labored effort at poetic pronouncements that made it feel overripe and pretentious.

He resolutely wrote every day of his life, safe on the page; an Irish lad from the tenements of New York with the soul of a poet and some inner tensions that brought on a bad case of bleeding ulcers.

Through the years he made brief sojourns to New York, but mostly hibernated in that little studio. If I wanted to see him, it would have to be in Stockbridge. I made fewer and fewer visits as the decades rocketed by, but stayed in touch by phone every few months.

His wife with whom he'd had two sons, Tom and Dan, predeceased him following a long illness. Bill became her devoted nursemaid and his life revolved around her comfort and care. When she finally passed on, he said to me:

"It's as if I looked at a map of the world and suddenly France was no longer there." Then he said, quoting Carl Sandburg, "I tell you the past is a bucket of ashes."

After Margaret's death, he slowly deteriorated and with each call he listed hilariously the breakdown of all his body parts. He was now in his nineties and the hearing was going; there was cancer; there was a new horror, it seemed, every year. Our phone calls, however, were still full of humor and fond reminiscences of his contemporaries' pasts. He remembered a French girl I'd brought up to see him in the early 1970s.

"Whatever happened to that little Frenchie you were banging?" he said. "I banged a couple of little ones in my time too."

"Have you ever had a homosexual experience?" I asked.

"Jesus, no, my boy. But after a long meeting in New York with Larry Olivier about taking *Two for the Seesaw* to London we were walking back to his hotel and he asked me up to his room."

"What did you do?"

"Blushed, turned, and ran."

———————

In the fall of 2008, I drove to Stockbridge. One of his care-takers had called to say that he was permanently bedridden and in and out of consciousness. If I wanted to see him I'd better come soon.

Forty years after my first visit to that house on Clark Road, I made my way slowly along the still unkempt path to the large, dark green house. Nothing had altered. It was, in fact, so unchanged that a wooden sled leaning up against the outer kitchen door stood exactly where I had remembered it re-siding. I walked the same steps through the same patio and opened the same unlocked white door with the lattice work X's on the windows, and entered the kitchen.

The house was silent. It was approximately 11 a.m. The porch, where there had been such riotous good times and where Margaret had convalesced and died, was returned to its former self. I wandered the rest of the ground floor—primitive paintings on the wall, small Mexican throws on the tattered couches, stacks of sheet music piled under the piano where Bill used to sit and pound out ragtime. Upstairs too. Bedrooms small, old quilts, broken lamps, and books by the thousands.

I returned to the kitchen and walked toward the back room off the pool to see if perhaps someone might be there. In the doorway, I stopped and stared at William Gibson, now ninety-three, lying in a hospital bed, several rosy plaid blankets tucked under his chin. His head seemed less than half its normal size, and the ends of his shoulders looked barely eighteen inches apart. He could not have been more than seventy-five pounds. His eyes were closed, his mouth open, and his face was so blotched and bruised with red and brown patches, it looked as if he'd been beaten by a bunch of thugs.

I sat for close to half an hour alone with him, looking and listening to the slow, steady rasp of his breath. Suddenly his eyes opened and stared up at the ceiling. I got up and leaned over into his direct line of vision, expecting a vacant stare, and instead this strong Irish voice said:

"Frankie! You look so young!"

"Well, I'm not," I said. "I'm seventy."

"That's young," he said.

And he drifted back to sleep.

His eyes opened again, but he was not lucid this time. He raised his head off the bed a bit and looked at a glass of orange juice on the table next to him. I brought it to his lips. He wanted to hold the straw so I pulled one of his arms outside the covers and as I did, they fell back to reveal a body in such ruin that if a Hollywood makeup artist had created the look, he would have been accused of sensationalism.

It was as if he had been beaten about his chest and shoulders and then a match had been taken to the raw skin. I could see not an ounce of what looked like normal flesh.

His son, Tom, now in his fifties, came into the room from his little cottage on the property, and we sat across from Bill for two hours as he went in and out of consciousness and lucidity. A long, rambling diatribe on the workings of bladder medication followed by a clear two minutes of reminiscences. And then he was gone again. During one of the rambling monologues Tom and I looked across at each other and burst into laughter.

I waited for a reemergence of recognition. It never came. So I kissed his forehead and left a house I'd first entered in 1966. A house in which the same black telephone had sat on the same small counter in the kitchen with the same number for over forty years. As I drove down Clark Road knowing I would never see him again, I remembered that our history to-

gether went even further back than our first meeting in 1966. Somewhere around 1946, Bill had written an early draft of a play entitled *A Cry of Players* about the young William Shakespeare. Margaret saw an actor in a workshop in New York and told Bill he would be the perfect Will. When they met at a coffee shop in the Village, the actor declined the role. "I'm going to be a movie star," he said. His name was Marlon Brando. Twenty years later Bill revised the play and rewrote it with me in mind, asking Anne Bancroft to play Will's wife, Anne Hathaway. We performed it at Lincoln Center in 1967 and I was fond of telling people that Bill had written it for me. He gave me a copy of the play inscribed:

> To Frankie,
> For whom I wrote this play when he was, would you believe, eight years old.
> —*Billy*

He died at ninety-four. A man consistently and comfortably incapable of artifice.

DOMINICK DUNNE

"**I** never thought this would happen to me," said Nick Dunne from the bed in which it did—just two days later.

———————

I received a call earlier in the day that he wanted to see me and could I come as soon as possible.

When I arrived at his chic and shabby cozy apartment on East 49th Street and Lexington Avenue in New York, he was asleep. Joan Didion was sitting on a straw chair in a small sunroom off the living room in which a hospital bed had been installed. Stephen Sondheim was standing at its foot. Nick's head was lolled back, his mouth wide open, one arm across his chest, the other, with the usual tube through which ran the usual sustenance from the usual hanging bag, lying along his side. A large black woman was sitting on a chair nearby reading a magazine.

"I have to go," said Steve. "I really can't wait any longer. I need to be in Roxbury by six. Tell him I love him," he told Nick's son, Griffin, who had come in from the sunroom to greet me. The black woman said she was going out to get something to eat.

"He's been asleep most of the afternoon," said Griffin. "Come say hello to Joan."

"I will," I said. From where I stood I could see her comfortably sunk into her seat, her translucent skin stretched across

toothpick bones, her gray white hair short with bangs barely covering a skeletal forehead. On the floor sat Griffin's best friend, Charlie Wessler, a film producer, smoking a cigarette and leaning in to catch what Joan was saying.

What else could any of them be doing? When death is clearly on his way up in the elevator, it's best to let him in and stay out of his way.

All the players in the room had had a much longer history with Nick than I. We had circled each other warily over the years. I resisted his style—his practiced reporter's skill at charming you, then trying to trip you up; getting you to reveal something you hadn't intended to. But I thought him an excellent writer and fearless investigator as I watched him cover the trials of Claus Von Bulow, O. J. Simpson, and Phil Spector, among others.

In 2008, I received a call from him about a small film I'd done called *Starting Out in the Evening*. It was the story of an aged writer who had not lived up to his early promise and was living alone on the Upper West Side of New York, but still writing every day.

Nick wanted to talk. It felt to me as if he were crying. "I watched it twice," he said. "The relationship with the daughter. I love Lili Taylor. It was heartbreaking how that man threw his life away."

"But he tries. He gets up every day and tries."

"Well, I just wanted to tell you I thought it was great."

"Thank you, Nick. It's a favorite film of mine."

An awkward pause and I bit the bullet:

"Nick. We don't really know each other very well. I've always been a little on guard against you."

"Yeah, well . . ."

"Would you like to have lunch?"

"Sure."

We picked a date. He chose Michael's on West 55th Street, in which literally every table has been rested upon by the pampered elbows of New York's literary lions for many a season. I lunched there often but seldom have I witnessed the kind of homage that was paid to Nick from the arriving and departing celebrities.

In the center of the room at a table for eight sat an actress who had written yet another book about dramatic weight loss and early lack of self-esteem. Surrounded by publicists, managers, and agents, she looked but dared not approach.

"She'll be fat again in a year," I joked. Nick didn't laugh.

"I've got cancer," he said. "And I'm going to fight."

"Well there's no time to waste," I said. "Tell me everything."

He spoke of a feud with Graydon Carter, editor of *Vanity Fair*, his writer's block on his latest book, and his never having recovered from his daughter's brutal murder by a crazed boyfriend decades earlier.

"Your movie knocked me for a loop. If this gets me I don't want to die with regrets."

He told me he was having trouble resolving the finish of the book, mostly about his main character's coming to peace with his sexuality; and he also spoke of his still unresolved feelings about Graydon.

"Well, you have to call him," I said.

"Yeah, I know. I'm a coward. No good at human relationships. Just can't do it. I failed with my sons too."

Nick was closing in on eighty-three. I had just entered my seventies. There seemed nothing to lose.

"So, are you gay?" I asked.

"I'm nothing now. I've been celibate for twenty years. It just got too difficult for me to deal with."

"What did?"

"Hiding it. Wanting it."

"Have you ever talked about it with your sons?"

"God no! I just couldn't. I'm sure they know. Anyway it's too late now and I don't miss it anymore."

"Why don't you sit down with Griffin and talk to him about it?"

"Oh he knows. What is there to talk about?"

"Give him the honor of sharing with him his father's true self."

"No no no. I can't. I just can't."

"I failed to communicate well with my son, too. So I understand. But it's the greatest gift you can bestow on your kids, trusting them and—"

Up to the table came a worshipper.

"Oh hi, . . . !"

"Do you know . . . ?"

"Of course!"

"Have you seen . . . ?"

"Did you hear . . . ?"

"Did you know . . . ?"

"Call me!"

———————

He had no desire to return to our subject and we passed our lunch in the familiar territory of work and gossip. I walked him to his next appointment.

"I'm going to have to face Graydon," he said, "or I won't be able to finish this book. I'm stuck."

"Pick up the phone and call him."

"I will."

"Let's do this again, Nick."

"Okay!"

And during the next year or more, as he fought his cancer,

we would manage a dozen or so such conversations at Michael's, over the phone, and once in Los Angeles at the Beverly Hills Hotel in 2009, when he was there covering the Oscars.

Nick was a great reporter and a brilliant observer of human contradictions. He was ruthless in his hates, a voracious gossiper, and a self-admitted starfucker. Faced with cancer, he fought valiantly, doubling and redoubling his efforts to stay in the game.

His fight took him to a clinic in Germany for stem cell treatments. He rallied, lost ground, rallied again, and finally the disease won. Griffin went to get him and bring him home on a chartered plane to die in his tiny apartment surrounded by his books and momentary distractions from visiting celebrities.

It was near the end now as I stood over him, as close as I could get. Is he gone? I wondered. So still, so lifeless. I put my mouth up to his ear.

"Nick. It's Frank. Wake up."

He did.

"Oh, Frank. You came."

He lifted his arms up as if he wanted to be taken out of the bed and I leaned in close. Round my neck they went and I kissed his cheek, now firm against mine.

"Are you going to stay?" he said. "I've got something to tell you."

"Yes."

I then circled round the bed, never letting go of his hand, and sat in a chair close to his right side. He closed his eyes once more and fell back asleep.

Joan came in and laid her hand on his foot before Charlie took her downstairs, and Griffin and I talked quietly across his father's body. It was countdown time.

Soon a dark-haired woman arrived who would close in on his left. Once an editor of his, she talked of a feud they'd once had, explaining that it was all over now, and she loved him. His eyes flicked open. He had been listening.

"We worked it out, didn't we?" he said to her.

"Yes we did dear," she replied.

It was clear she wasn't planning to leave his side, so I asked him in her presence what he wanted to talk to me about. If it were something personal, I assumed he'd ask her to give us a moment. But he looked up at me with a happy smile and said:

"Frank. I did it. I finished my book. Graydon and I made peace. I think it's good. I think it'll sell. I want you to see the new cover."

He called to Griffin, who brought in a mock-up of the book, now named *Too Much Money*.

"We changed the title," he said.

As he talked about the cuts he'd made and the decisions over the title and the marketing for the book, the lady continued to hold his hand, nodding in agreement and approval. Griffin stood by the bed for a while, looking distracted, and then slowly backed out of the room onto the sunporch.

The mock-up lay on Nick's lap as he talked animatedly about the planned campaign, the marketing budget, and his hopes for sales.

"It's going to be a hit, I think, Frank," he said. Toward the end of the book, a character called Gus, the fictionalized Nick, finally outs himself.

I got up when he wound down, leaned over, kissed him on the forehead, and told him I'd come see him again. His former editor held tight. As I reached the door, I looked into the sunporch and saw Griffin sitting alone, his back toward me, staring out the window. I decided not to invade his solitude.

Forty-eight hours later his father was gone. A man who, even on his deathbed, was unable to speak truth to a son sitting some twenty feet away but preferred rather to look at a mock-up of a new book title, discuss possible profits he would never enjoy, and have his hand held by a formerly estranged colleague. Nick left this earth leaving behind two boys whom sadly he had long since abandoned to carry on without him.

TONY CURTIS

Tony Curtis took no prisoners. Whenever I was in his company over the course of some thirty years, apart from the absurdity of his desperate attempts to look cool, hip, and young, I found him always to be charming, instantly connected, and very funny. He was, as well, ruthlessly honest when he didn't like someone or something. A no-shit guy who had taken a lot of abuse, often challengingly bringing it upon himself.

One Saturday evening in Malibu in 1989 there were about a dozen of us at a dinner and a private screening at Blake Edwards and Julie Andrews's magnificent house near Paradise Cove. The conversation turned to a discussion of one of the world's most famous and beloved actors.

"He was one of my idols," Tony said. "The guy turns out to be a fucking bore. He knew better than all of us where to put the camera, how to say the line, how to play the scene. He had no humor and no charm. I would do anything to avoid having lunch with him."

I told Tony that Mel Brooks had told me the same thing about this actor. He said that one day the guy walked into his offices and said, "How do you do, Mr. Brooks? My offices are right next door to yours. I'm so looking forward to our having lunch together." After the first lunch, Mel said, "I thought I'd kill myself if I had to eat a meal with this guy again. I told my secretary, if Cary Grant calls, I'm not in."

"Yeah," said Tony. "He sucked the air out of any room he was in."

The film they made together was *Operation Petticoat*. It was directed by Blake Edwards and he concurred about Grant, but added, "It was a huge hit and I would have worked with him again anytime."

That night the film we watched in Blake and Julie's screening room was *Mississippi Burning*. After the lights went up, there was much reverential talk about the subject matter, the direction, and the quality of the acting. Tony was sitting in the last row, silent and placid. After everyone else had had their say, he stood up and held forth for ten minutes, calling it a chickenshit worthless piece of crap.

"They played it so fucking safe. Lousy studio bullshit."

––––––––––––––

Watching Tony on television late one night in *Sweet Smell of Success*, I was impressed by the emotional power of his performance. He was playing a "cookie full of arsenic," as Burt Lancaster's character referred to him, and he played his part, a bloodsucking desperate press agent, with unsparing truth and a real measure of dignity.

Thereafter, whenever I saw him in a film, I stopped and watched a little closer. His performances in *The Defiant Ones*, *Spartacus*, and *Some Like It Hot* were deeply committed, honest, and emotionally true. The fact that the overwhelming majority of his films were terrible doesn't erase the fact that in each of them he was a one hundred percent professional and determined to do his best. The look of him, the sheer over-ripe face, jet-black hair, and New York accent made him an easy actor to dismiss as just a pretty boy who got lucky. He didn't make it any easier with a publicly cultivated persona as a wisecracking ladies' man. But he seemed to me filled with

immortal yearnings; acting, writing, painting, constantly cre-
atively expressing himself and looking for validation.

———————

One evening, when I was sitting alone with him in a corner
at Blake and Julie's, he held forth on the art of acting, and his
understanding of the necessity to cover up any technique and
appear spontaneous and, above all, truthful. "It's a moveable
feast, Frank. You gotta go with the flow and live in the mo-
ment."

Tony had a get-them-before-they-get-you frame of mind
that got him in trouble in Hollywood and his handful of re-
ally sterling performances didn't seem enough to overcome
the cocky swagger that lessened his reputation as an actor. But
those performances are there as a testament to a boy named
Schwartz from the Bronx who, in a profession with a stagger-
ing attrition rate, climbed to the top, hung in, and defiantly
kept punching to the finish.

JILL CLAYBURGH

She stood looking into the mirror above my dressing room table, arranging and rearranging her gorgeous mane of blond hair to look as though it hadn't been given a thought. It always looked that way. Completely natural and elegantly stylish. Like the woman.

Her makeup was minimal, seemingly nonexistent. Dressed in a belted print dress that accented her tiny, tiny waist and small bosom, she looked nowhere near her forty years. More like a recently graduated Vassar girl (it was actually Sarah Lawrence) about to meet her first potential employer.

It was the spring of 1984. Jill Clayburgh, Raul Julia, and I were in rehearsal for Noel Coward's *Design for Living*, directed by George C. Scott, and due to open at New York's Circle in the Square Theatre several weeks hence.

She was on her way to meet Sydney Pollack for a drink to discuss the female lead in *Out of Africa*, a film he would be directing later that year. "I don't know why I'm bothering," she said cheerfully, "Meryl's going to get it anyway." (She did.)

But she stepped back to survey the goods, threw whatever tools she had emptied from her canvas bag back into it, slung it over her delicate shoulder, kissed me on the top of the head, and sailed out the door, her lovely summer dress gently swaying round her hips as her high heels determinedly tap-tapped up the stairs.

Jill possessed an ineffable, pragmatic optimism that perme-

ated her being. An "I'll take whatever comes" gutsiness that I admired from the day we met.

———————

It was in 1967. She was twenty-four, I was twenty-nine. We were cast as husband and wife in a television movie to be produced by the then immensely successful David Susskind. It was entitled *The Choice*. The story was about two men in need of a heart transplant. Their surgeon (George Grizzard) would have to decide whom to give the only one available. Either the young, brilliant violinist (me) or an aging former secretary of state (Melvyn Douglas). I got the heart, and Mel, I think, got an Emmy. Mel's wife was to be played by the great English actress Celia Johnson.

We would rehearse our tearjerker in New York and shoot in Toronto. The show's minor claim to fame was in its depicting, for the first time on television, of an actual heart transplant performed by a pioneer in the field, Dr. Michael DeBakey. So fragile did the TV network believe the American public's stomach to be, that only thirty seconds of it were allowed to be aired.

Jill and I were, at the time, each involved in emotionally fraught relationships. She with another actor and I with a registered nurse. Jill was very drawn to the high strung and I was (and still am) a hypochondriac. We had each found perfect, if temporary ideal partners. We bonded immediately during rehearsals and once away from home, sealed our friendship prowling the discos of Toronto, dancing, drinking, and coming dangerously close to a tumble. But it was Jill who kept us out of bed. Things were confusing enough, she reasoned. It was the 1960s though, and disco dance floors may as well have been beds. There was a good deal of caressing, long good-night kisses, and a few times we fell asleep

in each other's arms. Both of our relationships subsequently crashed and burned, but by then our train had passed.

Jill's career soon started a meteoric rise and by the early 1970s she was a major film star, Oscar nominated for *An Unmarried Woman*. By 1984, at the time of our production, it was beginning to look like her ship of movie stardom was drifting off course, and while she was not happy about it, she was not the sort of person to blame the business or cry in self-pity. She was handling it.

She was, of course, an actress. And if women, as men often feel, are impossible to know, then actresses up the ante considerably. But Jill was a good egg, with an open and generous nature, free of artifice.

There was, of course, her laugh. Easy to get and infectious to hear. That mass of hair would tumble forward as she bent over in hysterics and then fly back in wild abandon. It became the unifying component in our budding ménage-à-trois with Raul.

The seventeen years between our gigs disappeared and Jill and I were as close as we had been before. And with the addition of Raul, we very quickly became the Marx Brothers of the New York theatre scene, with George C. as our tyrannical but benevolent Margaret Dumont.

At the close of our first week of rehearsal the three of us went to dinner, admitted that George scared the shit out of us, and told one another the parts we'd stupidly turned down in films that earned Oscars for the actors who took them. We were now all married with five children among us. Jill was forty, Raul forty-two, and I forty-six. We were playing lovers, each character having slept with the other separately and together, and each discovering they could not live without each other and would carry on at play's end forever joined in a hedonistic, unholy trinity.

I knew she was conflicted about returning to the stage and had, at that time, a fear, and even a dislike, of audiences. She hated the idea of being judged by them. Raul and I, on the other hand, were eager racehorses, anxious to gallop. Jill was hesitant about coming out of the gate in the first place. This was exacerbated by a passionate love affair with her first child, Lily, born to her and playwright David Rabe. Lily was as adored as any child I've ever seen. Every moment Jill could steal away from the show to be with her, she coveted. But still, she happily enjoyed being "the girl" with three men devotedly at her feet. George C. would have been quite happy to get her off those feet, but she handled him with good grace and lighthearted humor. She was a soft, feminine tomboy. Catnip to any man.

The limited and temporary freedom that backstage life gives actors turns up the sexual burners, and we grew deliciously physical with one another. One matinee, as Raul was pulling off his shirt for a quick change and Jill and I were kibitzing in his dressing room, she suddenly raced across the floor and clawed at his chest. "Oh give me some of that," she said, "give it to me!" And they began a series of silent film star passionate embraces. In seconds I insinuated myself into the mix and for the next few minutes we became a pulsating Oreo cookie with nothing remotely chaste about where our hands and mouths wandered. It was fast, hot, and dirty, and it was the kind of fun at which actors excel. We brought it all onstage with us and the fact that it was never consummated kept us fully charged sexually in front of our audiences.

Jill was not a great stage actress, which she would have been the first to admit. She didn't have the killer instinct

required to prowl the stage like a predatory lioness, daring the audience to look away from you. She had neither the voice nor the physical stamina for it, and she lacked the will to acquire either. Only later in her career, she told me, did she come to feel truly comfortable onstage. "I get now what you and Raul loved so much about being out there," she told me. But even back then, with her reserve and uncertainty, she was a game girl.

The play was an enormous success and while we saw less of each other, we made a habit on most matinee days of going to my apartment, often surrounded by our mates and kids, feeding them and ourselves, usually bringing back Jill's favorite franchise at the time, Chirpin' Chicken, then racing back for the evening performance.

I was the first to leave the production for a prior commitment. Jill followed a month later, and Raul stayed on until closing. For a year or more afterward Jill and I stayed in contact and managed some long lunches and a few late night telephone calls. But an incident so small and petty; a series of unreturned phone calls not worth the ink to explain, caused us to drift apart. I will forever regret the loss of those irretrievable years.

In the early days of our start-up careers, she said to me: "L.A. is not for me. Racing all over the place holding little bits of paper with the names of people I'm supposed to impress. They're going to have to come to me, baby."

And when they did, she handled the good years beautifully. Not for her the photo layouts with legs spread wide and breasts pumped high. Not for her the public confessions of illness, self-promotion, or mock humility. She was also one of the few

women I have ever known who could, when it was suggested we go somewhere, just get up, grab her bag, give her hair a quick toss, and head for the door. That funny, fun-loving face, the ready smile, and the intelligence, made her a spectacular and sexy package. A package kept all the more desirable by its hidden contents.

———————

One year before her death, I found a nine-minute tape of Jill, Lily, my former wife, and our two kids on a visit to Raul's farm in upstate New York. It was made on Memorial Day 1984. We had traveled there supposedly to run lines, but the scripts stayed in the car, never opened. Raul, his wife, Merel, and their two sons were waiting for us. We barbecued, rode motorbikes, and talked mostly about our children. I made a copy for Jill, sent it and received this note from her:

> Dearest Frank,
> Thank you so much for sending me that DVD. I approached it with a certain amount of trepidation, knowing it would be painful as well as beautiful and touching. I was not wrong. To see our faces! Our children's! My son had not yet been born. And Raul—so heartbreaking! Ahh! It also brought back the fantastic time we had together—weren't we going to open a bar like Bar Centrale? And how little I wanted to act at that time, being so consumed with Lily. You were both very kind to me when my heart was always so far away from the work. Thank you.
> I hope you are happy!
> Love, Jill

I didn't answer her note. I'll get to it, I thought. There's
plenty of time.

NORRIS CHURCH

Norris Church moved slowly across my country lawn in the early fall of 2010, one of the most beautiful women I have ever seen, and I was instantly drawn to her; simultaneously regretting it would be the first time we'd meet.

It was a party to celebrate my new house, attended by some thirty people or so. She arrived last on the arm of her son, John Buffalo, by the late Norman Mailer. Rail thin, a lovely silk bandana wrapped across her forehead and spilling over one shoulder with Native American jewelry around her neck and wrists and dressed in slacks and an elegant beige blouse, she tentatively moved toward a lawn chair and John carefully set her down there.

I understood immediately how irresistible she must have been to Norman. I leaned over to greet her, and she looked up, took my hand, and said:

"Oh Frank, thank you for being so kind to John. He needs a father now."

John had played in *Wall Street: Money Never Sleeps*, an Oliver Stone film I'd done a year earlier. We'd had a chance to get to know each other somewhat in New York, and later in Cannes, where the film was shown out of competition. When I asked if he'd like to come up that day, he told me he'd be in Provincetown with his mom and could they both come by on their way to New York.

"It's going to be a long ride," he said, "and she can use the break."

"Of course," I said. "She can have one of the guest rooms if she likes."

Throughout the afternoon, Norris engaged freely with everyone there. She remained, for the most part, seated on the wide-armed straw chair John had set her in, ate sparingly, but seemed anxious for human contact. When I could, I sat with her and she spoke of turning their family house in Provincetown into a retreat for writers. Then she spoke of her sons and of the storm that was Norman. Her ability to draw you in and appear peacefully at ease despite her infirmities made her an irresistible presence. In a very brief time, I knew what Norman had found—a woman of immense inner strength who seemed not the kind to back down or cry "poor me."

Toward the end of the afternoon, I was walking a few guests to their cars and when I turned back to the house, she was standing alone, looking at the unfinished garden only just begun by my daughter, Sara, earlier that spring. I walked over to her and she said, "This is going to need a good deal of tending to."

"I know" I said. "It was so beautiful a month ago but Sara isn't here enough to see to it and I have a black thumb."

A tall woman, almost my height, she turned toward me, took my hand, and put it up to her chest. We stood in silence for a few moments and then she said: "It's not going to be much longer now. Look in on John for me, would you?" Her eyes welled with tears and she put both her hands on my shoulders and lowered her head. We spoke not another word for a long while as she fought to regain her composure.

"Why don't you both stay tonight? The guest room is very comfortable. My daughter's in the other one, but John can bunk in the den."

"Thank you, but it's better for me to be home in Brooklyn, close to my doctors."

When they left and the house and grounds were cleaned up, Sara and I played our traditional game of Scrabble and she went to bed.

———

There is no question in my mind that had Norris stayed in my guest room, I would have visited her there, gotten into the bed if she'd let me, and held her in whatever fashion she needed. Her still magnificent beauty, her intelligence and warm persona, her tears, her cancer—even the death knell sounding— were, it felt to me, legitimate grounds for intimacy.

The next day I called John and asked him if I might take his mother out on a date. "Go for it, man," he said. I would not have the privilege, however. Her decline was rapid and she died that November at only sixty-one, from the cancer she had valiantly fought for eleven years. Sara's garden eventually had to be abandoned; it too withering and dying at far too young an age.

SUSANNAH YORK

She was sitting alone at a corner table in a restaurant bar close to a theater in the south of England, having just attended a performance of a play in which I was appearing opposite Joan Collins. The play was entitled *Moon over Buffalo,* on tour in preparation for a London run. The production was tacky, on the cheap, and a calamity for all involved. Not exactly a toe-tapper, it shuffled into town in 2002, presumptuously played the Old Vic, disintegrated, and dissolved into a compost heap out of which nothing remotely positive blossomed. To be sure, it was, as an experience, no bed of roses.

In 1969, Susannah York had been Oscar-nominated for her heartbreaking performance in the movie *They Shoot Horses, Don't They?* but wondered why she hadn't been asked if she wanted to be nominated in the first place. A misguided young starlet at the time, clearly never going to be a Hollywood player, she lost to Goldie Hawn in the lightweight *Cactus Flower.* But Susannah was so luminous a screen presence that she managed to share the early 1960s with that other staggeringly pretty English rose, Julie Christie, before joining the pile of former film beauties no longer young men's fantasies.

This once lovely English girl lifted her head when she saw me, reached out her hand, and said: "Oh, Mr. Langella, I so enjoyed your comic timing." It was as warm and sincere a compliment as she could muster; a sweet and gallant effort to

find something positive to say. And I was instantly drawn to her sad, sad eyes and fragile demeanor.

She had been escorted to the performance by my friend the English producer Duncan Weldon, who had asked me to join them for supper. He was nowhere to be seen at the moment, most likely somewhere being insincere to my costar. So I slipped in next to her and said: "Thank you, but I'm afraid there's no hope for this one." She gave me an enigmatic tentative smile and looked down at her hands.

Thirty-three years after *Horses*, now in her early sixties, her hair unkempt and grayish, she was instantly heartbreaking. The same lost-lamb expression was still there. But gone the voluptuous beauty, the young, firm body, and the promise that awaited in her sensuous mouth and clear blue eyes. Now, her thin, bony fingers were wrapped around my hand as she graciously and sincerely held forth on the things she thought positive and fixable about the production.

Duncan, who had indeed been chatting up Joan, joined us, and we ordered a light supper. I don't recall her drinking or even eating very much. She seemed a broken and sad woman who in no way was trying to maintain the ravishing beauty that had once been; and not asking, either, for any homage to be paid. At least ten years younger and looking ten years older than Joan, she seemed grateful for a night out and a friendly talk. A generous, curious, and nurturing dinner companion.

I learned of her death while watching a 2011 awards ceremony. Sweeping across the stage came an actress also once voluptuously beautiful and precisely Susannah's age at the time of her passing. "Doesn't she look great?" my companion said. But as the camera closed in on her stretched-to-the-breaking point features, self-consciously styled and dyed

hairdo, false breasts, and magnificently gowned seventy-two-year-old body, I saw a flash of her aged hands as she opened the envelope. I remembered with sadness Susannah York's equally aged hands in mine; but remembered also the fact that she had allowed herself to remain, after all, still recognizably a woman.

ELIZABETH TAYLOR

Never mind that the President of the United States was going to be placing a medal around her neck the next evening as a Kennedy Center honoree. And never mind that her fellow honorees were at their tables, happily surrounded by family and friends. Elizabeth Taylor was sitting glumly at a State Dinner in Washington, D.C., in 2002 accompanied by what appeared to be a professional handler.

I watched closely as she sat disinterested in and disassociated from her surroundings.

The ceremony that evening was to be hosted by then Secretary of State Colin Powell. Before it began Elizabeth got up and moved slowly out of the dining room. As she walked tentatively through a vast empty space toward the restrooms, I decided to get up and follow her. She was leaning heavily on a cane, her handler holding her other elbow as she took very small, almost baby-like steps. I came up beside her.

"Hello, Elizabeth. It's Frank."

"Oh, hi, baby."

"How are you?"

"I can't wait for this shit to be over!"

———

It was finally over for Elizabeth in March 2011. On the morning of her death I went searching for and found the pashmina scarf she'd given me on our last night together almost exactly

ten years earlier. It was approximately six feet in length, a deep rust color, with gold trim, and had embroidered on one corner in minute gold thread the maker's mark: AS1893. Elizabeth's mark on me, however, would be far more indelible.

It was impossible to get the better of Elizabeth Taylor. She could be slowed down, thrown off course for a bit, even brought to tears, but she could not, ultimately, be bested in the arena where it really counts—the courage of one's convictions. Doubt played no part in her psyche. She was exceptionally certain of herself and no outward setbacks—weight gains, garish dress, bad performances, ill health, sublime to ridiculous husbands—could slow her train. There was nothing modest about Elizabeth. She had a divine arrogance and would not take "No" for an answer even if the word were spoken directly into her face. She heard it only as "Not at the moment."

I stepped into her ring with the full knowledge that one or the other of us might land on the ropes occasionally. But how foolish of me to assume this titled heavyweight was ever going to hit the mat.

We met secretly. It was 2001. I had just ended a five-year relationship and she was free of her last husband, Larry Fortensky. "I think you will like each other," a mutual friend said to me at dinner in New York. "She is lonely, needs someone who won't be afraid of her."

"What exactly is it I would be afraid of?" I asked.

"Oh, you know, that she's Elizabeth Taylor."

"Is that all?"

I would be working in L.A. starting the following week and a dinner was arranged. "Just the two of us," I said. "Just her, no bodyguard, no assistant, and no dog."

Elizabeth agreed. Eight o'clock. Quiet place on the Strip.

"And she can't be late." Which was like asking Stevie Wonder not to be blind.

My instincts for self-preservation were by this point in my life well honed, and I asked our friend to let me know on my cell phone when he and Elizabeth would be pulling into the driveway of the restaurant.

"Elizabeth has a favorite booth. They're holding it for us. They'll take you to it."

"Nope, call me when you're in the driveway."

"All right."

At ten minutes to ten, my cell phone rang.

"Frank, where are you? Elizabeth's in the booth. She's waiting."

"How long has she been there?"

"At least ten minutes."

"I'll be right in."

Why I thought riding around or sitting in my car for an hour and forty-five minutes was better than sitting in a restaurant for that length of time I don't know, but it felt as though it would give me some measure of control over her. Exactly what Siegfried's Roy must have thought about that tiger.

"Elizabeth, Frank. Frank, Elizabeth," said my friend. She raised those violet eyes, gave me a broad smile, took my hand, and pulled me down into the booth, as our mutual friend discreetly departed.

Not much of our first conversation stays with me. It was the usual first-date stuff. But a small incident gave me a clue into the modus operandi of a woman who had pretty much ruled the world and the men in it since she became a star at twelve years of age.

We were seated unobtrusively in one corner. The restaurant was dark and near empty. A man sitting alone across the way got up to leave and saw her. He came up to the table and began

an obsequious tribute; not pushy, impolite, or even gushing. But he was vociferous in his praise and rather loquacious.

Elizabeth was charming to him, smiling and warm, but at the moment he'd gone around and passed Go once too often, she slowly moved her hand over to mine and, putting her thumb into its center, gripped it with enormous strength. It was the gesture of someone saying, "Help me, please. I'm not sure I can survive another moment of this." And it brought out the Tarzan in me. The Big Bad Tiger was going to eat my poor little Jane and I had to protect her.

I nicely shut the guy down and he moved away, whereupon she turned to me with a "My hero" expression that could have brought her a sixth Oscar nomination.

Round 1—Elizabeth.

———————

Outside on the street, standing next to her open car door, she moved into me, took both my hands, looked up, and said:

"We will see each other again." I would defy anyone hearing her speak that sentence to categorize it either as a question or a declaration.

I rode back to my hotel, thinking what a great dinner companion she'd been; funny, curious, immediate, and unpretentious. And she really loved dirty jokes. They couldn't be vulgar enough for her. I liked her very much. I liked her regular everyday girlishness. She's probably mellowed, I thought, and just needs a friend. I can handle that, on my terms.

Round 2—Frank.

———————

My phone was ringing as I opened my hotel room door.

"Hello?"

"Is this my little angel?"

I told her at dinner that my name at one time had an apostrophe as in L'angella. Meaning little angel.

"Hi Elizabeth."

"Would you like to come over to watch the Oscars at my house next week? There'll be lots of people here you'll know."

And I heard myself say, "Yes. Thanks."

Round 3—a draw.

I arrived on time for Oscar night, but it seemed the guests had been there for a while already. José Eber, her hairdresser, a man I instantly liked, and who I knew genuinely loved and cared about Elizabeth, was the only person in the room I recognized. It looked as if someone had called Central Casting and said, "Send me two dozen people who don't belong at an A or even B list Hollywood party." They were a motley crew of friends of her housekeeper, someone's cousin, some agent's secretary. All obviously lured there in order to be able to say they'd watched the Oscars at Elizabeth Taylor's house. None of them appeared to know each other and were hanging out in little groups of twos and threes, holding their buffet plates and talking quietly as if they all had just viewed the deceased.

Two large comfortable chairs were set in front of a giant television in the living room. I was told one of them was mine and I sat down in it. The rest of the seats were scattered about significantly behind. The others took their places and for the next two hours we watched in silence. Not a sound from the gathered mourners. There was the occasional trip to the buffet table to reload and José would disappear upstairs during commercials, but for the most part it was some thirty people waiting for Godot.

In the third hour, José came into the living room and said to no one in particular, "She's coming down." And moments later,

Elizabeth appeared just as someone on the television was saying, "And the winner is . . ." She was in a beautiful floor-length caftan, hair black and big, jewelry costume-gaudy, and lips a flame red. She came directly toward me, took both my hands in hers, put her face up for a kiss, looked deeply into my eyes, and said:

"Will you be my date tonight?"

A can of Red Bull was placed on a table next to her chair and she sat down, faced the TV, reached across the tiny divide, and took my hand. She never once looked at or acknowledged her other guests, or paid much attention to the television set. No one behind us spoke after her arrival. Not a word. Like a group of supernumeraries on a film set, they remained stony silent as if in fear of possible expulsion, no doubt.

For the remaining hour or more of the ceremony, Elizabeth would be handed a phone to take calls from, it seemed, an hysterical woman, locked in a family crisis. She soothed and calmed and said clearly,

"Put him on."

Then came a five-minute stream of full-voiced vitriol from a male voice, threatening and hateful. Elizabeth sat looking at her nails, sipping Red Bull, and listening. And at one point saying in a voice of deep and lethal surety:

"Oh, no, you won't."

The voice shouted something like:

"Yes, I will!"

And again Elizabeth said calmly:

"No, you won't. Because I control the money."

She then hung up, turned to me, and said: "Have you had anything to eat, baby?"

Somebody won something and the TV was turned off. Elizabeth remained in her seat, a plate on her lap, as the guests moved around and past her to the front door. She acknowledged no one's presence but mine, and in less than five min-

utes we were alone in the living room as people were clearing the buffet table in the dining room. José left after double kisses to us both. No doubt he would be relieved to go home, doff the cowboy hat, and kick off his boots.

Elizabeth and I sat and talked and once more I had a wonderful time with her. She was very funny about some of the people who had crossed the screen, totally unaware of any of the films or actors nominated and amusedly resigned to her family drama.

It was close to 1 a.m.

"I better go."

"Would you like to see the house?"

"Okay."

A brief tour ending in a walk toward the stairway, her hand tightly in mine.

"Come on up, baby, and put me to sleep."

She grabbed hold of the caftan and preceded me up the steps in bare feet; her slippers left by her chair in the living room. With each step she grew more and more hysterical, tripping on her hem, reaching for the banister, and, at one point, leaning forward and placing her hands on the steps in front of her.

"Oh baby, I'm not gonna make it," she said, howling in mock agony, like a woman trying to climb an icy hill and continuing to slide backward.

"Yes, you can," I said, placing both my hands on her fulsome cheeks and pushing. She dissolved in laughter, managed two or three steps, and collapsed on the landing. And we sat there while she caught her breath. A happy, giggly little girl.

"Come on in, baby."

Round 4—Elizabeth.

―――――――――

Down a hallway, first into her bathroom, where she removed her jewelry and dropped it on a mirrored tray. The room was

all girl and, it would seem, open for business. On every surface bowls of everything from Q-tips to cotton balls, to eyebrow pencils to emery boards—not a dozen, not two dozen of anything but seemingly hundreds. The cabinet doors were opened and there, neatly lined, in rows three deep, were large bottles of witch hazel. Dozens and dozens of bottles of witch hazel—a supply not possible to exhaust in her lifetime. When I asked her why she had so much, she said:

"It's in my contract."

"You'll never ever use it all," I said.

"Baby. It's in my contract."

There were giant closets filled to the brim. Shoes, bags, scarves, hats, jewelry, gowns, dresses, caftans, belts all in overflow. Create a movie set of a movie star bathroom like this and the designer would be accused of parody.

Then into the bedroom. Not quite Norma Desmond, but certainly not without its air of yesterday. Brightly lit, feminine colors, smelling heavily of her trademark perfume; not immense, but spacious enough and inviting. There were a few items of clothing tossed on a chair and on the floor next to the bed, a nightdress.

The bed itself was unmade and crowded. At its foot another large television. Across it, a hospital-like table on wheels that could be raised, lowered, or pushed aside. On it stood a famous photo of Elizabeth, Mike Todd, and their baby. Next to it, another of her and Richard Burton. And on the bed, a large box of open chocolates, picked through and half-eaten. Magazines, a remote, nail files, prescription bottles. She poured herself a glass of water, took two pills, dropped the caftan, slipped on the nightdress, and climbed in. Turning on her side and curling up spoon fashion, she put her hand out behind her and said:

"Stay a little while baby."

I took her hand and sat on the bed. Her eyes were closed,

her black hair smashed against the pillows, and her deep red lips slightly smudged.

"Shall I turn out the lights?"

"You're going?"

"Yes."

"Will you kiss me good night?"

Her face was turned away from mine. As she began to move it toward me, I leaned over and kissed her cheek.

"Good night."

"Oh baby, I left my slippers downstairs. Would you get them for me please?" I did, lingered for a while, then climbed the stairs and placed them by her bed. When I leaned over and said good night again, she turned her face fully to me and looked up.

"Will you call me tomorrow?"

"Yes."

"But not in the morning, baby. I don't see a lot of mornings."

I kissed her forehead, smoothed her hair off her face, pulled the covers up over her, and left her to sleep. Then I said good night to a bodyguard standing in the driveway and drove home.

Round 5—Frank.

———————

I did not call her the next day. If for no other reason than I was up and out long before she would reach consciousness and because I knew that a relationship with Elizabeth Taylor was quicksand. And there wasn't going to be anybody standing by with a tree branch to pull me out. I determined that I would not be seduced and commanded. I was going to throw in the towel and step out of the ring.

Our mutual friend called a few days later.

"Why haven't you called Elizabeth? She's hurt."

"I will. I'm working."

"Well, call her. Just to say hello. She's lonely. But not before one p.m."

I did. We connected on the phone. She was sweet, saucy, and shrewd.

"Did you get a good deal on your movie?"

"We're still apart on the money."

"How much?"

"A hundred thousand."

"Tell them you want a present."

"I don't wear diamonds."

"Pick out a painting. Let them buy it for you. You pay no commission and it grows in value."

"When are you going to work again?" I asked.

"Oh baby, it's too hard for me now."

"Well, I'm going to send you something. It's called *Sorry, Wrong Number*. It's the old Barbara Stanwyck vehicle about a woman who's an invalid and trapped in bed, alone in her house, when she hears a voice downstairs. It's someone coming to kill her sent by her husband. It's a great part for you."

"All my husbands wanted to kill me, baby. Would you bring me a copy and we can watch it together?"

"I'll send it over by messenger. Watch it and tell me what you think."

"Oh baby, let's watch it together. I want to hear what *you* think. Nobody is offering me anything good and you have such great taste."

"Sure."

Round 6—Elizabeth.

———————

Barbara Stanwyck never came out of her wrapper. It didn't get watched the night I brought it over and was never referred to again. We had a light supper and talked in the living

room. She was the best pal a man could want. Warm, funny, and completely committed to whatever the subject. Her maid, happy her boss had a beau, hovered nearby, cleared the dishes, excused herself, and said good night.

The same ritual.

Up the stairs.

Past the bathroom.

To the bed.

Water. Two pills.

"Stay with me." Curling up close spoon fashion, I wrapped my arms around her and looked at the room I had found myself in. A woman's bedroom. So inviting. So frightening. When she fell asleep I picked up her caftan, put it on the chair, and left.

As I passed her bodyguard again at the top of the driveway, he said:

"Miss Taylor is a wonderful lady. So kind to me and my family. But she's very lonely."

Once down from the hills and back to my small hotel, I decided it was enough. We had had innumerable phone conversations, a dinner out, and two evenings at her house. I had resisted her suggestion that we go out to another restaurant or an event.

"Hardly anybody asks me to their house, honey. Everybody thinks I'm busy."

And for the next several weeks, that's what I was—busy.

Round 7—Frank.

———————————

Then began a bizarre series of phone calls with messages left to "my little angel . . ."

As I left my hotel, the desk clerk would say:

"Mr. Langella, Miss Taylor needs to speak with you."

"Take a message."

Coming in at night.

"Mr. Langella, Miss Taylor has left several messages and asked me to have you call whenever you get in."

Friends were calling:

"Elizabeth says you're dating."

"Why aren't you returning Elizabeth's calls? She's hurt."

"Hi, Elizabeth. It's Frank."

Round 8—Elizabeth.

I would be leaving L.A. in about ten days and decided to meet with her one last time, but on my own turf.

"How would you like to come over to my hotel? It's a small private one. I have a suite with a full kitchen. I'll make us some pasta, crunchy bread, and a fattening dessert."

"You're on."

"You're not going to be late!"

"Me?"

We picked a date and about two hours before her scheduled arrival, the phone rang.

"Miss Taylor wants to know if she should bring some Red Bull."

"No, I bought her some."

One hour prior:

"Miss Taylor would like to know if she can bring Sugar [her dog]."

"No!"

Miss Taylor arrived for our eight o'clock date at precisely eight o'clock, sans Sugar.

Round 9—Frank.

And there in my hotel suite, in my jeans and T-shirt, cooking Elizabeth dinner with her curled up on my couch in slacks and

a blouse, watching me, I had one of the most wonderful evenings I have ever spent with a woman. She was full of questions about me and listening to my answers with rapt attention. No man could possibly have asked for better. Wearing very little makeup, her hair soft and easy, her voice low and soothing, she opened up about Richard, Mike, Larry, and the gang.

Were they stories she'd told before? Of course, but you would have never thought so. They were told with practiced skill and sincerity and even a slight wonderment, as if she were discovering something new and profound about herself right along with you.

"Larry wanted seven million. When I got sick, he came to the hospital and took my hand. 'I don't want the money,' he said. 'Good, baby,' I told him "cause I don't have it.'"

———

Of Mike Todd:

"I would love to wait till he had a room full of guys downstairs. Then I'd call out, 'Mike, could you come up here for a minute?' He was a bull. Never said no."

———

Of Eddie Fisher:

"The schmuck! But he brought Debbie and me back together."

———

Of Monty Clift:

"I got him together with Roddy [McDowall]."

———

Of John Warner:

"A nice man. But a mistake. I got so fat. We're friends now."

Of Richard Burton:

"Richard loved me."

And then:

"I almost died. I was on the table. I left my body. It was all white light and I saw Mike. He said, 'Elizabeth, it's not time. You have to go back. You have more to do.'" Sincere and committed as she seemed, I had the sense it was not me she was talking to but a room full of ghosts.

We sat at my little dining table and ate a meal of mozzarella and tomato, penne with garlic, broccoli, and olive oil and crunchy bread. The pasta was somewhat dry because I had forgotten to pour the marinara sauce on it but she ate it happily without comment. I followed it up with blueberries and vanilla ice cream for dessert, which she ate with equal enthusiasm.

I did make one reference to her work:

"That scene in *Suddenly, Last Summer* where you're pleading with Monty to save you is one of your best," I said.

"Monty was so sweet with me. And George too. We shot pool at the table between takes." She was referring, of course, to *A Place in the Sun*.

After dinner, I cleaned up and she returned to the couch where I joined her. It was there she delivered her knockout punch.

"I want to leave here," she said, reaching for my hand. "I want to find a place that's normal. Like a farm or a country house. Animals. No more of this shit. I'm finished. Let's go east and look for something."

She was fragile, tender, and extremely vulnerable as she moved in close to me. A small, sweet woman who wanted a man to be with her, protect her, and fill a void as deep as the deepest ocean. No man could possibly stay afloat in it. I knew that when I leaned in to kiss her, but still I kissed her.

At 2 a.m., when I closed my hotel room door and turned in the hall to take her downstairs to the garage, she pulled off her pashmina scarf and threw it over the top of my head, tossing one half over my shoulder.

Quietly, she said, "Keep it for me, baby, I'll pick it up next time I come over."

I did not respond. Like the true and valiant fighter she was, she took a step back, looked at me hard and clear, then turned and moved toward the elevator.

When we got down to the subbasement, I said:

"The car is up one level. You stay here and I'll bring it down. I don't want you walking up a ramp unnecessarily."

I found it, got in, started to pull down, but stopped and looked at her, standing and holding on to an iron railing, staring straight ahead, waiting to be transported by someone, anyone, somewhere, anywhere.

On the way home she sat silently, her hand on my thigh. I got lost in the Hills and she could not help me find the house she had lived in for over thirty years. When at last I recognized the gates and pulled in, she squeezed my hand tightly but said nothing.

I turned off the engine and we sat in silence for a long while. Then she said:

"It's not going to work with us, is it, baby?"

"No!"

"Why not?"

"You'd have me for lunch!"

She laughed.

"Keep the scarf," she said. "I've only worn it once."

I got out and came around the car, but her bodyguard had already opened the door on her side and was helping her out. He asked for my keys.

"I'll be glad to turn it around for you, sir," he said.

The front door opened. Sugar came scampering out to greet her mistress as Elizabeth's maid hovered in the doorway.

I picked up the dog, put her in Elizabeth's arms, leaned down to kiss her good night, then turned and stepped out of the ring, abandoning our insignificant bout; leaving no discernable winner. The gates opened and I drove away inhaling the pungent odor of her scarf on the seat next to me.

A decade later Elizabeth's magnificent violet eyes would close forever. Eyes set into a face so ravishing at birth, the rest of us could barely look away from them. Is it any wonder those eyes could not find a way of looking inward? Most everything she had amassed in a lifetime of excess would be displayed, greedily picked over, auctioned off, or resold. Had she elected, while still alive, to pitch a tent, throw open the flaps, and begin the circus herself, it would have made her richer than ever. But not rich enough. The woman who had often said, "I can't remember a day when I wasn't famous," had died fame's inexorable victim.

The movie queen I left standing in her driveway with a maid, a bodyguard, and a lapdog, the gates closing in front of her, was going to climb the stairs, drop her clothes on the floor, take two pills, and get into bed. It would be light soon. Her eyes growing heavy, drifting off to sleep, she would again miss the coming dawn. But no more than she would miss the pashmina scarf she had draped over my shoulders. No more than she would miss me. She would awake that afternoon continuing her indiscriminate search for the one thing she could never and would never have: Enough!

RACHEL "BUNNY" MELLON

"It is the blacks who have real soul. The blacks who understand what love is. All the pain they have suffered, all the indignities, has given them nobility and grace. Since I was a little girl I always looked to them for strength and warmth. I want to die in their arms on the farm in Virginia."

Bunny Mellon will turn 102 in 2012; and this singular woman will most likely, in the not too distant future, be granted her wish. Although she is not yet residing among the subjects of this book, I would like to share a few of my memories of her with you, and she has graciously given me permission to do so.

She was born Rachel Lambert on August 9, 1909, to the head of the Warner/Lambert Pharmaceutical Company; one of his three children. In 1943 she married Stacy Lloyd. They divorced in 1946. Two years later she married banking heir Paul Mellon, taking her two small children, Eliza and Stacy, with her.

Bunny's life is privileged beyond the imagination of most people. The wealth enormous and the perks extraordinary. But despite that, she lives by this simple maxim:

"Nothing should be noticed."

That this very private woman should have found herself world-famous for fifteen minutes as she approached her one-

hundredth birthday is so at odds with her nature that the absurdity of it was certainly not lost, even on her.

She had been paid a visit by an ambitious politician named John Edwards, who had been introduced to her by the decorator Bryan Huffman. Senator Edwards and his wife were anxious to be the next President and First Lady. "He came to see me when he was running. And I decided to contribute to his campaign. I thought he was very real and very bright. What's all the fuss about?"

She was, of course, referring to the firestorm that ensued over John Edwards's sex life, illegitimate child, ultimate separation from his wife, and four-hundred-dollar haircuts. Her financial support of Senator Edwards dragged her into the limelight in a way she had rarely experienced.

"Well, I suppose it's my own damn fault," she told me, "he was so attractive. White shirt, white pants, sleeves rolled up. And you know I'm weak on good looks."

There is not much else Bunny Mellon is weak on; and her greatest strength, her most profound gift, is loyalty. I have counted on it unconditionally throughout my adult life.

Just as I have counted on the fact that when I visited her, she would always leave a book at my bedside table she thought might interest me or send me a handmade quilt from Nantucket or a scarf from Paris. Easy for the rich to do such things. See it. Buy it. Write a note. A driver delivers it or an assistant mails it. But Bunny *meant* it.

Raised to have impeccable manners and treat all human beings with respect and consideration, she is a model of decency, kindness, forbearance, and compassion, but by no means a pushover or a head-in-the-sand socialite. Selective in her close friendships, clever in her dealings with the press, brilliant during her fifty-year marriage to Paul, and flawless in her discretion during her friendship with Jackie Kennedy; she is a

woman who, it seems to me, has done just about everything right.

———————

It was a hot sunny afternoon in the summer of 1961 when I first met her behind the Cape Playhouse in Dennis, Massachusetts. I was apprenticing at this legendary theater, learning to build sets, shop for props, and anything else assigned to me while taking acting workshops and playing roles in afternoon children's theater. At night, I worked backstage for the touring productions passing through with stars of the era.

I was stenciling a flat in a fleur-de-lis pattern in the back parking lot, sweating profusely and covered in paint, when a female voice said: "Excuse me, I wonder if you could help me, I'm looking for my daughter, Eliza?"

"I think she's in the costume shop," I said, not looking up.

"Am I allowed to go inside the theater?"

"I don't know. But I'll go get her if you'd like."

"Oh thank you, that's very kind of you."

I put down my paintbrush, looked up and my twenty-three-year-old eyes saw a woman the likes of whom I'd never encountered before. She was dressed in a deep blue, heavy linen skirt, white boatneck pullover, with a blue sailor hat on her head and espadrilles on her feet, and she appeared to me a visitor from another planet. Face free of makeup, hair soft and easy, with a picnic basket in her hand, she gave the impression of having just been sketched on an artist's pad and brought to life for a summer's afternoon; tall, elegant, and extraordinarily soft-spoken. Not a beauty, but a woman with the power to make you feel she was.

Liza came bounding out of the costume shop. Not yet twenty, awkward and shy, she was the antithesis of her mother; a tomboy with a great horse laugh and a devilish sense of humor.

"Hi Mummy. You've met my friend Frank."

"Yes, he's a painter."

Came the guffaw and Liza said, looking at me: "Oh sure he is, and I'm Madame Chanel, didn't you know?!"

"Liza, you've got to go and wash your hands."

"Be right back," she said breezily and took off for the slop sink.

For the next ten minutes, Bunny asked me where I was born, did I have brothers or sisters, did I want to be an actor, and wove a seductive web in which I willingly became entangled. A woman beautifully schooled in the art of direct and specific interest in another at first meeting.

Liza returned and off they went to have a picnic nearby; no doubt under a tree in the shade with cloth napkins and chilled white wine.

In the summer of 1961 Eliza Lloyd was a vibrant, fragile young girl and I a high-strung, sensitive young man. We instantly formed a strong bond. It was through my initial relationship with her and my subsequent friendship with Bunny that I found myself sleeping in the beds of their staggering residences in Virginia, Antigua in the British West Indies, Cape Cod, Paris, Washington, D.C, New York, and Nantucket. I entered their lives with very little life experience of my own; if not exactly wet behind the ears then certainly very, very damp. Bunny chose to adopt me. And she had a willing pupil, anxious to better himself, learn the world, and understand how to behave in it. I was invited to their Cape house often that first summer and was dubbed "Liza's friend from the playhouse" for the rest of it. Bunny reached out her hand to me, took mine, and vastly improved my gait. And she did it mostly by example.

One afternoon, sitting down by the dock with a group of Liza's young friends from school, Bunny asked me to read aloud a couple of paragraphs in a book of philosophy. When I came to the name of the French philosopher René Descartes, totally unfamiliar to me, I spoke it as I saw it. Dess–Cart–Tees. My pronunciation was greeted with derisive laughter and dismissive comments. I wasn't sure why, but continued reading and later, as the afternoon wore on with swimming and sailing, which I watched from the shore because I was neither a good swimmer nor a good sailor, Bunny said, "Frank, would you read me that passage again? It was so interesting, particularly the part that refers to Descartes." And she pronounced it properly as in: Daycart.

She had found a way to correct my ignorance and preserve my dignity as casually as if she were opening a packet of sugar. What she had done, of course, was open my mind. And into it, she began to pour generous granules of knowledge in all the arenas I needed it most.

When I asked her how to handle myself at a cocktail party with people I didn't know, she said: "It's very simple. Just repeat the last few words of whatever has just been said to you in the form of a question and you'll have no trouble. For instance, if someone says to you 'I just went to an art show and saw the most fascinating painting' you then say: 'Oh really, the most fascinating painting?' And you'll be off and running." And this:

"Be careful of people who come toward you with their arms flung wide to embrace you. It's a trap."

———

Not that I ever found her to be trapped by anyone for long. She has chosen her friends carefully throughout her life and sometimes they reward her loyalty in the most astonishing ways.

Perhaps the most astonishing to me came from the French clothing designer Hubert de Givenchy.

At a small birthday lunch for Bunny one summer; just me, Jackie O., and Eliza, the doorbell rang at the Cape house precisely the moment we sat down to lunch. Buds, the family butler, told Bunny that a gentleman had arrived from Msr. Givenchy and needed to deliver a package directly to her. Bunny clasped her hands in delight and in came a man in a dark suit and tie, holding a small, beautifully ribboned box. He placed it before Bunny and said, *"De la part de Monsieur Givenchy,"* and stepped back. "Oh how *pritty,"* Bunny said as she undid the ribbon and lifted the top of the box. Inside was a small glass case and inside that was a pound of sweet butter.

"Hubert knows how much I love this butter," she said matter-of-factly. "It's from his cows on his farm." The man smiled and left.

"Do you suppose he flew all the way from France, got a car, and drove all the way out here?" I said.

"Sure," Jackie said. "It's Bunny's birthday."

And we ate what I calculated to be an approximately $20,000 bar of butter.

Not much compared to a little bauble given to her by her good friend, the Tiffany jeweler Johnny Schlumberger on another birthday. We were sitting on her Syrie Maugham couch in the Cape house when she felt something buried in its cushions.

"Oh that's where that went," she said, pulling out an enormous brooch worth somewhere in the neighborhood of a quarter million dollars, "I thought I'd lost it."

On New Year's Eve of 1968 I was spending the holiday and my birthday, as usual during that period, with Eliza and the

family. After everyone had gone to bed Bunny put on some music for herself and began to dance around the small pond in the open garden of the Antigua house. Being a bit more than just tipsy, she fell backward over a potted plant and broke her ankle. I was summoned to her room at 3 a.m. to find her lying on her bed, leg up on a pillow, and her ankle bound tightly with a Balenciaga scarf. Paul was sitting on a chair beside the bed looking extremely relieved to see me come in. He instantly got up and said:

"Bun, I'm going to bed. Frank will keep you company."

"Gosh, Paul, it hurts very badly."

"Well you brought it on yourself, dear."

So I got a blanket, and spent that particular New Year's Eve asleep on the floor next to the bed; waking every few hours to give her painkillers until they ran out.

The next morning we were accompanied to the Mellon plane, which would take us to New York, by the local doctor, who bound her leg tightly in some sheet-like material, put large pieces of white tape over it, strapped it to the inside wall of the plane, and left. Shortly after we were airborne, Bunny turned to me and said: "Frank, would you please go to the back and find me a wide short glass of some kind?"

"Do you want something to drink?" I asked.

"No, just the glass."

I got one, returned with it, and sat down.

"I wonder if you'd mind leaving me alone for just a few moments?"

I did and in a short while, her voice rang out in the most charming, lilting manner: "You can come back now." When I returned, she had draped the Balenciaga scarf over the glass, handed it to me and asked if I would be good enough to empty it into the toilet in the rear of the plane. I carried the glass and

its warm contents there as I was asked, returned to my seat, and handed her back the scarf.

"Thank you," she said. "I suppose now we can consider ourselves very good friends."

I knew she was in great pain, had no strong medication left, and was enduring the bumpy ride home with some difficulty but she never for a moment looked as if she were anywhere but at a lovely soothing concert in Carnegie Hall.

The next morning her broken ankle was repaired, and after her operation, I walked home from the hospital, passed by my agent's office, and went in as a surprise. "What are you doing in town?" he said.

"Oh a friend of mine broke her ankle and we had to come back to get her an operation, so I'm back a week early."

"Well Frank and Eleanor Perry are looking for someone to play the third lead in their new movie. Here's the script, sit here and read it and I'll call over to see if they'll meet you."

I did. It was a great part and I wanted to play it. The next morning I went in, read, and got it. Had Bunny not broken her ankle two nights earlier I would have still been in Antigua, swimming in the Caribbean, unemployed and nearly broke. Happenstance had intervened. The film, *The Diary of a Mad Housewife*, was an enormous success in 1970 and launched my movie career.

Liza and I moved on to other partners, marriages, and divorces, but retained our friendship. Tragically she was hit by a truck in Greenwich Village in 2000, and sent into a coma. Bunny set up a room for her at Oak Spring Farms, in Upperville, Virginia, the Mellon home base. It sits among 4,000 magnificent acres with its own private one-mile airstrip and personal jet.

It was there Liza remained with private doctors and full-time nurses continually available. And despite the doctor's gentle protestations that the damage was severe and there was no chance, Bunny never gave up the hope that Liza would recover.

"Frank, I know it," she would say, "I just know it. She is coming back to us." It was sadly ironic that Liza's outgoing phone message in her Greenwich Village apartment was: "Hi! I'm gone, but I'll be back!"

She spent eight years in that coma never to return; and died of pneumonia in 2008. "Caroline is my daughter now," Bunny said, referring of course to Caroline Kennedy Schlossberg.

Bunny's eyesight has begun to fade during this past decade and she has often been in doctors' offices trying every method possible to stall the inevitable and fighting all sorts of old age ailments. But in our phone calls she is always cheerful, positive, and upbeat. "I've just got to get started. I want to build a new office for myself at the farm . . . I have to go up to Nantucket and work on the land . . . spring will be coming and I'm just not *ready*!"

In late June of 2009 she called. "Where are you spending the Fourth of July?"

"I'm going to Charleston, South Carolina, to stay with some friends for a few days."

"Why don't you come to me for the day and then the plane can take you there."

And as easily as another friend might drop me off in a taxi on their way home, early on the morning of the fourth, Bunny's car arrived to take me to Teterboro Airport; the plane waiting to transport me to Oak Spring.

We touched down on the private airstrip and once again the car drove me toward the house close to fifty years after I had first visited there. The land was gorgeously lush and green with miles and miles of perfect fences, horses in the fields, and the dairy farm pristine and calm. I remembered the long bike rides with Liza over the back country roads, the walks with Bunny and her beagle, Benjamin, every night at dusk. Most of all, the silence and peace of the place; the feeling of luxurious safety. Safety of a kind that only great wealth can assure and protect.

The car brought me up to the house, drove off, and I was left standing in the courtyard once again. A low stone wall surrounding a patio of irregular stones, weeds allowed to sprout at just the right height meandering between them, plants and flowers casually growing on the grounds. All placed there in a fashion as if to say: Mother Nature stopped by, did this, and left. I walked through the courtyard to the front door, finding it open, as always.

In the foyer, straw hats hung on hooks. Baskets under tables, a long wooden bench piled high with large books, the day's newspapers, and a folded gray and orange blanket embroidered with the letters P.M.

"Paul and I wanted a cozy house," she told me when I first visited. "We both grew up in big, cold houses, and hated it, so we built this." And indeed, Oak Spring Farms is a civilized, understated, modest environment. Again, the kind of modest only great wealth can engender. And again, nothing designed to be noticed. Nothing that says, "Look at how I decorated this. Look at my statement."

On a desk by the window in the large living room sat a picture of Jackie falling off a horse as it leapt over a fence. Next to it a photo of Caroline and John-John as children. On another table, a photograph of Paul and Bunny with the Queen

Mother at the Epson Derby in 1972 when Paul's horse Mill Reef won the race. When that photograph was taken I was standing just a few feet off camera, thirty-four years old in a green, inappropriate-to-the-occasion Cerutti suit.

"Harry, is it really you?" came the familiar cultured voice from the bottom of the stairs. I went out to the hall to greet and embrace her.

"Hi Mertz."

Sometime in the late sixties, I had nicknamed Bunny Myrtle and Liza Mabel one day when they returned from a shopping spree in New York, pretending to be a couple of secretaries. Bunny turned and said, "If I'm Myrtle and Liza's Mabel then you're Harry." The nicknames stuck and we have called each other by those names ever since.

Nancy Collins, a tall, lovely young woman, Bunny's full-time nurse, had accompanied her downstairs and we all moved slowly back into the living room. Maria, one of the kitchen staff, brought in her famous iced tea, which tasted as delicious as ever, and John, another of the staff, came in to announce luncheon. Nancy left us and we went into the dining room and sat down to a traditional Fourth of July meal at the Mellon farm: Salmon with dill sauce and parsley, peas, asparagus with hollandaise, and strawberry shortcake for dessert. At each of our settings a small silver dish with three After-Eight thin mints resting on them.

As has become our habit in the last year or so, we began to reminisce. "Remember the day I found you and Jackie sitting on the floor at the Cape house with all that jewelry?" I said.

"Oh yes! Jackie was trying to decide whether or not to marry Ari. If she hadn't, she'd have sent it all back. It didn't much mean anything to her anyway. She was a good girl. You know how we became friends? She called me when Jack was a senator and said: 'Will you help me, Mrs. Mellon? I don't

know a lot.' And that was it. We never had a cross word till the day she died. One afternoon she rang and said: 'I have awful news. Jack is going to run for president.' She knew all about the women, of course, but she stuck, and decided she was going to do a good job. I thought she did. She was a wonderful First Lady. I remember one day at the White House when I was redesigning the Rose Garden for Jackie and the President, we were waiting for an elevator. When it came, I stepped back to let her go in first.

" 'What are you doing?' she said.

" 'Well, you're the First Lady.'

" 'Stop that nonsense! Get in!' "

We moved into the living room for coffee and she fell silent. After a while, she said: "Harry, I've been such a lump lately. I've got to get *started*. Let's go for a ride and then to my library." I got up from the couch, and took her hand. As she stood up, she said, "I'm feeling a little weird, I think maybe I got up too fast." She sat back down and said, "Would you ask Nancy to come in here, please? Oh, and why don't you go into the kitchen and say hello to everybody. They'll be happy to see you."

I knew she wanted to recover from her dizzy spell privately, so I left and found Nancy, who went in to sit with her. When I walked back into the kitchen, there were Maria and John and Stanley and all the others. Three generations of black families who had worked for the Mellon family most of their lives, some since childhood, smiling and laughing and embracing me as they talked of their families, their children, and their great-grandchildren. And their love and respect for Bunny was palpable.

"Mrs. Mellon paid to fix all the teeth of the children at the village in Antigua."

"Mrs. Mellon built the Trinity Church here in Upperville, where everyone can worship."

"Mrs. Mellon gave the dock and the land around it at the Cape house to Eddie Crosby, who's been looking after the boats all these years."

I left them, collected Bunny, and we went out to the courtyard.

"The keys should be in the ignition," she said, "let's go for a ride."

The two of us moved through her world slowly, stopping by the dairy, lingering at the pool, ending up at the private library she had built on the property, where I unlocked the door and stepped into a magical kingdom. Her library is an extraordinary testament to all things horticultural. "I'm a gardener, Frank," she said, "that's what I do." And her gardens are indeed breathtaking places to be. Even the bees and the butterflies who inhabit them seem bigger, better, and happier.

I sat her down on a large white couch beneath a giant yellow Mark Rothko painting.

"That may be the biggest Rothko I've ever seen," I said.

"Maybe it is. It was lying on the floor with lots of others in a studio in New York. I'd just been to the doctor's and I went over to have a look. I called Paul and told him we had to have them; that we could get thirteen of them all for under five hundred thousand dollars. 'That's cheap,' he said. And it was in 1971, so we bought them. Have a look around, Harry, I'm going to close my eyes for a few moments."

I walked through the library opening shutters and drawers and looking on the walls. From every window were views of Bunny's glorious handiwork. On every surface magnificent, priceless, ancient books on botany and horticulture, and on the walls still more beautiful paintings. It would soon be time for me to take the plane on to South Carolina so I went over and sat next to her on the couch. As she slept, her head lolling back on a small soft pillow, I watched her breathing; some-

thing she needed to keep on doing only a scant thirty-five days more in order to wake up alive on her one-hundredth birthday.

I put my hand on her shoulder.

"Mertz?"

She opened her eyes and looked at me. "Oh, Harry. Isn't it peaceful here?"

"Yes. Thanks to you."

"Oh no! Thanks to great artists and Mother Nature. I just appreciate."

I closed the shutters, turned off the lights, locked the door, and we drove back to the main house. As we got out of the car, I said, "Let's take a picture."

We stood by the front door and as she leaned in against my shoulder I held the camera at arm's length and snapped us.

"Oh I didn't fix my hair," she said, neatening and tidying it as she spoke. "Take another one."

I did, then turned and embraced her. As I kissed her good-bye she said:

"What do you look like these days?"

"Oh," I joked, "I'm still six-foot-three and still have a full head of dark brown hair, weigh about 180 pounds, can run as fast as I ever could, and get just about anyone I want into bed."

She got it, laughed, and said:

"Well, I'm ninety-nine years old now, Harry, and that's *it*. Next birthday, ninety-*eight*."

Nancy came out to help her back to the house, but Bunny wanted to see me off and stood waving good-bye until the car was down the driveway. And staring from the back window I watched her, nearly blind, continue to wave good-bye to a guest she could not see.

———

Jackie Onassis, Bunny's best friend, died in 1994. Paul Mellon, her husband of fifty-one years, followed in 1999. Liza, her only daughter, left her in 2008, and Robert Isabell, a high-end party planner who had become her constant and devoted friend in her later years, passed away only four days after our Fourth of July visit in 2009. He is buried near the Mellon farm in a tiny Civil War cemetery. Paul and Liza rest in the private family plot at Trinity Church in Upperville, where Bunny has allocated a spot next to them.

For my sake, I hope this extraordinary woman stays on the planet for as long as she can bear to. When she does finally leave us, she will do it surrounded by the people she most loves, and who most deeply love her. And she will, I'm certain, pass away in the manner in which she preferred to live her life, calling little attention to herself and steadfastly adhering to her maxim: "Nothing should be noticed."

———————

It would be impossible to relate here all the many lessons Bunny Mellon taught me during the fifty years I have known her, but perhaps most prescient, as relates to the subjects of this book, including myself, is a piece of advice she gave me when, at twenty-four years old, I asked her:

"What should I do when I meet a famous person?"

"Oh Frank," she said, "don't think too much about famous people. They already think too much about themselves."

AFTERWORD

Walking up Madison Avenue one afternoon in 1980, passing by Frank Campbell's funeral home on the northwest corner of 81st Street, I saw coming out of the door my old friend Peter Witt, a theatrical agent, blowing his nose.

"Hello, Peter."

"Hello, Frank, " he said, wiping his eyes. "We lost another one."

"Who died?"

He told me the name of a renowned Broadway star whom he had represented for many years.

"He was such a wonderful actor," I said.

"Yes, he was. Wonderful!"

"I'm so sorry I never met him."

"Ach!" he said. "You didn't miss much."

———

So before the next name to drop is mine, and the reviews start coming in, I'd like to take back Center Stage for a moment. A position closer to my nature than the supporting role I have elected to play here.

A good deal of my actor's life has consisted of packing and unpacking suitcases, playing house in hotel rooms around the world, joining happy and unhappy families for finite periods, serially embracing temporary partners, and indulging passions that flared and fizzled with predictable frequency.

Representatives came and went; as did my successes, missteps, miscalculations, and outright failures. Concurrently, I dropped anchor after anchor along the way: marriages, children, multiple residences, mortgages, family obligations, and close circles of friends. All entered into with fierce commitment.

Racing for that bus to New York in 1953 was not just my adolescent effort to escape a geographical prison, nor was it to answer the call first sounded by happenstance in the wings of my grammar school auditorium. It was, unknown to me at the time, to quiet a panic soundlessly pounding inside an unsettled baby, arms up, yearning to be held, crying out for recognition and validation, anxious to stay in flight as long as he could.

And the wilderness in which I wandered as a young boy, believing myself forever lost, never to reach a destination, I have now come to feel is precisely the place to be. There is no lasting comfort, it seems to me, in the safe landing. Better to stay in flight, take the next bus, relinquish control, trust in happenstance, and embrace impermanence.

If fame is indeed fleeting, then so are titles, awards, wealth, position, youth, beauty, and sexual pleasure. So are contentment and happiness. So are pain and suffering.

The finish line, after all, is inevitable. Like the subjects of this book, each of us will live on only in memory. With that in mind, perhaps the best way to navigate the split-second start-to-finish race might be to heed the words of George Bernard Shaw (the last name dropped herein) who wrote:

> *Life has a way of slipping through your fingers.*
> *But, if you stick to your soul, it will stick to you.*

Not a bad piece of advice. And you don't even have to be famous to follow it.

FL

IN RETROSPECT

In September 1989, I wrote an essay entitled "The Demon Seesaw Actors Ride," which was published in the *New York Times*. Most of its subjects have left us, apart from the hypochondriac, who is still doing just fine. I include it here, some twenty-three years later, as a further testament to the heroic members of my profession and to the universal, timeless pitfalls of fame and fortune.

<div align="right">

FL
September 1, 2012

</div>

His hands were trembling so much I thought he was going to break into a hundred pieces, like a Tom and Jerry cartoon character. He had been sitting at a nearby table in an L.A. actors' hangout, and as he got up to leave, he threw me a "We've never met, but I know you" wave. I waved back and asked him to join my table. He hesitated a beat, then came over.

I was having a late supper with an actress friend, keeping a date we'd made in New York earlier that week. We three exchanged perfunctory L.A. versus New York cliches: the requisite "Love your work" phrase and avoidance of the "What are you doing?" question. The trembling hands continued throughout our ten-minute conversation. I resisted the urge to ask him if he was all right because something inside me understood the tremble and knew the answer.

This man had once been at the top of our profession. A series of successful films and an Oscar nomination had capped a hot streak lasting some four or five years in the mid-1970s. Things turned bad. He was now fifty and forgotten. Facing me was an actor climbing the ladder again. Lightly tanned, clean-shaven, eggshell thin, in a blazer and tie, the hands trembling to hold onto the bottom rungs once more. He excused himself and said he was off to see a midnight movie. "I want to get lost in the dark of the theater," he said.

––––––––––

My friend and I fell silent, wondered if we should have been more solicitous, and decided it was best not to invade a shell that seemed barely held together. But his tremble stayed with me through dinner and after I drove her home. It became a symbol of the questions I had been asking myself more persistently each year. Why do actors live the lives we do?

Some basic truths about us, some fundamentals: married, single, divorced, straight, gay, bi, rich, broke, breaking in or holding on, the morning after Oscar, Tony, or Emmy, or struggling along without recognition; whether we are newcomers, superstars, an enduring light, a flash in the pan, a has-been or a comeback king, from low self-esteem to insufferable arrogance—we are the seesaw kids. Kids who hold on tight and wait, wait for the call, the audition, the part, the review—and then we do it again. Those are the ground rules. You must accept them if you are an actor. And you must accept the demons.

One veteran character actor told me he is so excited when the job comes to a close that he takes himself and his wife to Martha's Vineyard, and for four or five days he is in bliss. "And then," he said, "every time the phone rings, I am running up the dock like an old fool, thinking, 'Oh, God, please don't hang up. I hope it's work.' I've got money now," he said, "but

that's no comfort." Another actor, thirty-four years old, told me that when he's waiting he drives back and forth across the United States, calling his agent from phone booths every few days. He has no money and no comfort. And another, convinced each time his illnesses are not hypochondriacal, drives himself to doctors' offices and waits for test results. One actress does health spas, another buys and sells houses, a third designs gardens. "Dangerous things, gardens," she said. "You never want to come out of them." A not unsuccessful man with an Oscar told me that when he is out of work, an inertia so great overwhelms him that he is practically catatonic. He could not leave his home during one period for over three months. "Why?" I asked. "Fear," he said.

And fear encourages the demons insecurity and uncertainty. An elderly actress was over for dinner. When we sat down she threw back a straight Scotch and said, "You know what I did today? I did a general get-to-know-you, they call it, at a new agency I've just signed with. Look, I don't expect them to kiss my ass, but I have been at this for thirty-eight years and I sat there as kids younger than my children said things like, 'She'd be great as so-and-so's wife in his new series' or 'How good are your contacts in town? Who do you know personally?'" She was torn between her insecurity and need to be accepted, and her anger at expecting and not receiving the treatment she felt her lifetime of achievement had entitled her to.

An agent once said to me when I mentioned I was in my third month of unemployment, "How I envy you! You can sleep late; take the kids to the park; go on holiday."

"Why don't I take the keys to your office," I said, "lock the doors, send home your staff, and let you know when you can come back to work. Wait until I have something for you."

He laughed but didn't get it. How could he? How could anyone who has not experienced unemployment several times a year every year of his working life? No matter how often an actor may tell himself that a refusal is not necessarily a rejection, the word "no" only deepens his self-doubt.

And even when employed, the actor is still stalked by uncertainty. A great Broadway star once told me that during the entire rehearsal period of one of her many triumphs, she got out of her taxi twenty blocks before the rehearsal studio and walked the entire way in order to stop shaking. "I was certain I was going to be fired," she said. I recalled that when I was a young actor my famous leading lady asked if I would drive her to the first day of rehearsals out of town. "Sure," I said, too cocky to be nervous myself. She got into my car; we drove three blocks and she promptly vomited. "Wait until there is more at stake," she said. "You'll know what it's like." And as the seesaw rocked back and forth for me, I remembered her words.

I remembered again when, years later, a close friend of mine called and said, "You're back in town. Let's have dinner." It had been close to ten months since we had seen each other. We met at a local restaurant. When last I'd seen him, he and his wife had just bought a beautiful Bel Air house, one Mercedes, and one Jaguar, and put their children in private schools. During our dinner he freely admitted that it had all gone bad for them. As we waited in the garage, he told me the house was sold, as well as the cars; and they were now living in a two-bedroom apartment in West Hollywood. A wreck of a car was brought up by the attendant. "Ah, well," he said, "back to coach—keeps you humble." He drove away smiling, with a wave.

In between actors' waves to one another there are months and even years of travel to foreign countries, divorces, awards,

clinics, love affairs, or feuds, and yet whenever we meet we pick up the thread again.

Though sometimes it's more the needle than the thread. Actors can be immensely cruel to one another. There are times when you meet an actor you don't know and he greets you with hostility or condescension or even dismissal. It can be blown away sometimes—but sometimes it develops into downright hatred. A difference in acting styles, position on a set, being surrounded by too many assistants, can cause actors to polarize. If your career moves ahead or drops behind a friend's, the friendship is jeopardized. Your demons against his.

And those demons themselves are competing with an irrevocable one: aging. One strong, up-from-the-floor fighter of an actress said to me, "I won't be seeing you for a while, darling. I'm off to play the mother in a TV pilot. Can you imagine? The mother!" she said again. And then totally without rancor, she said, "You know, I never dreamed it would turn out like this. I thought it would always be Phaedra or Shaw or working with the great directors. I never dreamed."

During one lunch by a pool, a young friend of mine said of a fiftyish actor walking by our table, "Look at him. A fine figure of a has-been." I laughed, but it stung. A sag in your career or a sag in your chin, and you're a party joke. And if someone else isn't noticing your graying hair or expanding waistline, you are. The actor's anxiety over aging is more acute than most people's. Part of the product starts to wear out and the consumer wants a new one.

Several years ago, on the set of a film, eight of us between the ages of thirty-five and fifty sat around the table. I studied my face-lifted, hair-dyed, overtanned, lipo-bellied, toupeed, capped-teeth, skin-peeled colleagues. One friend said, "I'm

making it at last—at forty-eight—I'm making it. I'm going to dye my hair, pump my muscles, and smile my way to stardom."

That smile can be difficult to maintain. In Paris one early morning, waiting to be fitted for a beard, I noticed in the booth next to me one of the world's great beauties. As she was being fitted for a wig, an old film of hers was mentioned. The man attending her said, meaning no harm, "God, you were beautiful then." She smiled, looked him in the eye, and said, without a trace of bitterness, "Ah, well, we all have our moments, don't we." When the moment passes, it requires of the older actor a profound dignity. Those who age gracefully before the public do so while struggling privately to let go of that for which they were initially loved.

And deeper inside us, past vanity, past fear, past the waiting, past uncertainty and insecurity, there is a demon I can find no name for.

One early morning I looked out the window of the rented house in the country where I was working. Sitting poolside, wrapped in a fur coat, smoking a cigarette, surrounded by empty champagne bottles, was my leading lady. It was 6 A.M. I went down and sat next to her. A long silence and then she said, "I can't. I can't anymore. I can't go where I have to go inside to be really good and survive. I hate revealing myself and I despise myself for wanting to be liked." She eventually fell victim to that demon and left the profession.

I fear the demons like every other actor. But more than their existence, I fear their departure from me. I need them. They keep away the nameless one. Actors have a legitimate claim on the word "survivor." But just surviving is a victory with no spoils. I want the spoils, and I'll take the pain that goes with them.

With each new role comes a test of heart, mind, and spirit. Through the work, an actor finds his place in society. Up against a task larger than himself, he can transform and overcome. More than suffering, more than success, more than defeat, the work strengthens and illuminates. It calms the tremble. It steadies the seesaw.

Captured forever in a unique memoir, Broadway and film star Frank Langella's myriad encounters with some of the past century's most famous human beings are profoundly affecting, funny, wicked, sometimes shocking, and utterly irresistible. With sharp wit and a perceptive eye, Mr. Langella takes us with him into the private worlds and privileged lives of movie stars, presidents, royalty, literary lions, the social elite, and the greats of the Broadway stage.

How did Mr. Langella terrify a dozing Jackie Onassis? Why did he streak for Sir Laurence Olivier in an English castle? What led Elizabeth Taylor to wrap him in her pashmina scarf? Why did the Queen Mother need Mr. Langella's help? And what did Marilyn Monroe say to him that helped change the course of his life?

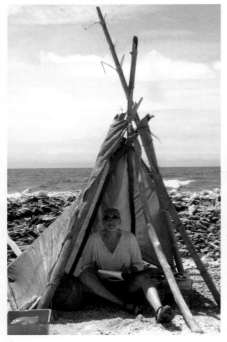

Through these shared experiences, we learn something, too, of Mr. Langella's personal journey from the age of fifteen to the present day. Like its author—and its subjects—*Dropped Names* is simply riveting and unforgettable.

Biography & Autobiography/ Entertainment & Performing Arts

ISBN 978-0-06-209449-0

HARPER ● PERENNIAL
www.harperperennial.com

Cover design by Archie Ferguson
Author photograph by Sara Langella

51499

9 780062 094490

EAN

USA $14.99

0413